Fauvism

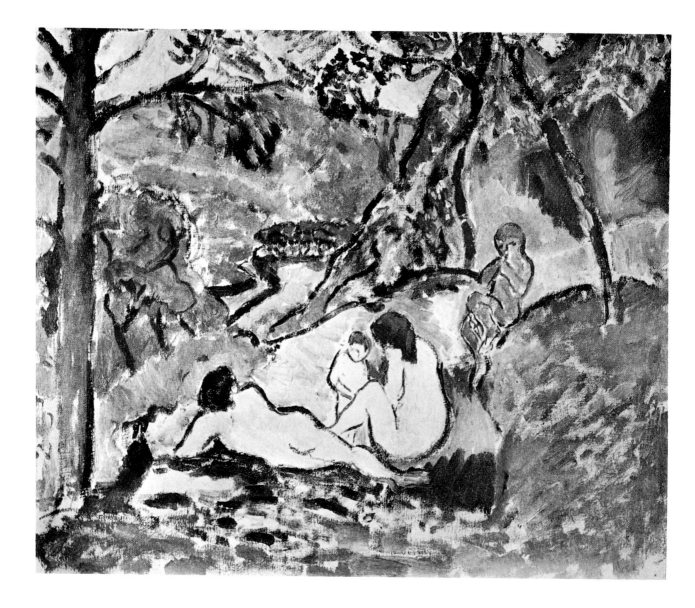

The "Wild Beasts"

Fauvism

and Its Affinities

John Elderfield

The Museum of Modern Art

Distributed by Oxford University Press, New York, Toronto

This book and the exhibition it accompanies have been organized by The Museum of Modern Art and made possible with the generous support of SCM Corporation and the National Endowment for the Arts in Washington, D.C., a Federal agency.

SCHEDULE OF THE EXHIBITION
The Museum of Modern Art, New York, March 26–June 1, 1976
San Francisco Museum of Modern Art, June 29–August 15, 1976
The Kimbell Art Museum, Fort Worth, September 11–October 31, 1976

Library of Congress Catalog Card Number 76-1491
Clothbound ISBN 0-87070-639-X
Paperbound ISBN 0-87070-638-1
Designed by Frederick Myers
Type set by Set-Rite Typographers, Inc., New York, N.Y.
Color printed by Lebanon Valley Offset, Inc., Annville, Pa.
Printed by General Offset, Inc., New York, N.Y.
Bound by Sendor Bindery, New York, N.Y.
The Museum of Modern Art
11 West 53 Street, New York, N.Y. 10019
Printed in the United States of America

Frontispiece
Matisse: *Pastoral*. 1906. Oil, 18⅛ x 21¾″. Musée d'Art Moderne de la Ville de Paris

Cover
(front left) Matisse: *Portrait of Derain*. 1905. Oil, 15⅛ x 11⅛″. The Trustees of The Tate Gallery, London

(front right) Derain: *Portrait of Matisse*. 1905. Oil, 18⅛ x 13¾″. The Trustees of The Tate Gallery, London

(back left) Matisse: *Portrait of Marquet*. 1905–06. Oil on panel, 16¼ x 12¼″. Nasjonalgalleriet, Oslo

(back right) Vlaminck: *Portrait of Derain*. 1905. Oil, 10¾ x 8¾″. Collection Mr. and Mrs. Jacques Gelman, Mexico City

Acknowledgments

This book is published on the occasion of an exhibition of Fauvist art at The Museum of Modern Art. As author of the book and director of the exhibition, I am obliged to many individuals and organizations for their generosity and assistance in bringing this project to fruition. Among the scholars who have been helpful in elucidating historical questions, my thanks go especially to Marcel Giry, John Golding, Michel Hoog, Michel Kellermann, John Rewald, Pierre Schneider, and Sarah Whitfield; and also to Ellen C. Oppler, whose own examination of Fauvism was particularly valuable to the present author. For additional information and assistance, I am grateful to Jack Cowart, Gaston Diehl, Pierre Georgel, Maurice Jardot, Daniel-Henry Kahnweiler, and Maurice Laffaille.

On behalf of the Trustees of The Museum of Modern Art, together with the Trustees of the San Francisco Museum of Modern Art and of the Kimbell Art Museum, Fort Worth, where the exhibition is subsequently to be shown, we are deeply grateful to the SCM Corporation and to the National Endowment for the Arts, which have provided significant funds to make this major exhibition possible. Its success has depended upon the generosity of the owners of key works who have lent their pictures to the exhibition knowing that they would thus be deprived of them for many months. In addition to nine important lenders who wish to remain anonymous, our deepest thanks are due to these owners of works included in the exhibition:

Mrs. John A. Beck; Mrs. Harry Lynde Bradley; M. Boris J. Fize; Mr. and Mrs Ben J. Fortson; Mr. and Mrs. Jacques Gelman; Mr. and Mrs. Leonard Hutton; Mr. Charles Lachman; Mrs. Phyllis Lambert; M. Pierre Lévy; Mme Lucile Manguin; M. André Martinais; Mr. and Mrs. William S. Paley; Mr. and Mrs. Gifford Phillips; Mr. and Mrs. David Rockefeller; Mr. and Mrs. Norbert Schimmel; Mrs. Evelyn Sharp; Mrs. Bertram Smith; Mr. and Mrs. Nathan Smooke; Miss Kate Steichen; Dr. Jean Valtat; Mr. and Mrs. John Hay Whitney; The Baltimore Museum of Art; Musée des Beaux-Arts, Bordeaux; The Brooklyn Museum; The Art Institute of Chicago; The Kimbell Art Museum, Fort Worth; Musée d'Art et d'Histoire, Geneva; Musée de Peinture et de Sculpture, Grenoble; The Museum of Fine Arts, Houston; The Tate Gallery, London; The Milwaukee Art Center; Musée Matisse, Cimiez, Nice; Nasjonalgalleriet, Oslo; Centre National d'Art et de Culture Georges Pompidou. Musée National d'Art Moderne, Paris; Musée d'Art Moderne de la Ville de Paris; Musée de l'Annonciade, Saint-Tropez; San Francisco Museum of Modern Art; St. Louis Art Museum; Musée d'Art Moderne, Strasbourg; Staatsgalerie, Stuttgart; The Museum of Modern Art, Tehran; The Bridgestone Museum of Art, Tokyo; Museum des 20. Jahrhunderts, Vienna; Galerie Beyeler, Basel; Acquavella Galleries, New York; Perls Galleries, New York; Galerie Alex Maguy, Paris.

This exhibition is the first to benefit from The Museum of Modern Art's formal agreement with the French government, providing for the reciprocal loans of works of art. I am particularly indebted to Pontus Hultén and Germain Viatte for the cooperation of the Centre National d'Art et de Culture Georges Pompidou; and to Hubert Landais, Inspecteur Général des Musées de France, for facilitating loans from other French museums. For their support of this project my thanks go to the mayors of Bordeaux, Le Havre, Nice, Strasbourg, and particularly Saint-Tropez, where Alain Mousseigne, Curator of the Musée de l'Annonciade, made special concessions so that important works could appear in the exhibition.

This exhibition is also the first occasion on which The Museum of Modern Art has had the pleasure of cooperating with the recently founded Museum of Modern Art, Tehran. His Excellency Karim Pasha Bahadori, head of the Private Cabinet of Her Imperial Majesty the Shahbanou of Iran, has made this cooperation possible. Among other museum colleagues, Sir Norman Reid, Michael Compton, and Judith Jeffreys of The Tate Gallery, London, and Thomas L. Freudenheim and Brenda Richardson of the Baltimore Museum of Art have made special arrangements so that their paintings could be in the exhibition. The directors of the participating museums, Henry Hopkins of the San Francisco Museum of Modern Art and Richard F. Brown of the Kimbell Art Museum, have taken a keen interest in the exhibition as it has developed.

For their assistance in tracing specific works, I am grateful to L'Association pour la Diffusion des Arts Graphiques et Plastiques, Ann Allbeury, Douglas Cooper, François Daulte, Dolly van Dongen, Lucile Manguin, Pierre Matisse, Robert Schmit, S. Martin Summers, Maurice Tuchman, Mlles Vlaminck, Charles Zadok, and especially to Ernst Beyeler, Leonard Hutton, and Klaus Perls. Monique Barbier, Françoise Cachin-Nora, Bereshteh Daftari, and particularly Richard Wattenmaker were of invaluable assistance in mediating certain important loan requests.

Besides the lenders themselves, among those who have gone to much trouble making photographs or information available are Mme Abdulhak, Knut Bert, Olive Bragazzi, Oscar Ghez, Charles Jäggli-Hahnloser, Alex Maguy, Thomas P. Lee, Magne Malmanger, John Neff, Katherine Ritchie, Angelica Rudenstein, Hélène Seckel, Karen Tsujimoto, Dina Vierny, and E. L. L. de Wilde.

An exhibition and book of this order can only be achieved with the cooperation of an expert staff. Many members of the Museum's staff have worked under tremendous pressure in order

to realize this project in a very short time. Principal among them has been Elizabeth Streibert, who vigorously coordinated matters relating to loans and dispatched numerous other tasks associated with the publication; her contribution has been crucial to the project's success. Judith Cousins Di Meo worked as Researcher for the project, gathering documentation early in its development, and was an enthusiastic and invaluable helper throughout. Bonnie Nielson typed the manuscript of the book, and shared with Ruth Priever and Kathy Martin the considerable secretarial work involved. Inga Forslund prepared a comprehensive bibliography on Fauvism of which a shortened version is published here.

Of the staff members whose important contributions apply to the exhibition in particular, my principal indebtedness is to Richard Palmer, Coordinator of Exhibitions. Jack Limpert mediated the funding of the exhibition. Monique Beudert of the Registrar's Department overcame the difficulties in assembling works of art from many different sources. Jean Volkmer and Anny Eder Aviram of the Department of Conservation worked to restore some key paintings before they could be exhibited. Alicia Legg, Associate Curator of Painting and Sculpture, graciously consented to advise and assist in the installation of the exhibition. To these, and to all of my colleagues in the Department of Painting and Sculpture, who furthered my work in numerous ways, go my deepest thanks.

It has been a very great pleasure to work with Mary Lea Bandy, who perceptively edited the text of this book, with the expert assistance of Susan Wolf. Fred Myers, working against an imminent deadline, was responsible for its handsome design, and Jack Doenias saw through the printing of the color plates and the general production of the book. Richard L. Tooke of the Department of Rights and Reproductions and Frances Keech, Permissions Editor, both helped to bring it into being.

Finally my thanks go to Richard Oldenburg, Director of The Museum of Modern Art, for both his enthusiastic support of this project and his encouragement throughout its development, and especially to William Rubin, Director of the Department of Painting and Sculpture, who helped to arrange crucial loans for the exhibition and carefully read the manuscript of the book, making a number of important suggestions that are incorporated in the text. His advice and assistance have extended to every aspect of this project, and are very warmly appreciated.

J.E.

List of Illustrations

The following list is divided into two sections. The first is a listing of works in chronological order by each of the Fauve artists. Where two or more works are dated to the same year, they are listed alphabetically within that year. The second section lists works by other artists, alphabetized by name of artist. Page numbers with an asterisk indicate works reproduced in color.

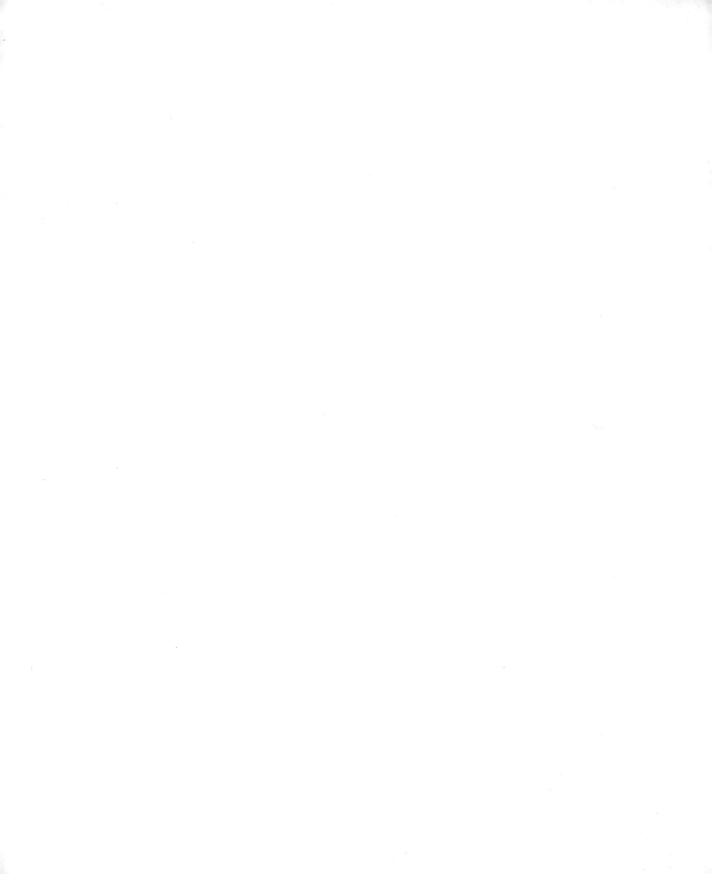

Introduction

Genuinely new art is always challenging, sometimes even shocking to those not prepared for it. In 1905, the paintings of Matisse, Derain, Vlaminck, and their friends seemed shocking to conservative museum-goers; hence the eventual popularity of the term *les fauves,* or "wild beasts," by which these artists became known. But shock and surprise quickly disappear. To look again at these exquisitely decorative paintings is to realize that the term *Fauvism* tells us hardly anything at all about the ambitions or concepts that inform Fauvist art. "Wild beasts" seems the most unlikely of descriptions for these artists. The title Fauvism is in fact a misleading one for the movement to be discussed here.

Matisse and his friends were first called *fauves* when they exhibited together at the Paris Salon d'Automne of 1905. The artists themselves did not use the name. "Matisse tells me that he still has no idea what 'fauvism' means," reported Georges Duthuit later.[1] The Fauvist movement, it could be said, was the result of public and critical reactions to the artists' work. It began when their work first provoked widespread public interest, in the autumn of 1905, and lasted until approximately the autumn of 1907, when critics realized that the group was disintegrating. Critical recognition, however, inevitably lags behind artistic innovation. The Fauvist style (or better, styles) slightly preceded the Fauvist movement: the first true Fauve paintings were exhibited at the Salon des Indépendants in the spring of 1905; the last important Fauvist Salon was the Indépendants two years later. The Fauvist group, in contrast, preceded both the movement and the style, since it had begun to emerge even before 1900. It comprised, in fact, three fairly distinct circles: first, Henri Matisse and his fellow students from Gustave Moreau's studio and the Académie Carrière, including Albert Marquet, Henri Manguin, Charles Camoin, and Jean Puy, and, somewhat apart from these, Georges Rouault; second, the so-called "school of Chatou," namely André Derain and Maurice de Vlaminck; and third, the latecomers to the group from Le Havre, Emile-Othon Friesz, Raoul Dufy, and Georges Braque. There was also the Dutchman, Kees van Dongen, who met the others at the salons and galleries where they all exhibited. Matisse was both leader and linchpin of these circles. When he became friendly with Derain in 1905, the original Matisse circle suffered from his absence while Derain, and in turn Vlaminck, benefited. Only when the Havrais artists saw Matisse's paintings did they develop their own Fauve styles. When Matisse and Derain finally went their own separate ways in 1907, Fauvism itself ended.

The course of Fauvism was crucially affected by the interaction of personalities. The nature of these personalities is well expressed in the series of portraits the artists painted of each other. Matisse and Derain spent the summer of 1905 at the small Mediterranean seaport of Collioure not far from the Spanish border and there painted some of the works that created such a sensation in the Salon d'Automne of that year. Among the most familiar paintings from that amazingly productive summer are their companion portraits: broadly set out in intense, saturated colors, Matisse represented as the self-contained and self-confident master and Derain as his youthful and rather more exuberant colleague (p. 14). Also from Collioure comes an unfinished, far more casually painted portrait by Derain: a rare image of Matisse as a true *fauve,* with violent red beard and paint-smeared hand, advancing from an interior that seems almost to be in flames (p. 16). This was undoubtedly how many people imagined Matisse, although the finished painting is far more accurate a representation of his sober and professorial public image.[2] When Derain wished to convince his parents that painting was a respectable career, it was Matisse who was invited as evidence of that fact.[3] Only in very private images, such as the unfinished Derain painting, does one see the intense artistic excitement and even anxiety lying behind Matisse's calm and decorative art.

Neither Matisse nor Derain was a *fauve* by personality. Only Vlaminck acted out something approaching a *fauve* existence. Matisse finally gave up violin duets with him because he played fortissimo all the time. "The same might have been said of his painting of this period," Alfred Barr has remarked.[4] This is certainly borne out by the portraits he and Derain painted of each other in 1905. The vivid red face and summary handling in Vlaminck's portrait of Derain (p. 48) take greater liberties with natural appearances than does the Derain of Vlaminck (p. 15). But this is by no means the case with all of Vlaminck's paintings. His style of painting was no "wilder" than van Gogh's, for example, and his subjects were frequently even charming.

Matisse, Derain, and Vlaminck are the most important of the Fauves. They were certainly the most daring pictorially. Dufy, Braque, Friesz, Marquet, and the others to be considered here seem to justify the label of "wild beasts" even less. This said, however, it needs emphasizing that works that look exquisitely decorative today appeared in 1905 to be brutal and violent—especially to a public that had yet to come to terms with van Gogh and the other Post-Impressionists. What is more, even when compared with Post-Impressionist painting, the color and

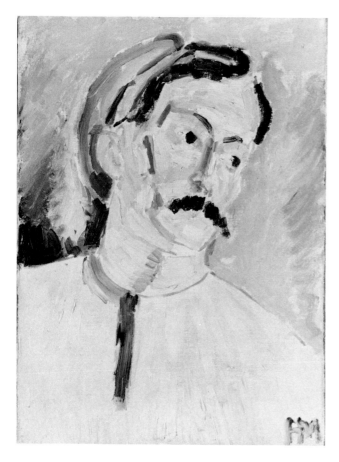

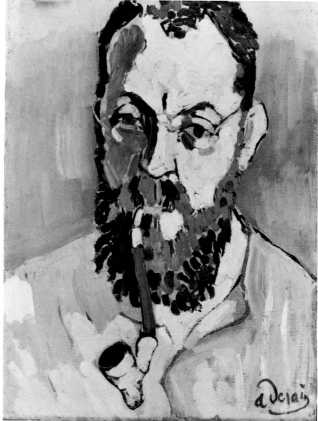

Matisse: *Portrait of Derain*. 1905. Oil, 15⅛ x 11⅛". The Trustees of The Tate Gallery, London

Derain: *Portrait of Matisse*. 1905. Oil, 18⅛ x 13¾". The Trustees of The Tate Gallery, London

brushwork of the Fauves possess a directness and individual clarity that even now can seem, if not raw, then declamatory, and of astonishing directness and purity. "This is the starting point of Fauvism," Matisse said later, "the courage to return to the purity of means."[5] His talk of a return is significant. Fauvism was not only—and not immediately—a simplification of painting, though that is what it became. It was initially an attempt to recreate, in an age dominated by Symbolist and literary aesthetics, a kind of painting with the same directness and antitheoretical orientation that the art of the Impressionists had possessed, but one created in cognizance of the heightened color juxtapositions and emotive understanding of painting that were the heritage of Post-Impressionism. In this sense, Fauvism was a synthetic movement, seeking to use and to encompass the methods of the immediate past. Nearly all of the Fauvist painters passed through a phase of heightened and exaggerated Divisionism, based on the work of Seurat and Signac. The first true

Fauvist style, largely the work of Matisse and Derain in 1905 and best described as mixed-technique Fauvism, combined features derived from Seurat and van Gogh, scumbled, scrubbed brushwork, and arbitrary color divisions reminiscent of Cézanne. The classic flat-color Fauvism of 1906-07 would have been inconceivable without the example of Gauguin. But if Fauvism was a synthetic movement, it was also a radical one. The means and methods of the past were used not in any spirit of submission, but of renewal. As Matisse aptly put it, "The artist, encumbered with all the techniques of the past and present, asked himself: 'What do I want?' This was the dominating anxiety of Fauvism."[6]

This indeed is the anxiety, and excitement, visible in Derain's unfinished portrait of Matisse: of the attempt to find new stimulus in the tradition of pure painting initiated by the Impressionists, and to find a particularly personal and individualist stimulus, too. That the Fauves were successful in this is evident,

14

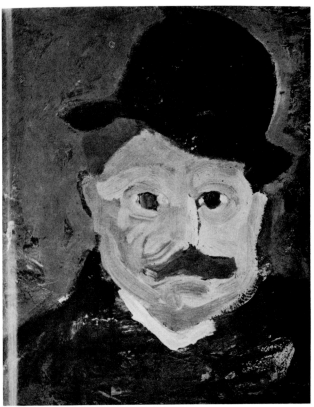

Matisse: *Portrait of Marquet.* 1905-06. Oil on panel, 16¼ x 12¼".
Nasjonalgalleriet, Oslo

Derain: *Portrait of Vlaminck.* 1905. Oil, 16¼ x 13". Collection Mlles
Vlaminck, Brézolles, France

if only in the fact that their very individuality as painters makes
an all-encompassing definition of Fauvism—or even a listing of
Fauve painters—extremely difficult.

Fauvism was not a self-sufficient and relatively autonomous
movement in the way most modern movements have been.
Although it existed by virtue of friendships and professional
contacts, it had no announced theories or intentions as did, say,
Futurism. Nor had it a single common style that can be plotted
rationally, as is the case with Cubism. Its perimeters, therefore,
necessarily seem vague. In consequence, both exhibitions and
studies devoted to the movement sometimes treat it with alarm-
ing latitude. For example, it has been considered but an aspect
of the broad Expressionist impulse that affected early twentieth-
century art,[7] or part of a new art of color that extended far beyond
the boundaries of the Fauve group.[8] Indeed, Fauvism was not
alone in certain of its general ambitions; it was, nevertheless, a
unique artistic movement that requires definition as such.

Where there is genuine difficulty is in establishing its relation-
ship to the contemporary Parisian avant-garde, and in deciding
whether friendship alone, or stylistic similarity alone, suffices
to denote Fauve membership.

Rouault, for example, was one of those represented at the Fauve
Salon; but his emotive dramatis personae of prostitutes and
clowns would seem to separate him from the other Fauves. (Yet
van Dongen, too, was attracted to that same artificial world, if
not from the same religious impulse.) Beneath Rouault's
chiaroscuro effects is a real brutality of brushwork, and occa-
sionally of color, that exceeds that of any widely accepted Fauve.
If, however, our primary criterion is liberated pure color, then
Rouault is rightly excluded from most histories of Fauvism.[9] On
the other hand, not all high-color painting from 1904 to 1907 is
Fauvist. A large number of painters, including Picasso, were
attracted to bright flat hues at that time, and several already
established colorists—including Louis Valtat, who is often con-

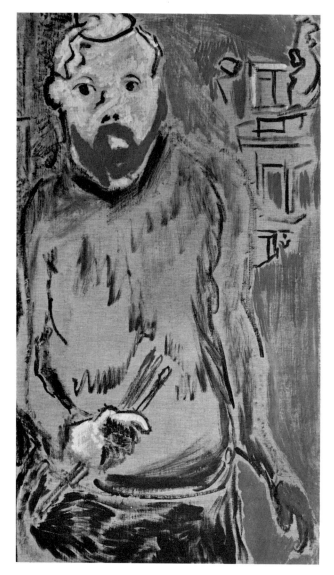

Derain: *Matisse.* 1905. Oil, 36⅝ x 20½". Musée Matisse, Nice

tion of Fauvism. To see what that color describes is to discover contradictions of another kind. Although many Fauvist paintings overtly celebrate the pleasures of the landscape world, high color itself does not preclude an emotive and charged iconography. An important thread running through Fauvism is the development of a Neo-Symbolist and then Neo-Classical and primitivist imaginative painting, from Matisse's *Luxe, calme et volupté* of 1904-05 at one side to Derain's series of Bathers from 1907 at the other, which join the final phase of "Cézannist" Fauvism to the emerging aesthetic of Cubism. Fauvism was not an isolated movement but part of a greater artistic ferment in French painting in the first decade of this century.

The affinities of Fauvism demand study alongside Fauvism itself. A record of its historical background and development before 1905 is certainly crucial to its understanding; this is the subject of the first of the following chapters. The "classical" Fauve paintings of 1905 to 1907 are discussed in chapter two, and the "imaginative" paintings mentioned above are considered together in the final chapter. The common denominator is the presence of Matisse. It was he, provoking and guiding the experiments of his younger colleagues, who engendered Fauvism. And yet, in the Fauve group, Matisse was dominant and withdrawn at the same time. Not only was he older than the others (Braque, the youngest, was thirteen years his junior), but he led from the outside, as it were, following his own personal direction and avoiding a priori commitments of any kind. The history of Fauvism is largely the history of this essentially private artist's single sustained period of cooperation with the Parisian avant-garde, albeit for a very short period. Within this period, we see an emphasis upon the autonomy of color almost entirely new in Western art, a concern with directness of expression that countenanced mixed techniques and formal dislocations for the sake of personal feeling, and a truly youthful bravado that in its search for the vital and the new discovered the power of the primitive. We also see a rendering of external reality that found pleasurable stimulus in the "vacation culture"[11] subject matter of the Impressionists, but that pushed it at times either to the verge of a vernacular urban realism or toward a more ideal celebration of the *bonheur de vivre.* Finally, and perhaps most basic of all, is a belief in both individual and pictorial autonomy, which found a remarkable balance between the concern for purely visual sensation and for personal and internal emotion, and in so doing rediscovered a tradition of high decorative art that has provoked some of the most sublime as well as expressive paintings of this century.

sidered among the Fauves—were still active.[10] The lessons of Post-Impressionist color were being taken up in many different ways in this period. The Fauvist way, if we can speak of anything so definite, overlaps and intersects with the others. Nor is it possible to look only to a tradition of liberated color for a defini-

The Formation of Fauvism

The first contacts that led eventually to the creation of Fauvism date to 1892. In that year, Henri Matisse, then twenty-two and having just spent his first year in Paris in the frustrating atmosphere of Bouguereau's class at the Académie Julian, joined the studio of Gustave Moreau at the Ecole des Beaux-Arts.[1] There he met Georges Desvallières, who was to be one of the organizers of the famous Salon d'Automne of 1905, and some of those who were to be represented there: Georges Rouault, two years Matisse's junior, and Albert Marquet, then only seventeen and attending evening classes at the Ecole des Arts Décoratifs. All of Matisse's future collaborators in Fauvism were younger than he was. Manguin and Camoin, who joined Moreau's studio in 1895 and 1896, were seven and ten years younger, respectively. For all of them—with the exception of Rouault, who followed an independent path—Matisse was the leader from the start. In 1896, he sent several of his student paintings to the recently founded Société Nationale des Beaux-Arts; sold one of them to the state; was elected an associate member of the society, nominated by its president, Puvis de Chavannes; and seemed set upon a respected academic painting career. A year later, however, the situation was upturned. *The Dinner Table* (right), which he exhibited at the Nationale in 1897, provoked considerable hostile reaction, for Matisse had begun to investigate Impressionism, albeit tentatively, and the commotion surrounding the state's acceptance of the Caillebotte Bequest, which was finally exhibited that same spring at the Luxembourg Museum, showed that Impressionism was still a controversial subject.[2] Moreau nonetheless defended *The Dinner Table,* and Matisse appreciated his master's "intelligent encouragement."[3] What Moreau principally encouraged was individuality (in this he was unique among the academicians), and his studio was the principal birthplace of the Fauve circle. Indeed, even in 1905 Louis Vauxcelles was referring to the Fauves as "that cohort, cultivated to the point of Byzantinism, that formed around Moreau."[4]

It was, however, precisely Moreau's "Byzantinism," his exotic literary style, that Matisse and his friends avoided.[5] Despite Moreau's brilliance as a teacher, his studio was a hermetic and isolated one. The Fauves-to-be discovered modernism on their own, and one by one began to practice it. They saw the Impressionists at the Caillebotte Bequest, Cézannes and van Goghs at Vollard's gallery, and paintings by Vuillard, Bonnard, and the Nabis and by Signac, Cross, and the Neo-Impressionists at the Salon des Indépendants. In the summer of 1897, Matisse met van Gogh's English friend, John Russell, who further acquainted

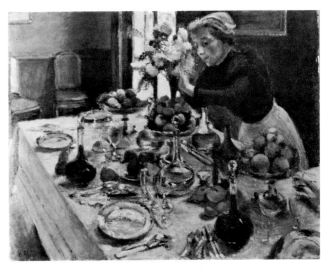

Matisse: *The Dinner Table.* 1897. Oil, 39½ x 51½". Private collection, Paris

him with Impressionist and Post-Impressionist painting. He also met Pissarro, who encouraged him to visit London in 1898 to study Turner. Returning to Paris the following year, after having traveled also to Corsica and to Toulouse, Matisse found that Moreau had died and the highly conservative Fernand Cormon had succeeded him. Matisse was soon asked to leave the studio[6] "I imagined that I could return to the Académie Julian," he wrote later, "...but I had to take flight quickly: the students took my studies for jokes. By chance I heard that there was on the rue de Rennes, in the courtyard of the Vieux Colombier, a studio organized by an Italian where Carrière came to correct every week. I worked there, and there I met Jean Puy, Laprade, Biette, Derain, Chabaud. There wasn't a single pupil of Moreau's there."[7] In fact, Matisse continued to keep in contact with his earlier friends, especially with Marquet, who lived in the same building as he did. But Matisse's enrollment at the Académie Carrière did enlarge his circle to include other Fauves-to-be, the most important of them being Derain. Through Derain, Matisse met Vlaminck. Derain lived in the suburbs of Paris at Chatou and traveled into the city by train to attend the academy. During a minor train derailment in June 1900, he met his Chatou neighbor Vlaminck.[8] They went out painting together the very next day, shared a studio together the following year, and in 1901 at the van Gogh exhibition at Bernheim-Jeune's,

which so impressed the Fauves, Derain introduced Vlaminck to Matisse. The essential triangle of Fauvism was thus established.

It was, however, almost immediately broken. Derain was conscripted into the army that same year, and Vlaminck remained in Chatou, apart from Matisse and his friends, until Derain's return three years later. It was Matisse and Marquet who began to exhibit together in 1901 and around whom the others began to gather. And it was their paintings that the final group of Fauves-to-be saw when they arrived in Paris from Le Havre in 1900. These were the latecomers to the group, Dufy, Friesz, and Braque. They, too, were much younger than Matisse: eight, ten, and thirteen years, respectively. Braque was only eighteen when he arrived in Paris to take his diploma as a house painter, avoiding the academies and learning about painting from the Vollard and Durand-Ruel galleries and from the Louvre[9] Dufy and Friesz had met in the mid-1890s in the studio of Charles Lhuillier at Le Havre, by all accounts as liberal and sympathetic as Moreau's.[10] By 1900 they were in Paris with municipal scholarships to Bonnat's studio at the Ecole des Beaux-Arts. Matisse was still being talked about in the school. Soon his paintings could be seen in public exhibitions, at the Indépendants from 1901 and at Berthe Weill's gallery from 1902. Initially, the Le Havre artists, as newcomers to Paris, were not in contact with Matisse's circle; but they began to exhibit at the same institutions and were gradually attracted by his direction. So too were van Dongen, who had reached Paris from Holland in 1887,[11] and Derain, when he returned from military service in 1904 and brought in Vlaminck from his isolation at Chatou. Although the Fauves were never a coherent, unified group, but a series of fluctuating constellations, they came temporarily to settle their orbits around Matisse, creating for a few brief years a dazzling combination of energy and color before dispersing to follow their own paths once again.

Exactly when this process created Fauvism is not easily decided. The Fauvist group, the Fauvist movement, and the Fauvist style (or styles) did not emerge simultaneously. The group was largely a matter of association and cooperation between the artists, and it developed very gradually from the first contacts in 1892 to the establishment of the core group in 1900 and through until 1906, when the youngest Fauve, Braque, began to work with the others and the group was finally complete. The movement was a result of the public reputation that Matisse and his friends enjoyed after the Salon d'Automne of 1905, though the title they received then, *les fauves,* was not in common use until 1907. By then the styles of Fauvism were being abandoned by most of their creators. The earliest Fauve style began to emerge, as we shall see, in the summer of 1904. It has long been recognized, however, that even before this members of the original Matisse circle had practiced a form of high-color painting that presaged their Fauve styles. "From around 1900," Derain said, "a kind of fauvism held sway. One has only to look

at the studies from the model that Matisse made at that time."[12] This early "kind of fauvism" has subsequently become known as pre-Fauvism or proto-Fauvism.[13] Marquet dated its beginnings to "as early at 1898 [when] Matisse and I were working in what was later called the *fauve* manner. The first showing of the Indépendants in which, I believe, we were the only painters to express ourselves in pure colors, took place in 1901."[14] Marquet is correct both as to the creators and the duration of what is probably most suitably designated proto-Fauvism, since it did not immediately precede Fauvism but was, instead, a short-lived and circumscribed episode involving Matisse and Marquet and lasting only from the end of 1898 to 1901. In 1901, Matisse turned away from high color, Marquet following him, and did not return to it again consistently until the summer of 1904. By then, the other Fauves-to-be in Matisse's immediate circle, together with Derain and Vlaminck, had heightened their palettes, having in fact begun to do so at the very time Matisse and Marquet darkened theirs. This second Fauvist prelude, between 1901 and 1904, which must be distinguished from the first since it occurred independent of Matisse's leadership (though not of his earlier example), might well be called pre-Fauvism.

Designations such as this are useful in clarifying the complexity of the development of Fauvism. They also tend to isolate the work of the Fauves from that of their contemporaries; whereas to look at the wider picture of Parisian art around 1900 is to see that the use of heightened color, far from being a unique proto-Fauve and pre-Fauve phenomenon, was a principal characteristic of advanced painting. It is in this broader context that the early work of the Fauves is best considered.

In 1900, the Impressionist mode was still the dominant one in French painting. Although the Impressionist style, in its purest and narrowest definition, is now generally considered as having come to an end in the mid-1880s, such a view was far from common in Paris in 1900. Impressionism was thought of as an ongoing, productive style.[15] We may prefer the word *mode,* for it was the principles or norms of Impressionism, rather than its original stylistic definition, which continued to attract young painters, the Fauves-to-be included: the external, natural world as a stimulus for a largely optically based art, one that either could emphasize the individuality of optical sensations at the expense of the objective *impression*[16]—carrying the art at times into the subjective—or could extend the objective to the methodical and even to the scientific. These two poles are, of course, those which the great Post-Impressionists helped to define. Gauguin, van Gogh, Seurat, and Cézanne, as well as the Impressionists themselves in their later years, developed the modalities of Impressionism even as they modified them. Insofar as technique is concerned, they all began with the flecked, pictorially autonomous brushstrokes of pure Impressionism, exaggerating or objectifying them; only Gauguin abandoned them significantly. Gauguin was also the only Post-Impressionist to begin to turn

away from the subject matter of original Impressionism—landscape viewed through nonrural eyes—to something more exotic and literary,[17] which related not only to the directly literary Symbolists but also to the work of such "anti-Impressionists" as Moreau and Redon. By 1900, however, many of Gauguin's followers, the Nabis, had turned away from the flat-color style toward a relaxed, but often more intensely colored, form of Impressionism, perhaps best exemplified by the work of Bonnard and Vuillard. Although the flattened decorative manner, popularized in the Art Nouveau style, continued, the Nabi and Neo-Impressionist versions of the Impressionist mode dominated painting in 1900 and were the most visible styles in the salons and galleries visited by Matisse and his circle.

The influence of the Neo-Impressionists upon the early development of Fauvism is more securely documented than that of the Nabis. In 1898, while still at Moreau's studio, Matisse read Signac's series of articles, "D'Eugène Delacroix au néo-impressionnisme," in *La Revue Blanche*.[18] His studies of Turner in London that year, followed by his extended stay in the strong light of Corsica and Toulouse, undoubtedly prepared him for experimentation with heightened colors. Returning to Paris in 1899, he began to work in two fairly distinct manners, typified by the paintings *The Invalid* (right) and *Buffet and Table* (below). The first is characterized by broad, rough brushstrokes, which anticipate his Fauvism of 1905. Its color, however, though often intense, is essentially tonal in setting, being an exaggeration of local color rather than the liberated pure hues that appeared with Fauvism. The color of *Buffet and Table*, in contrast, does anticipate Fauvism, although in touch it is a more conservative work, deriving from various Impressionist sources, particularly Neo-Impressionist ones.

It has been commented that proto-Fauvism had its own Neo-Impressionist prelude as did Fauvism itself later.[19] Matisse's proto-Fauve work, however, reveals nothing of the methodical *divisionisme* he adopted later, in *Luxe, calme et volupté* of 1904-05 (p. 25). Instead, it shows a particularly loose and unprogrammatic use of Neo-Impressionist methods.

It is significant that Matisse's first Neo-Impressionist experiments were principally affected by the work of Signac and Cross, who used block- or mosaic-like units of color far more enlarged in size than the components of Seurat's pure and meticulous *pointillisme*. Their blunter, exaggerated form of Neo-Impressionism was the more popular one around 1900, in part because it was far more accessible a manner for artists familiar with Impressionist methods, seeming less a theoretical science of color (though it was this as well) than an adaptation of the Impressionist brushstroke as the vehicle for heightened colors. While the *pointillisme* of Seurat also made use of individually pure hues, the minuteness of his strokes caused them to combine optically in an allover grayness of effect. In contrast, the color mosaics of Signac and Cross seemed to be composed of sets of

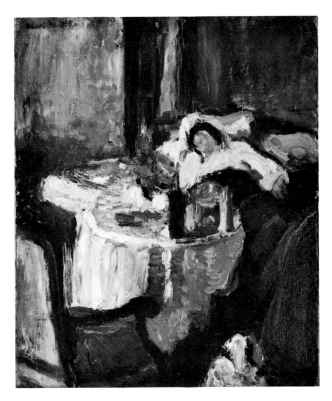

(top) Matisse: *The Invalid.* 1899. Oil, 18⅛ x 15". The Baltimore Museum of Art. The Cone Collection

(above) Matisse: *Buffet and Table.* 1899. Oil, 25⅞ x 32⅛". Dumbarton Oaks Collection, Washington, D.C.

Matisse: *Still Life against the Light*. 1899. Oil, 29¼ x 36⅞". Private collection, France

individual hues, each identified with the flat brushstroke units of the paintings.

This type of brushstroke could also be seen in the paintings of Bonnard and Vuillard at this time, sometimes coupled with very intense color and occasionally with large flat areas of color, as with certain Vuillard self-portraits that directly prefigure the mixed-technique methods of the Fauves[20] Matisse's first major modernist painting, *The Dinner Table* of 1897, belongs very much to the Nabi-*intimiste* side of the Impressionist tradition. Comparing this with *Buffet and Table,* we see that Matisse has used a similar subject, but only as the basis for what is essentially an investigation, and in some ways a dissection, of the Impressionist pictorial vocabulary. "It was the style of modern painting," it has rightly been said, "—the color and the touch— rather than its view of life that affected him."[21] Certainly from around 1900, Matisse began an obsessive, if not yet methodical, pursuit of the varying stylistic options of Impressionist-mode painting, turning the Impressionists' engrossment in the external world into an engrossment in the world of art, and especially in that of color. The subjects are Impressionist and Nabi ones, still lifes and city views, as well as those of the academy, posed nudes. What are most striking, however, are the freedom and flexibility that Matisse discovered in the art of his time, and his unwillingness from the start to be bound by any system.

In fact, his ambition seems already to have been to synthesize the modern tradition as it then existed. This synthesis only found its fruition in the Fauvism of 1905, but in the proto-Fauve period we see Matisse not only combining Neo-Impressionist and Nabi methods, but grafting them to his alternative 1899 style, that of *The Invalid,* which was itself deeply influenced by a third major

Post-Impressionist option, that of Cézanne. By 1899, the art of Cézanne had become so important to Matisse that he had bought by installments a small Cézanne painting of three bathers?[22] Matisse's broad treatment in *The Invalid* would seem to derive from his determination to keep a hold on structure and on the solidity of objects even as he began his researches into color. The demise of Fauvism is often explained by the influence of Cézanne. Although it is true that Cézanne was to be reevaluated in an important way in 1907, and that this specific reevaluation helped to bring Fauvism to an end, Cézannism was nevertheless a crucial component of Fauvism from the very start.

Matisse's *First Orange Still Life* and *Still Life against the Light* (left) followed *Buffet and Table* in 1899 and consolidated his proto-Fauve manner. This, like his early true Fauvism, was essentially a mixed-technique style using both exaggerated Impressionist-mode brushstrokes and exaggerated local colors, including large flat areas of dramatic oranges and startlingly intense highlights in complementary greens and blues. Matisse's adoption of a mixed-technique style, or better, mixed-style technique (for in 1900 the various components were still not completely combined), already shows not only great daring but great stylistic self-consciousness. It was by isolating and combining autonomous pictorial components that Fauvism itself was to be created?[23]

In 1900, Matisse's art was probably "wilder" than in his true Fauvist period. An impetuous, almost reckless, freedom is visible in the cascades of green and crimson brush and palette-knife marks passing across both figure and ground in the so-called Fauve nudes (pp. 21, 22), which Marquet and Matisse painted from the same model, probably early in 1899?[24] A certain spirit of competitiveness, most likely deriving from their experiences as students together, came to be characteristic of the Fauves. Having tackled similar subjects at the Académie Carrière, they worked together at Jean Biette's studio in the rue Dutot and at the house that Manguin had acquired following his marriage in 1899, where musicians and writers (including Dubussy, Ravel, Octave Mirbeau, and Joachim Gasquet) visited along with painters?[25] Of the painters, only Marquet attempted to keep pace with Matisse. Jean Puy seems to have been perplexed by Matisse's new direction. "He had no hesitation," Puy writes, "about introducing extreme and wholly artificial elements in his pictures. Very often, for example, he laid in the side planes of the nose and the pools of shadow under the eyebrows with an almost pure vermilion…or again some of his nudes looked as if they were wearing orange slippers."[26] He is probably referring to the painting of 1900 that has come to be known as *Nude with Rose Slippers* (p. 22), one of a number of more solidly painted figures that move from the Neo-Impressionist touch and flat disembodied color of 1899 toward a darker and more sculptural feeling, certainly indebted to Cézanne. This soon took Matisse into his so-called "dark period" of 1901-04, which is traditionally seen as a tem-

Marquet: *"Fauve" Nude.* 1899. Oil on paper mounted on canvas, 28¾ x 19¾". Musée des Beaux-Arts, Bordeaux

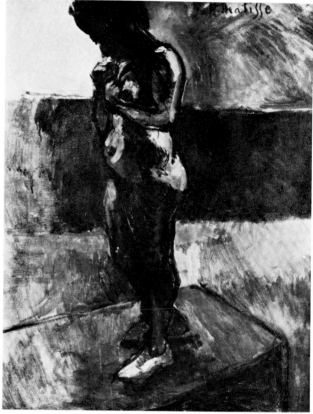

Matisse: *Nude in the Studio*. 1899. Oil, 25¾ x 19¾". The Bridgestone Museum of Art, Tokyo

Matisse: *Nude with Rose Slippers*. 1900. Oil, 28¾ x 23⅝". Private collection

porary repudiation of the first moves he had made along the Fauvist path. It is certainly true that Matisse did turn away from the allover high color that had characterized his early still lifes; yet we may note the continuity through the "dark period" of certain principles developed within proto-Fauvism. Of the figure paintings, only the Neo-Impressionist nude of 1899 is brightly colored throughout. The *Nude with Rose Slippers* depends upon a few sharp accents on the figure itself and a color-zoned background divided into alternating stripes of light and dark. Both the color accenting and color zoning persist into the "dark period." The *Standing Nude* of 1903 (p. 23)[27] uses linear accents of bright color to outline the figure in a way far more daring than any comparable painting of 1899-1900. As far as color zoning is concerned, it is noticeable that as soon as Matisse began figure painting in 1899, he immediately hit upon the device of carrying the figure the full height of the picture. Although the *Nude in the Studio* (above left) of 1899 is an allover painting in its facture, Matisse's compositional method divides the work into

three principal coloristic zones. In the *Nude with Rose Slippers*, they are turned sideways so as to distinguish the dark motif; but they do persist in the original vertical arrangement through to works like the *Portrait of Lucien Guitry* of 1903 (p. 23), where the area compartmentalization of the painting is emphasized by the color accents of the figure: the intense stripe of reds dividing the blue of one side of the painting from the green of the other. It was a method Matisse was significantly to extend in his paintings of 1905.

While the figures themselves in Matisse's early paintings look to Cézanne and to the sculpture Matisse was now beginning to make,[28] the color zoning owes something to the flat patterning of the Nabis. Both Nabi patterning and Nabi color are evident in the views of Notre Dame and of bridges on the Seine that Matisse painted around 1900, in the generally dominant violets and quiet greens and in the more relaxed mood than that of the paintings of figures. The other Fauves-to-be were the ones to feel the influence of the flat Nabi style most strongly, and of Nabi

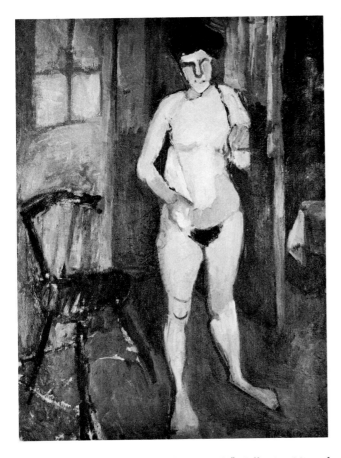

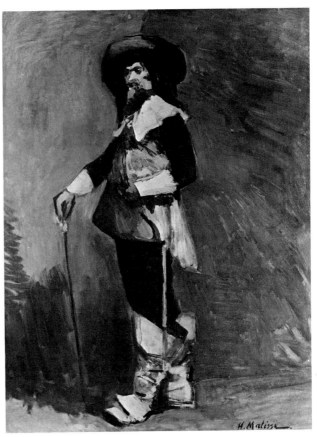

Matisse: *Standing Nude.* 1903. Oil, 32 x 23½". Collection Mr. and Mrs. Gifford Phillips, Santa Monica, California

Matisse: *Portrait of Lucien Guitry (as Cyrano).* 1903. Oil, 32¾ x 23½". Collection Mr. and Mrs. William S. Paley, New York

subjects, too, both the domestic and the decadent. "I would sometimes begin a canvas in a bright tonality," wrote Marquet of his "rivalry" with Matisse, "then, as I went on with it, ended on a grayish tone."[29] This is evident in his views of the Seine of this period. In Marquet's *Portrait of Mme Matisse* of 1900 (p. 24), he persisted in brighter tonalities—the strong oranges of this work closely relate it to Matisse's still lifes of the previous year—but the homely, intimate nature of the subject and the blurring of color zones carry it nearer to the work of Vuillard.

Marquet's early brush drawings of Paris street subjects (p. 24) look toward another side of Nabi art, to the "Japanese" calligraphic style of Bonnard's drawings.[30] Nabi graphic art would certainly have been familiar to the Matisse circle, both from the volumes of Bonnard and Vuillard lithographs published by Vollard and from these artists' illustrations in *La Revue Blanche.* In 1902, while serving in the army, Derain and his friends bought *La Revue Blanche.*[31] Derain's own illustrations for Vlaminck's 1902 novel, *D'un lit dans l'autre,* recall Bonnard's style, while

the strident, poster-like yellow cover is obviously indebted to Toulouse-Lautrec.[32] Van Dongen's contemporary illustrations for *L'Assiette au Beurre* of 1901,[33] as well as his paintings of this period, are also in a Lautrec-influenced style, as are their subjects—prostitutes and their clients in Montmartre. Rouault, of course, was beginning in 1902 to make such subjects particularly his own.

Matisse and his circle were not the only ones using the lessons of established high-key Impressionist-mode painting, nor were they (with the exception of Matisse himself) the most daring or inventive as yet in how they were using their sources. In March 1899, the Durand-Ruel Gallery held an important survey of contemporary painting, which displayed in depth the two principal camps of late Impressionist colorists, the Neo-Impressionists and the Nabis. Between them, in the room of honor, was an exhibition of the little-known pastels of Odilon Redon, and surrounding the Redons, works of some younger artists described at the time as *les coloristes.*[34] Redon is not often included among those

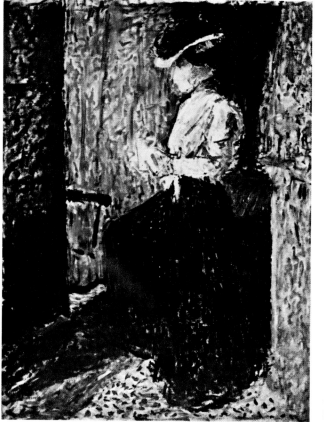

Marquet: *Portrait of Mme Matisse.* ca. 1900. Oil, 51¼ x 38¼". Musée Matisse, Nice

Marquet: *Dancing Couple.* 1904. Ink on paper, 6⅛ x 4⅜". Musée des Beaux-Arts, Bordeaux

who were influential to the development of Fauvism, though in 1912 André Salmon did wonder whether without Redon Fauvist color could ever have been so completely manifested.[35] It is significant that Redon was highly prized in advanced circles in 1900; that Matisse met Redon and became friendly with him around this time, when he was moving into his proto-Fauve period; and that Matisse's admiration for "the purity and ardor of [Redon's] palette" is documented.[36] He bought two of Redon's pastels, the works in the 1899 exhibition having impressed him very much, "not of course for their dreamlike fantasy," as Barr has written, "but for their brilliant color harmonies which, suspended in misty space, seemed completely liberated from all naturalistic or descriptive function."[37]

There are some later, isolated Fauve paintings, most notably Vlaminck's surprising and almost abstract *Flowers (Symphony in Colors)* of 1906-07 (p. 125), which looks back to Redon in some respects.[38] It may also not be amiss to discover Redon partly behind the strain of unnatural violets, lavenders, and purples that

occur in proto-Fauvist works, even in such early Fauvist ones as Matisse's *Woman with the Hat* (p. 53). Redon's influence, however, remained by and large a generalized one, and was bound to, for the Fauves without exception began their modernist alignment not in the unreal and artificial universe that Redon and the Fauves' first master, Moreau, had created, but in the more purely visual and external world of the Impressionist tradition.

The *coloristes* who surrounded Redon at the 1899 exhibition are especially relevant to any discussion of Fauvism, if only because one of their number, Louis Valtat, is frequently included as one of *les fauves*.[39] This is because a Valtat *Marine* was reproduced alongside paintings by Matisse, Manguin, Derain, Rouault, and Puy in the famous issue of *L'Illustration* of November 4, 1905 (p. 44), which pilloried the exhibitors at the Salon d'Automne that year. We shall see, however, that the juxtapositions of an uninformed picture editor are not the best guide of Fauve membership. Someone closer to the currents of contemporary art, the critic Louis Vauxcelles, is a more reliable guide:

Matisse: *Luxe, calme et volupté.* 1904-05. Oil, 38¾ x 46⅝." Private collection, Paris

Matisse: *The Open Window, Collioure.* 1905. Oil, 21¾ x 18⅛." Collection Mr. and Mrs. John Hay Whitney, New York

Matisse: *Girl Reading (La Lecture)*. 1905-06. Oil, 28½ x 23⅜." The Museum of Modern Art, New York. Promised gift of Mr. and Mrs. David Rockefeller

Matisse: *Landscape at Collioure*. 1905. Oil, 15⅜ x 18⅜." Collection Mrs. Bertram Smith, New York

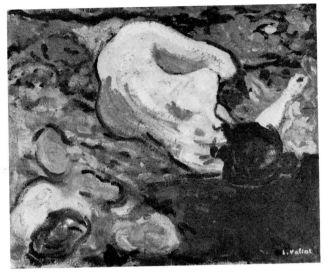

Valtat: *Water Carriers at Arcachon.* 1897. Oil, 51¼ x 63¾". Collection Oscar Ghez, Geneva

Valtat: *Nude in the Garden.* 1894. Oil, 17⅜ x 21⅝". Private collection

reviewing the Salon d'Automne of 1906, he distinguished three groupings of younger artists: the Nabis, Matisse and the Fauves, and Valtat and Albert André.[40] Valtat, André, and Georges d'Espagnat and Georges-Daniel de Monfreid (who were also represented at the 1899 Durand-Ruel show) comprised a loosely knit group that stands stylistically between the Fauves and Nabis, closer to the Nabis and particularly to their Gauguinesque side.[41] De Monfreid was Gauguin's close friend. André, too, had met Gauguin, in Montparnasse in 1893-94. He was especially close both to d'Espagnat and to Valtat, with whom he had studied at the Académie Julian. This circle intersected that of Matisse. Its members exhibited at many of the same salons as the Fauves, though never with the Matisse group, and Valtat and André were Matisse's exact contemporaries. There were, moreover, ties of friendship between Valtat and André and the more conservative of the Fauves, especially Camoin, Manguin, and Puy. For the period following 1905, when these Fauves lost something of their first exuberant impulse, there is perhaps a better case to be made for viewing these three as *amis de Valtat* than Valtat as one of the *amis de Matisse.*[42]

Valtat's paintings from the early 1890s onward reveal characteristics broadly similar to those of some of the Fauves, for he, too, worked across the stylistic axis laid out by the Neo-Impressionists and the Nabis, but he cannot be said to have practiced a true Fauve style. His sensitive *Nude in the Garden* of 1894 (above) reveals heightened color and loose, relaxed structure; essentially, however, it is an Impressionist-mode painting. Some of his works come very close to Neo-Impressionism, others to Lautrec, and many follow the path of the Nabis.[43] In the *Water Carriers*

of Arcachon of 1897 (above) we see bright, flat color contained within a complex linear draftsmanship, and a subject reminiscent of the Pont-Aven school. The style this painting embodies persisted through to the Fauve years.[44] Bright color itself, however, is not enough to identify Fauvism. As Matisse said, "That is only the surface; what characterized fauvism was that we rejected imitative colors, and that with pure colors we obtained stronger reactions—more striking simultaneous reactions; and there was also the *luminosity* of our colors...."[45] Not all of the Fauves, in fact, consistently rejected imitative color. The stylistic as well as social boundaries between the less adventurous Fauves and the Valtat circle do intersect. Indeed, Valtat and the *coloristes* "present the most persuasive demonstration that a heightened palette derived from several Post-Impressionist sources was the outstanding trait among the younger artists."[46] But whereas the *coloristes* remained tied to their Post-Impressionist sources, Matisse was already chafing against them, and unwilling to stay long on any path. The new one he chose in 1901 led him away from color.

At the very moment when Matisse began to enter his "dark period," he discovered two other colorists who had just begun their own experiments, Derain and Vlaminck. They had met, we remember, in 1900. Vlaminck suggested that their meeting marks the beginning of Fauvism itself. The day after they met, he related, they went out to paint together:

Each of us set up his easel, Derain facing Chatou, with the bridge and steeple in front of him, myself to one side, attracted by the poplars. Naturally I finished first. I walked over to Derain holding my canvas

against my legs so that he couldn't see it. I looked at his picture. Solid, skillful, powerful, already a Derain. "What about yours?" he said. I spun my canvas around. Derain looked at it in silence for a minute, nodded his head and declared, "Very fine." That was the starting point of all Fauvism.[47]

It is a typical Vlaminck anecdote. He was a self-taught painter who prided himself on his very rawness, once claiming that he had learned more from a harness maker at Croissy who made crude portraits in red and blue varnish than from any museum.[48] "I wanted to burn down the Ecole des Beaux-Arts with my cobalts and vermilions," he wrote. "I wanted to express my feelings without troubling what painting was like before me....Life and me, me and life—that's all that matters."[49] Despite this disparagement of the past, he could also write that after having seen a van Gogh exhibition in 1901, "I was so moved I wanted to cry with joy and despair. On that day I loved van Gogh more than I loved my father."[50] Indeed, Vlaminck dated his liberation as a Fauve painter to that exhibition, and claimed furthermore that it was only when Derain brought Matisse to Chatou to see their work that he, too, was converted to Fauvism.[51] This is Matisse's account of the episode:

I knew Derain from having met him in the studio of Eugène Carrière where he worked, and I took an interest in the serious, scrupulous work of this highly gifted artist. One day I went to the van Gogh exhibition at Bernheim's in the rue Laffitte. I saw Derain in the company of an enormous young fellow who proclaimed his enthusiasm in a voice of authority. He said, "You see, you've got to paint with pure cobalts, pure vermilions, pure veronese." I think Derain was a bit afraid of him. But he admired him for his enthusiasm and his passion. He came up to me and introduced Vlaminck. Derain asked me to go to see his parents to persuade them that painting was a respectable trade, contrary to what they thought. And to give more weight to my visit, I took my wife with me. To tell the truth, the painting of Derain and Vlaminck did not surprise me, for it was close to the researches I myself was pursuing. But I was moved to see that these very young men had certain convictions similar to my own[52]

The reticent Derain was probably overawed by Vlaminck—and so probably were Derain's parents, if Vlaminck's accounts of his and Derain's escapades are to be believed[53]—hence the visit from the Matisses. But Vlaminck certainly was not the leader of the Fauves that his own writings suggest him to be. Although there are certain isolated Vlamincks from around 1900, such as the *Man with the Pipe* (right), which prefigure Fauvism, it is only to a very limited extent: in the excited handling and in the touches of high local color within the thick impastoes of what was still *chiaroscuro* painting. Van Gogh's lesson was important to Vlaminck, yet, as we shall see, he did not make full use of it

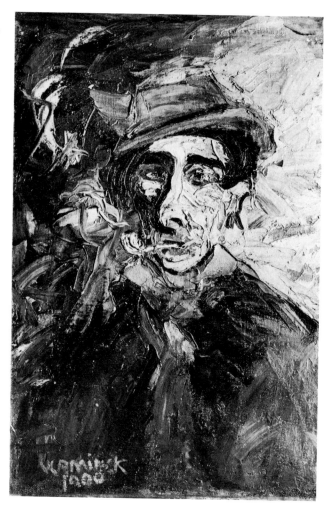

Vlaminck: *Man with the Pipe.* 1900. Oil, 28⅞ x 19¾". Centre National d'Art et de Culture Georges Pompidou. Musée National d'Art Moderne, Paris. Gift of Mme Vlaminck

after the Dutchman's 1901 exhibition, but rather after that of 1905 at the Salon des Indépendants, and then not completely until he had been exposed to the 1905 Collioure landscapes of the two other principal Fauves.

Derain's early experiments were interrupted by his call-up to the army at the end of 1901, a break in his work he bitterly regretted, because he had already realized, in theory at least, that a new, more colorful, simpler form of painting was ready to be born. "I am aware that the realist period in painting is over," he wrote to Vlaminck. "We are about to embark on a new phase. Without partaking of the abstraction apparent in van Gogh's canvases, abstraction which I don't dispute, I believe that lines and colors are intimately related and enjoy a parallel existence

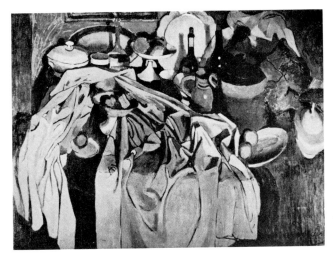

Derain: *Still Life.* 1904. Oil, 40 x 42". Private collection, France

from the very start, and allow us to embark on a great independent and unbounded existence....Thus we may find a field, not novel, but more real, and, above all, simpler in its synthesis."[54] He was not able to embark on this new phase until early in 1904. In 1903, during his period of army service, he painted the boldly designed but still conservative *The Ball at Suresnes,* and he seemed none too satisfied with his work of this period. "I am doing paintings of officers," he wrote to Vlaminck. "It's a frightful trial. What a lot of trouble to take over rubbish!"[55] Having left the army, he quickly passed through the Neo-Impressionist and then flat, color-zone styles that Matisse and Marquet had explored earlier.[56] And again like Matisse, he underwent the influence of Cézanne and of Gauguin, who may both be seen behind his large and powerful *Still Life* of 1904 (above).

With Derain's return from the army, both he and Vlaminck renewed their acquaintanceship with the Matisse circle, which by then was starting to attract public attention. By following the record of the circle's joint exhibitions from 1901 onward we can see how the Fauve group was consolidated[57]

In the spring of 1901, Matisse sent a group of paintings to the Salon des Indépendants, the first time he had exhibited publicly since the Nationale of 1899. By 1901, the Nationale had become far more conservative in approach than it had been earlier, particularly after the death of its liberal president, Puvis de Chavannes, in 1898. Although the Indépendants was nonselective and engulfed serious artists among amateurs, it was the obvious place for Matisse to show among the moderns, especially since it was presided over by Signac, whose work had provoked his first real experiments with high color.

Marquet and Puy were also represented at the Indépendants of 1901. The following year the group really began to come to-

gether. In the winter of 1901–02, the critic Roger Marx, who had previously helped Moreau's students in selling their copies from the Louvre to the state, introduced Matisse to the dealer Berthe Weill[58] In February 1902, a group of Moreau students, including Matisse and Marquet, were exhibited at her gallery. Marquet sold one of his works to the architect Frantz Jourdain, who was to be the first president of the Salon d'Automne upon its foundation the following year. At the Indépendants of 1902, Manguin was represented with Matisse, Marquet, and Puy, and in 1903, Camoin exhibited there, too, as did Dufy and Friesz, though as yet the Le Havre painters were not in contact with Matisse's circle. It is certain, however, that each knew the work of the other. Dufy had shown at Weill's in February 1903, and Matisse and Marquet at the same gallery in May. The main event of that year was the establishment of the Salon d'Automne, for the Fauves-to-be had a vested interest in it from the start. Jourdain was president, and among the founders were Desvallières, Rouault, and Marquet, who had been friends since their time at Moreau's studio, and Carrière, the second teacher of the Fauves, as well as the critics Roger Marx and J. K. Huysmans and the artists Redon and Vallatton. There was some conservative representation: the critic Camille Mauclair, who was to attack the Fauves at the 1905 Salon, was among the founders. The first Salon, at which Matisse, Marquet, and Rouault all showed, was dominated by former Nabis—Bonnard, Vuillard, Denis, and Serusier—and by the large retrospective of the work of Gauguin, who had died the year before in the Marquesas. But Matisse and his friends still had their first loyalties toward the Indépendants, especially from 1904 when Matisse and Signac became friends, a friendship leading to Matisse's visit to Signac's house at Saint-Tropez that summer. The visit led to Matisse's production of *Luxe, calme et volupté,* exhibited at the 1905 Indépendants, where as president of the hanging committee he organized what deserves to be considered the first group exhibition of the Fauves.

By then, the Fauve group was almost complete. In 1904, at the Indépendants in the spring, at Berthe Weill's in April, and at the Salon d'Automne, Matisse, Marquet, Manguin, Camoin, and Puy all showed together. By then they were also painting together, often at Manguin's studio, where they shared the same model. In June, Matisse was given his first one-man exhibition by Vollard. He had known Vollard since 1899, when he bought from him a Bathers by Cézanne and a Rodin plaster and traded one of his own paintings for a Gauguin portrait. Vollard had been following the work of Matisse's circle, but without making any commitment toward it. It was once again Roger Marx who urged that Matisse deserved an exhibition. He wrote a complimentary catalogue preface, praising Matisse's rejection of fashionable success at the Nationale for "the challenge of struggle and the bitter honor of satisfying himself. The more one ponders the more it becomes evident in this case that the constant growth

of his talent was caused by endlessly renewed efforts which stimulated the artist to make the most ruthless demands upon himself."[59]

The exhibition did not bring Matisse any more success, but it undoubtedly raised Matisse's reputation among his colleagues, as well as increasing Vollard's interest in the Fauves-to-be. That November, he gave van Dongen his first one-man show. The following February he visited Derain on Matisse's advice and bought the entire contents of his studio. He did the same for Vlaminck a year later.

After his exhibition at Vollard's, Matisse traveled to Saint-Tropez to spend the summer with Signac. The 1904-05 season in Paris was to be dominated by Neo-Impressionism.[60] Matisse's contributions to the 1904 Salon d'Automne did not yet fully reveal his commitment to that style. He was, however, close to Signac and his friends. So, too, was van Dongen, who had first shown in Paris in the Indépendants that spring, but who only in the autumn found a common ground in Neo-Impressionism with Matisse. His November 1904 exhibition at Vollard's was introduced by the theoretician of Neo-Impressionism, Félix Fénéon. In January of the next year, he began showing at Weill's.

It was also in the autumn of 1904 that the other Fauves joined Matisse. Dufy and Friesz exhibited at the Indépendants in the spring, as they had done the previous year, and Dufy, who was fast to become Berthe Weill's favorite Fauve, showed twice at her gallery in 1904.[61] He did not, however, exhibit at the Salon d'Automne. Friesz did, and was reputedly so impressed by Matisse's paintings there that he was converted to the high-color manner.[62] (Dufy's "revelation" had to await his seeing Luxe, calme et volupté the following spring.) Also back in the circle, having completed his military service though not yet exhibiting again, was Derain. With Derain's return, Vlaminck met Matisse again, and he, too, was brought into the group. Matisse invited the pair from Chatou to exhibit at the 1905 Indépendants. As chairman, Matisse co-opted onto the hanging committee Camoin, Manguin, Marquet, and Puy. Van Dongen, Dufy, and Friesz submitted paintings and were accepted. Except for Braque, the Fauvist circle was now complete.

Although the Fauves were not so named until the autumn of 1905, Fauvism itself, as a group if not as a movement, preceded its title, which in any case did not become widely used until late in 1906. It was clear enough, at least to informed opinion, that at the 1905 Indépendants there had been a burst of new talent, though no one could find common denominators there. Louis Vauxcelles, the critic of Gil Blas, began his front-page review of the show with the claim that "we possess today a luxuriant generation of young painters, daring to the point of excess, honest draftsmen, powerful colorists, from whom will arise the masters of tomorrow."[63] Moreover, he noted Matisse's prominence among the former Moreau pupils. Charles Morice, in the influential Mercure de France, noted colloquially that "we

are at the beginning of 'something else'."[64] He did not venture to say what that was; instead, during the summer of 1905, he organized an "Enquête sur les tendances actuelles des arts plastiques" among a very wide range of artists, asking for their views as to what that "something" was, and specifically whether they thought Impressionism was finally finished, whether painting from nature was still viable, and what their opinions were of Whistler, Fantin-Latour, Gauguin, and especially Cézanne.[65] This may have been a crude and, as it turned out, unproductive device,[66] but it does show which questions were felt to be crucial to the creation of a new style, at least to someone sensitive to new currents. Even in 1905, Impressionism was the style every aspiring modernist had to come to terms with. Nature or the imagination was a principal Post-Impressionist dilemma. Artists' attitudes to Cézanne continued to be important in the next few years. But despite Morice's perspicacity in this respect, he found much that was not to his liking at the Indépendants, particularly the increasing group of "pointillistes et confettistes," as he called them,[67] and he included Matisse and van Dongen among them. The Indépendants was as dominated by Neo-Impressionists as was the Salon d'Automne by Nabis.

Matisse's contribution to the Indépendants, Luxe, calme et volupté (p. 25), had its source in the landscape studies he had painted in the summer of 1904 at Signac's villa in Saint-Tropez. At first, he had resisted a return to the Neo-Impressionist style; his major work from the first part of that summer, The Terrace, Saint-Tropez (p. 33), reveals a heightened flat-color style, but one still very dependent upon local color. The return was not accomplished without considerable difficulty and worry. "Matisse the anxious, the madly anxious," wrote Cross, Signac's neighbor at Le Lavandou, to his friend Théo van Rysselberghe.[68] Before he left Saint-Tropez, Matisse had painted a daring preliminary sketch for Luxe, calme et volupté (p. 98), which finally banished the austerities of his "dark period" and began what seemed to be a reprise of his proto-Fauvist development. That is to say, it is in a highly casual version of the Neo-Impressionist style. Back in Paris that winter, however, he saw the large show of Signac's paintings at the Druet Gallery. "Carried away by this luminous Signac exhibition," wrote Jean Puy, "Matisse was a thoroughgoing pointillist for a whole year."[69] His attachment to Neo-Impressionism became far more clear-cut than it had been earlier: Luxe, calme et volupté overtly depends upon Signac's particular divisioniste method in a way no proto-Fauve painting does. The widely spaced color mosaic is methodically if not scientifically organized. The work is the masterpiece of Matisse's pre-Fauvist period, the summary and concentration of his efforts in the Neo-Impressionist style.

Other paintings from the winter of 1904-05 are less methodical in treatment and suggest direct comparison with the proto-Fauve works of 1899, especially because some were made in the same spirit of rivalry with his companions as had existed earlier.

Matisse: *The Terrace, Saint-Tropez.* 1904. Oil 28¼ x 22¾". Isabella Stewart Gardner Museum, Boston. Gift of Thomas Whittemore

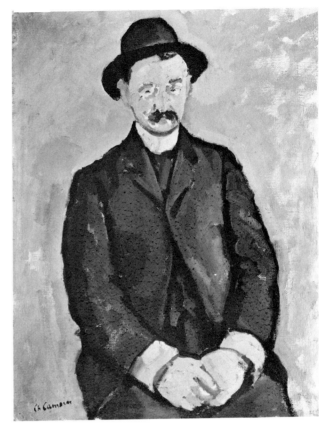

Camoin: *Portrait of Marquet.* 1904. Oil, 36¼ x 28⅛". Centre National d'Art et de Culture Georges Pompidou. Musée National d'Art Moderne, Paris. Gift of Mme Albert Marquet

Matisse had communicated his new enthusiasm for high color and the Neo-Impressionist touch to his friends, and a second period of joint activity began. In 1904, Manguin painted a model in his studio with Marquet in the background and reflected in a mirror (p. 35 right). In the winter of 1904-05, Matisse, Marquet, and Manguin made companion paintings in the same studio (pp. 34, 35).[70] The new Neo-Impressionist touch is evident in the work of Matisse's friends, but as in proto-Fauvism so in pre-Fauvism their inventiveness was never as sustained as Matisse's. Even Marquet found that Matisse's new enthusiasm was not to his taste. He began a portrait of André Rouveyre with a study in the bright-colored, "chopped straw" technique of a Seurat sketch,[71] but the completed painting bears closer comparison with several of Manet's full-length portraits, even down to the diagonally placed signature at the base.[72]

In 1904, Camoin was looking mainly to Cézanne, whom he visited that year.[73] His portrait of Marquet (above) is highly reminiscent of certain of Cézanne's portraits of his wife.[74] Only

in inherently colorful subjects did he employ vivid and startling juxtapositions of color, as in the costume of the *Young Neapolitan.*[75] Subjects of this kind offered a way for the less audacious Fauves to brighten and intensify their paintings, matching the brilliance of Matisse's color without going through the same process of abstraction. Another way was to heighten local colors, as in Puy's *Landscape at Saint-Alban-les-Eaux* of 1904 or, in a more cautious way, in Vlaminck's *Quai Sganzin at Nanterre* (p. 36), probably of the same year.[76] Certainly in 1904, no member of Matisse's original circle was close to him in the daring or inventiveness of their color. This continued to be the case, by and large, within Fauvism itself. It was the newer members of the group who became the more daring. Even in 1904 this was beginning to happen. Van Dongen, for example, had discovered Neo-Impressionism, independent of Matisse, through his contacts with Fénéon and his circle.[77] His *Sideshow,* exhibited at the 1905 Indépendants, reveals a highly personalized and energetic version of Neo-Impressionist methods. Reviewing the Salon,

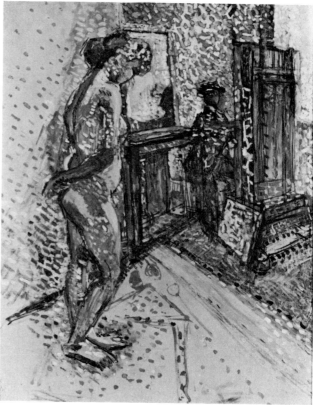

Matisse: *Marquet Painting a Nude.* 1904-05. Oil on paper, 12¼ x 9½". Centre National d'Art et de Culture Georges Pompidou. Musée Nationale d'Art Moderne, Paris

Formerly attributed to Matisse: *Marquet (or Manguin) Painting a Nude.* 1904-05. Oil, 35⅞ x 28⅜". Centre National d'Art et de Culture Georges Pompidou. Musée National d'Art Moderne, Paris

the critic Charles Morice found the work to be vertiginous.[78]

It was Derain, however, who increasingly showed himself ready to match Matisse in ambition, and who was even at times in advance of him. Fauvism is as widely thought of as Matisse's invention as Cubism was at one time seen as Picasso's alone; but just as it was Braque who produced the first true Cubist paintings, so Derain's work was more surely Fauvist before Matisse's. By the winter of 1904-05 at the latest, when Matisse was deep in Neo-Impressionism, Derain's painting had entered that "new phase . . . more real, and, above all, simpler in its synthesis" for which he had been hoping. In 1904 he painted a powerful frontal self-portrait (p. 37), which prepares for his Collioure portrait of Matisse in the summer of 1905 (p. 14) and for the portraits that he and Vlaminck made of each other later (pp. 15, 48). It was, however, in landscape that Derain made the greatest advances. The *Snowscape at Chatou,* probably one of the paintings Vollard acquired from Derain's studio in February 1905, and *The Old Tree* (p. 70) and *The Bridge at Le Pecq* (p. 38), both exhibited at the 1905 Indépendants, are all Fauve paintings. *The Bridge at Le Pecq* has a flat and tense surface composed of mixed stylistic devices such as Matisse would not match until the summer of that year at Collioure. The combination of large Nabi-derived color areas and Neo-Impressionist infilling, with Impressionist handling in the background, is especially striking, because the different manners are so successfully combined. For the placement of flecked brushstrokes over broad color zones, Derain was able to look to the example of van Gogh, but his particular treatment of the method carries van Gogh's approach into the realm of the powerfully decorative. It was probably this work that prompted Vauxcelles to comment on Derain's admixture of van Gogh and *japonisme,* which he found "ingénieusement décoratif!"[79] The elongated figures, it has been suggested, may owe something to Marquet,[80] whereas the Neo-Impressionist element certainly is indebted to Matisse. Nevertheless, we find

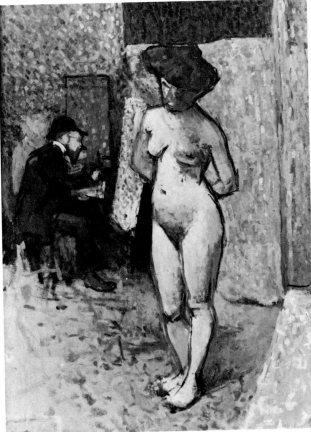

Manguin: *Nude in the Studio.* 1904. Oil, 36¼ x 28¾". Galerie de Paris

Marquet: *Matisse Painting in Manguin's Studio.* 1904–05. Oil, 39⅜ x 28¾". Centre National d'Art et de Culture Georges Pompidou. Musée National d'Art Moderne, Paris

in this painting such typically Fauvist forms as the broken-color divisions of the trees to the right-hand side, an innovation usually ascribed to Matisse's *Landscape at Collioure* of 1905 (p. 52), with the implication that Derain adopted it from Matisse.[81] This clearly was not the case.

If Derain did initiate Fauvism in the winter of 1904–05, he did not have the confidence to pursue it alone. Having seen *Luxe, calme et volupté* in the spring Indépendants, he followed Matisse into Neo-Impressionism with a series of paintings executed in London of the Thames, its bridges, and the buildings surrounding it. *Charing Cross Bridge* (p. 46) and *Effects of Sunlight on the Water* (p. 39 top left) are in some ways companion works and were probably painted early in the stay in London. The astonishing treatment of the sky in the first painting suggests that Derain has been looking at Turner's work. His rendering of the Thames itself, however, cannot but remind one of the pictures Monet had painted of the same view (p. 39 bottom right).[82]

The second painting is far more generalized in subject and consolidated in style, drenched in flecked Impressionist and Neo-Impressionist brushstrokes across a curvilinear Art Nouveau sky. Finally, Derain began painting with consistently Neo-Impressionist marks, though not in any way surrendering the fireworks of the more impetuous pictures, contrasting the darkly silhouetted blue buildings against green skies and water (p. 39 top right), and with extraordinary spectral suns that directly prefigure not only Vlaminck's use of similar images (p. 39 bottom left), but also the earliest of Delaunay's Disks (p. 40).[83] It is not possible to confirm, other than on internal stylistic grounds, the chronology of these London paintings, nor to know precisely when Derain did visit London in this period.[84] He made two trips there, in 1905 and in 1906. These paintings clearly belong to the first visit, but it is not certain whether they were painted in the spring or the autumn. A spring visit, immediately after the Indépendants, seems most likely, since *Luxe, calme et volupté*

Vlaminck: *Quai Sganzin at Nanterre.* 1904. Oil, 28¾ x 36¼″. Private collection

did create a considerable stir at that exhibition, and converted other Fauves to Matisse's side.

The Nabi apologist, Maurice Denis, thought Matisse's painting too much "le schéma d'une théorie," and advised him to return to nature and find there "la tradition française."[85] He also found most of the exhibitors at the Indépendants "plutôt anarchiste," and he was not alone in this. A writer in Emile Bernard's journal, *La Rénovation Esthétique,* entitled his review "L'Anarchie artistique—Les Indépendants."[86] He specifically was attacking the Seurat and van Gogh retrospectives at the Salon. It was, however, a charge to be taken up and applied to the Fauves from that autumn onward. It is worth pausing, therefore, to con-

sider its validity, for there is evidence that some of the Fauves, though not Matisse, were attracted to anarchism in their early years. Certainly the social and intellectual background to Fauvism has important bearing on the character and development of the movement.

Matisse and his circle came together at the height of *la belle époque.* All of the Fauves-to-be were in Paris by the time of the Exposition Universelle of 1900, the last of the great world fairs that had celebrated the prestige of the *haute bourgeoisie* and catered to its taste for conspicuous consumption through the nineteenth century. Matisse and Marquet prepared for the exposition by painting laurel leaves on the cornice of the Grand Palais for

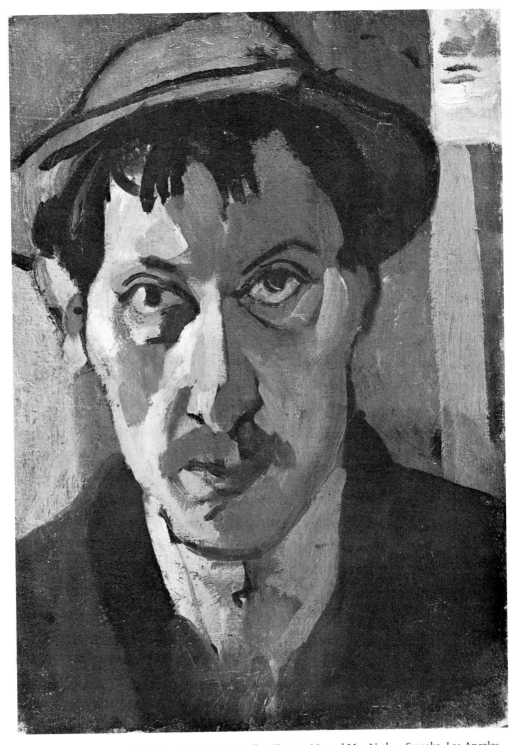

Derain: *Self-Portrait with Soft Hat.* 1904. Oil, 14 x 10". Collection Mr. and Mrs. Nathan Smooke, Los Angeles

Derain: *The Bridge at Le Pecq.* 1904-05. Oil, 38⅝ x 45¾". Private collection, Paris

poor wages.[87] Vlaminck played the violin in the cafés and music halls surrounding the exposition complex, and, finding himself appalled by just how few were in fact able to enjoy *la belle époque*, began to write novels of social criticism.[88] He had begun to read Marx and Kropotkin while serving as an army conscript, and joined an anarchist group, contributing to the anarchist journal, *Le Libertaire.*[89] After his discharge in 1900 he briefly considered a political career, but felt "too much an anarchist to accept the conventional discipline" such a career would involve.[90] He did nonetheless transmit his ideas to Derain, who likewise developed left-wing sympathies.[91] Dufy was basically apolitical, but when he lived in Montmartre in 1902-03, he was close to anarchist circles and was even subject to police attention.[92] Van Dongen was an active anarchist in his early

years. The satirical, antiestablishment journal, *L'Assiette au Beurre,* to which he contributed illustrations, was not far removed from directly political journals of the same nature, while the Neo-Impressionist circle of Signac, Cross, Luce, and Fénéon, who befriended him in Paris, was composed of fully committed anarchists. Fénéon was even implicated in an anarchist bombing.[93]

It should not be thought too surprising, therefore, that anarchism should be mentioned with reference to the art of Seurat and van Gogh if that were the political affiliation of the Neo-Impressionists. One must also remember that several of the favored gathering places for artists in Montmartre, such as the Lapin Agile frequented by Apollinaire's circle, were visited by social as well as artistic radicals.[94] The tradition of cooperation

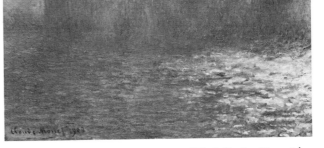

(top) Derain: *Effects of Sunlight on the Water*. 1905. Oil, 30¾ x 39⅜". Musée de l'Annonciade, Saint-Tropez

(above) Vlaminck: *The White House*. 1905-06. Oil, 17⅞ x 21¾". The Museum of Fine Arts, Houston. Extended Loan of Miss Catherine Merchant

(top) Derain: *Big Ben*. 1905. Oil, 31⅛ x 33⅞". Collection Pierre Lévy, France

(above) Monet: *The Thames and Parliament, Effect of Sunlight*. 1903. Oil, 32 x 36¼". The Brooklyn Museum. Bequest of Mrs. Grace Underwood Barton

between the two was an important feature of the late nineteenth-century artistic and literary Parisian scene. It was perhaps only to be expected that any new and controversial art would find itself attacked in terms partly derived from the political controversies of the past—and should find the public's attitude toward the paintings colored by that fact.

In a review of 1906, Maurice Denis talked of the anarchy of

Matisse's circle[95] and Vauxcelles noted that other writers were saying the same thing[96] In 1908, Louis Lormel dubbed that year's Salon d'Automne, where Matisse was given a retrospective exhibition, "le Salon de l'art anarchiste," and found supposed affinities between what he called "la démoralisation sociale" and "la démoralisation artistique."[97] Writing about the same Salon in the most virulent notice the Fauves ever received,

Delaunay: *Solar Disk (Landscape with Disk)*. 1906. Oil, 21⅝ x 18⅛".
Centre National d'Art et de Culture Georges Pompidou. Musée
National d'Art Moderne, Paris. Gift of Mme Delaunay

Péladan denounced Matisse and his friends for having no respect for the rules of art and for being anarchists of painting.[98] Matisse's reply to Péladan, the famous "Notes of a Painter,"[99] could hardly be further from the statement of an anarchist, speaking as it did of an art for the businessman rather than for the artisan. The "Notes," however, represent Matisse's repudiation of the "wildness" of Fauvism, but he had not in any case shared the early political commitments of some of his younger colleagues. In fact, their political commitments did not extend into the Fauvist period, with the single exception of Vlaminck's. By 1905, they had put radical politics behind them, and as they began to achieve commercial success, those particular "youthful excesses" were forgotten.[100] A politician who helped them to this success by his patronage was Marcel Sembat, the Socialist deputy of Montmartre, who wrote a monograph on Matisse in 1920; but that a high-ranking Socialist should be interested in advanced art merely demonstrates the way the Fauves inherited the advantages as well as disadvantages of already established links between social and artistic radicalism. As far as the disadvantages are concerned, the criticism the Fauves suffered was largely a hangover from the political commitment of the Neo-

Impressionist generation, with which the Fauves were not unnaturally connected, given the social and stylistic affinities between the two groups.

For the Fauves to be called anarchists, or indeed "wild beasts," which amounted in some respects to the same thing, had little justification in the subjects of their paintings, or finally in their style. Nothing of the early left-wing ideology of Vlaminck and Derain is reflected in their work. True, their paintings of bustling port scenes form a link between the urban and proletarian interests of the Neo-Impressionists and those of artists like Léger, Delaunay, and La Fresnaye. The *port de plaisance,* however, is a far more frequent Fauve subject than the *port de commerce.* The Fauves kept apart from the contemporary Abbaye de Créteil circle, whose preoccupation with specifically modern themes, with a Whitmanesque kind of vitalism, and with a socially relevant art attracted some of the future Cubists.[101] But if the Socialist and the modern as such did not particularly interest the Fauves, the vitalist did. Anarchism in the social or political sense had finally little effect on Fauve painting, but there was a sure association between Fauvism and individuality, self-expression, and youthful vitality, which was both noticed by contemporary critics and acknowledged by the artists themselves. Critics widely linked Fauvism to the excesses of youth. On one occasion, Vauxcelles playfully called the Matisse circle *les enfants terribles.*[102] They were commonly described as *les jeunes* or reproached as being like children playing with a new box of colors.[103] Braque, Derain, and Vlaminck later spoke of their Fauvist alignment as one that was bound not to outlast their early years.[104] They were attracted by young art in general, that is, primitive and folk art, as well as practicing a style of painting that looks youthful and vital, and held to attitudes that speak of unconformity and willful distrust of a priori systems and beliefs. This is not merely to refer, say, to Vlaminck's iconoclastic outbursts or to such curious, eccentric habits as his wearing painted wooden ties,[105] but to a deep-seated commitment to individual freedom that is one of the most basic general characteristics of Fauvism, and one that helps to explain both its amorphousness as a movement and the short-lived nature of its existence.

Despite their circle of friendship and their generally similar styles, the Fauves were never a group linked by clearly defined ideological premises in the way the Nabis or the Neo-Impressionists were, nor did they seek to make any theoretical statement about their work, let alone produce a group manifesto, as did most subsequent modern movements. Instead, on the one hand they extended the Post-Impressionist tradition of individualism of van Gogh, Gauguin, and Cézanne, and on the other partook of a widespread belief in direct expression, uninhibited by didactic, moralistic, or any other a priori concern. We see the same obsession with immediacy of experience, the same *culte de la vie* in the contemporaneous enthusiasm for

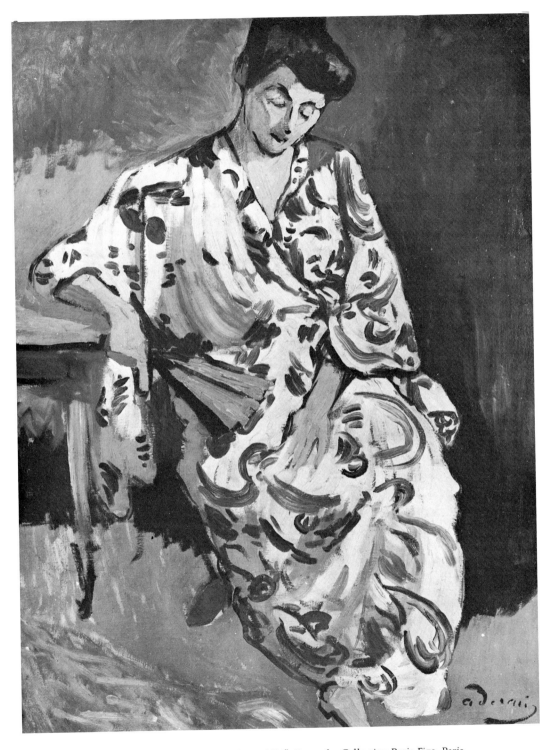

Derain: *Woman with a Shawl*. 1905. Oil, 31½ x 25⅝". Formerly Collection Boris Fize, Paris

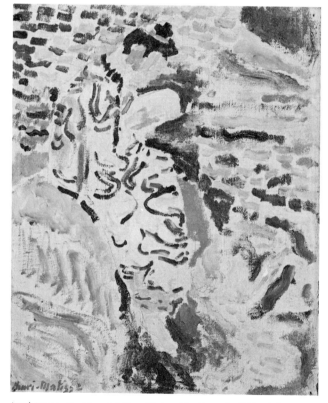

(top) Marquet: *Mme Matisse Doing Needlework.* 1905. Oil, 25⅝ x 31⅞". Private collection

(top right) Camoin: *Mme Matisse Doing Needlework.* 1905. Oil, 25⅝ x 31⅞". Musée d'Art Moderne, Strasbourg

(above) Matisse: *La Japonaise: Woman beside the Water.* 1905. Oil, 13¾ x 11⅛". Private collection

Nietzsche, which some of the Fauves shared;[106] in the vitality and violence of Alfred Jarry; in the continuing tradition of Gauguin's cult of the primitive, which the Fauves both extended and revised; and in the calls for simplicity of the literary "Naturist" movement, whose members, like the Fauves, preferred eclecticism and the title of "barbarians" to the theoretical bias of late nineteenth-century Symbolism.[107] "The artist," Matisse wrote, "encumbered with all the techniques of the past and the present, asked himself: 'What do I want?' This was the dominating anxiety of Fauvism."[108] And yet such a cry of self-sufficiency was itself the product of past and present traditions. Their individuality linked, rather than separated, the Fauves to the currents and attitudes of their time. Paradoxically, it meant that their specific forms of individuality were not easily or immediately distinguished from others.

It would be wrong, however, to underestimate the coherence of the Fauve group. Their dedication to individuality produced a spirit of keen competitiveness, which kept them together. This is well illustrated by a curious entry in the catalogue of the 1905 Salon des Indépendants, which reads: "Matisse (Mme. Henri): 2770. Ecran tapisserie sur un carton d'André Derain." Its history is as follows: Mme Matisse had purchased a Japanese gown, which she wore when her husband painted her on Signac's terrace at Saint-Tropez in 1904 (p. 33). In 1905, she posed for Derain in the same costume and he produced his *Woman with a Shawl* (p. 41). Mme Matisse then prepared a tapestry version of the painting, the item mentioned in the catalogue for the Indépendants, and while she was working on it, Camoin and Marquet chose identical-sized canvases and painted her, again wearing her Oriental costume (above). The domestic tone of this episode shows just how far removed from anarchism these artists were, and also how close they were becoming in their

rivalry and in their purely artistic radicalism. When Matisse returned to the same subject in the summer of 1905, painting his *Japonaise* (p. 42) at Collioure, Fauvism was ready to be born. The paintings he brought back from Collioure dominated the *cage centrale* of the Salon d'Automne that year. If the Indépendants that spring had demonstrated to critics that something new and daring was emerging, from the reactions to the Salon d'Automne it seemed clear that it had finally arrived.

The Fauves were not yet in autumn 1905 a coherent movement stylistically. To the extent that we can speak of a common Fauve style, one shared by most of the protagonists, that is best reserved for the flat-color Fauvism of 1906. The mixed-technique Fauvism of the latter half of 1905 was largely the creation of Matisse and Derain at Collioure. Many of the Fauve paintings at the Salon d'Automne, though certainly vivid and provocative high-color works, were not yet free from dependence upon earlier models. The Fauvist group preceded the Salon d'Automne, the shared Fauvist style followed it. It was, however, the public reaction to the Salon d'Automne that brought the Fauvist movement into existence.

The naming of Fauvism is one of the most famous episodes in the anecdotal history of modern art. "We were showing at the Salon d'Automne," Matisse recalled later. "Derain, Manguin, Marquet, Puy, and some others were exhibiting together in one of the big galleries. The sculptor Marque showed an Italianate bust of a child in the center of this hall. Vauxcelles came into this room and said: 'Well, Donatello among the wild beasts' [*'Donatello au milieu des Fauves*'].''[109] Fauvism had attracted to itself more than the usual number of myths surrounding modern movements, including the idea that its very title was first used in a spirit of hostility. Louis Vauxcelles, however, was anything but an opponent. His review of the Indépendants began, as we have seen, with a vigorous assertion of the health of contemporary painting. He had also emphasized to his readers his close association with the Fauves-to-be. When he wrote in *Gil Blas* about the Salon d'Automne, it was from a serious and sympathetic point of view.[110] He systematically discussed, room by room, all the work exhibited: from Cézanne and Renoir to the Nabis, through the large Ingres and Manet retrospectives that were part of the Salon to the now legendary Salle VII, where Matisse's friend Desvallières had decided to put together the most highly colored paintings[111] and the bust by Albert Marque (p. 44).[112] Vauxcelles repeated the quip he had used to Matisse: "Among the orgy of pure colors: Donatello among the wild beasts" [*"chez les fauves"*].[113]

Although not everything he saw in the *cage centrale* pleased Vauxcelles, the general tone of his review was far from unfavorable. And the report he wrote nine days later of the Fauve group's show at Berthe Weill's gallery was full of praise for "our young victors of the Salon d'Automne."[114] What has confused the issue is the appearance of Vauxcelles's comments on Fauve paintings (excerpted from his *Gil Blas* review) in the now notorious issue of the conservative weekly, *L'Illustration,* of November 4, 1905 (p. 44).[115] *L'Illustration* had previously ignored the two modern salons, the Salon des Indépendants and the Salon d'Automne. This time, in answer to suggestions of its one-sided reporting, it presented a pictorial survey of the recent exhibition, to give its readers "at least some idea of the works by these little known masters which the most serious newspapers have so warmly praised." Beside the illustrations, prominent among which were Rouault's *Peddlers, Actors, Clowns,* Puy's *Lounging under the Pines,* and Matisse's *Woman with the Hat* and *Open Window,* were printed a sample of critical reactions, mostly by Vauxcelles and by Gustave Geffroy of *Le Journal.* "These are the opinions of the most distinguished art critics in Paris and we shelter behind their authority," ran the editorial comment with high irony. "We should simply like to point out that although critics once kept their eulogies for the established masters and their sarcasm for the beginners, things are very different today." The Fauves, that is to say, had been all too favorably received to suit the ultra-conservative *L'Illustration.* What is more, it was not only the eulogies the Fauves had received that *L'Illustration* disliked, but the similar reception for Cézanne, Rousseau, and Vuillard, whose paintings were reproduced opposite those of the Fauves. Indeed, the *L'Illustration* presentation was less an attack on the new movement, for in 1905 Fauvism did not have a widely recognized group identity nor was its title in common use, than a defense of its own neglect of the modern salons, especially the Salon d'Automne.

Because the Salon d'Automne, unlike the Indépendants, was selective in what it exhibited, it appeared the most uncompromisingly modernist of the Paris salons, and a natural target of both reactionary critics and hostile public. The president of the Republic, Emile Loubet, refused to open this Salon as he customarily did for the others. The viciousness of some of the attacks on the Fauve Salon was therefore not unexpected, although it has to be said that the Fauves evoked criticism more hostile in character than was dealt out to most of their co-exhibitors, except for the Douanier Rousseau, whose submission was far more widely attacked than any Fauve painting.[116] Camille Mauclair, former critic for the respected *Mercure de France* and one of the founders of the Salon, had just completed an admiring study of Whistler.[117] He adapted the well-known Ruskin epithet to the Fauves' paintings, calling them "a pot of colors flung in the public's face."[118] Marcel Nicolle, a provincial critic writing for *Le Journal de Rouen,* took the image a step further, speaking of the "uncouth and naive games of a child playing with a box of colors" and agreed with most of the other hostile critics that this had nothing at all to do with art![119] "Incoherents" and "invertebrates" were common charges, according to Jean Puy.[120]

If the conservative critics automatically attacked the Salon, then equally the liberal ones felt duty bound to defend it, even if

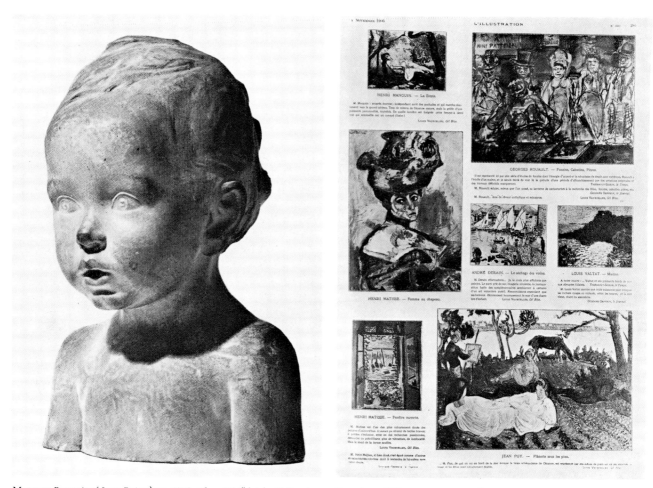

Marque: *Portrait of Jean Baignères.* 1905. Clay, 11¾" high. Collection Jean Baignères, France

Page from *L'Illustration*, November 4, 1905

they did not particularly approve of what was shown there. Introducing the Salon catalogue, Elie Faure remarked that the very hostility new art provoked demonstrated its vitality.[121] André Gide was commissioned to write on the Salon by the scholarly *Gazette des Beaux-Arts;* so impressed with the exhibition was its editor, the Fauves' friend Roger Marx, that he broke his embargo on the discussion of contemporary art in his journal's pages.[122] Gide, though not at all happy with Matisse's work, recognized that new art was bound to be shocking at first. Many indeed were shocked, even Matisse's admirers. Leo Stein, who bought the *Woman with the Hat,* thought it was "a thing brilliant and powerful, but the nastiest smear of paint I had ever seen."[123] This admixture of admiration and alarm seems to have been typical among Matisse's friends.

In the final count, the furor the Fauves caused only increased their standing among the enlightened observers, for whom it was not the Fauves but the conservative public who were barbarians. Early in his *Gil Blas* review of Salle VII, Vauxcelles applauded Matisse's courage in showing such audacious painting, knowing it "would have the fate of a Christian maiden delivered up to the wild beasts of the Circus" [*"livrée aux fauves du Cirque"*].[124] The *fauve* image, that is to say, first appeared in print applied not to the artists but to their brutish and uncomprehending public. It became attached to the artists nonetheless, and by 1907 it was in common use. It is ironic that Matisse's contributions to the *cage centrale,* which seemed so far in spirit from the classical, "Donatello" bust, were produced in the idyllic surrounding of the Côte d'Azur, in a landscape that the Fauves first celebrated for its purity of light and color and then idealized as the site of a new classical Golden Age.

Derain: *Regent Street.* 1906. Oil, 26 x 39." Collection Mr. and Mrs. Jacques Gelman, Mexico City

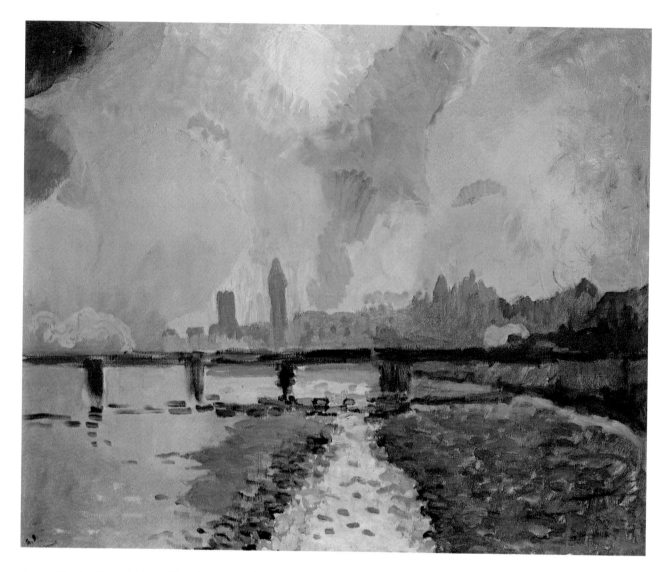

Derain: *Charing Cross Bridge.* 1905. Oil, 32 x 39⅜." Private collection, New York

Derain: *The Mountains, Collioure.* 1905. Oil, 31¼ x 39¼." Collection Mr. and Mrs. John Hay Whitney, New York

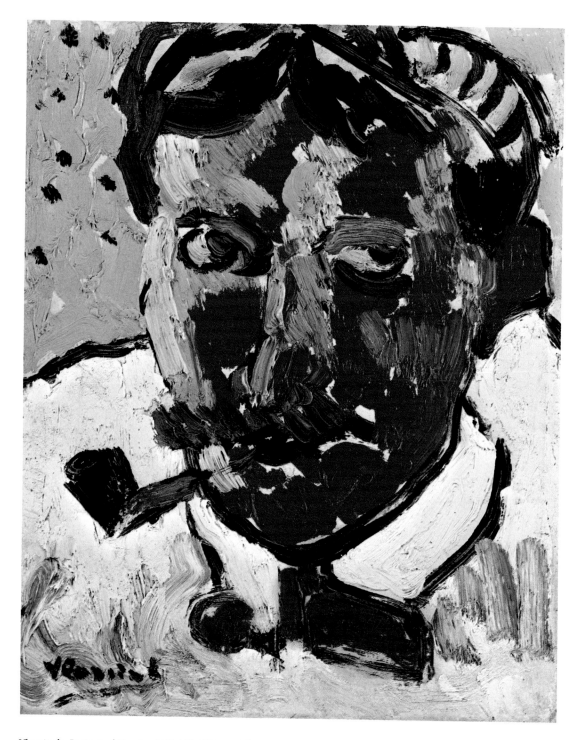

Vlaminck: *Portrait of Derain.* 1905. Oil, 10¾ x 8¾." Collection Mr. and Mrs. Jacques Gelman, Mexico City

The Fauvist World

Fauvism finally emerged at Collioure in the summer of 1905. Matisse and his family traveled south after the spring Indépendants. In June they were joined by Derain. Then began an astonishingly productive period of cooperation between the two artists. It took them beyond the confines of Neo-Impressionism and produced the paintings that created such a sensation when exhibited in the Salon d'Automne of that year.

On July 28, Derain wrote to Vlaminck from Collioure summarizing what he had learned so far. This is an important letter for our understanding of the development of Fauvism, and worth quoting at length in the notational form in which Derain wrote it:

1. A new conception of light consisting in this: the negation of shadows. Light here is very strong, shadows very luminous. Every shadow is a whole world of clarity and luminosity which contrasts with sunlight: what is known as reflections.

Both of us, so far, have overlooked this, and in the future, where composition is concerned, it will make for a renewal of expression.

2. Noted, when working with Matisse, that I must eradicate everything involved with the division of tones. He goes on, but I've had my fill of it completely and hardly ever use it now. It's logical enough in a luminous, harmonious picture. But it only injures things that owe their expression to deliberate disharmonies.

It is, in fact, a world that carries the seeds of its own destruction when pushed to the limit. I am quickly going to return to the sort of painting I sent in to the Indépendants that, after all, is the most logical from my viewpoint and agrees perfectly with my means of expression!

Derain's preoccupation with light is, of course, Impressionist and Neo-Impressionist in its derivation. To conceive of shadows and reflections as being equal in luminosity, however, is not. Derain was proposing a kind of painting without shadows in the traditional sense. Shadows were to be treated instead as areas of luminous color no different from those created by reflected light. This meant a new purified form of color painting where light was rendered by contrasts of hue, not of tone. The effect of this on pictorial composition, which, Derain notes, "will make for a renewal of expression," is not only to produce an assertively surface-organized picture, but one wherein strongly contrasting areas of color came to achieve new prominence. Whereas the Impressionists were not, of course, ignorant of the colorfulness of shadows, they did not dispense with tonal distinctions between shaded and nonshaded areas. Instead, they joined them pic-torially within a fairly uniformly textured surface. The implications of Derain's position are that contrasts, and therefore areas and zones of color, will assume new importance and that the Impressionist uniformity of facture can be dispensed with, and further that the uniformity of Neo-Impressionism was unduly limiting, for it is clear that his objection to "the division of tones" of Neo-Impressionism was that it did not allow for contrasts or deliberate disharmonies.

In the spring of 1905, under the influence of Matisse's Neo-Impressionism, Derain had abandoned his pre-Indépendants style, that is to say, the mixed-technique style of *The Bridge at Le Pecq* (p. 38). It was to this "sort of painting" that he returned at Collioure, or at least to a far more refined and luminous version of it. The fact that he had now passed through a phase of pure Neo-Impressionism seems to have invested his art with a new clarity and directness of color, indeed with an awareness of the potency of distinct and isolated hues, that we do not see before Collioure (p. 50). Although Derain had not used the widely spaced brushstrokes set against a white ground that appear in *Luxe, calme et volupté*, Matisse probably urged him to thus simplify his style at Collioure. From Derain's letters it is clear that they discussed questions of color theory and technique. In one, Derain states proudly: "I've been slugging away with Matisse and I don't think he realized I possessed a science of color...."[2] It was in the end not "science," but the light of Collioure coupled with Matisse's encouragement that liberated the young painter. His letters testify to this, too[3] Comparing the pre-Indépendants painting, *The Bridge at Le Pecq*, with the *View of Collioure* (p. 50) reveals the same combination of broken Divisionist touch in the warm colors and solid infilling in the blues. Yet whereas the brushstrokes in the first painting tend to merge together, and the figures and buildings create a definite, if illogical, perspective, the space of the Collioure painting appears to spread not backward but laterally. The far more clearly defined color units and solidly flattened background make for a newly open kind of painting[4] This quality of openness—of painting that spreads itself outward across the viewer's field of vision—characterizes the best of Fauvist art.

The color infilling of both works probably owes something to the example of Gauguin, whose art had been seen in some quantity in Paris in 1903 and 1905[5] The deeper orchestration of the 1904-05 painting, and of similar works, can also be related to Gauguin in color. Since Escholier's 1956 biography of Matisse, it has been known that, while at Collioure, Matisse and Derain were taken by their neighbor Maillol to see de Monfreid's major

(above) Derain: *View of Collioure*. 1905. Oil, 26 x 32⅜". Museum Folkwang, Essen

(above left) Derain: *Collioure (The White Horse)*. 1905. Oil, 28⅜ x 35⅞". Collection Pierre Lévy, France

(left) Derain: *Fishermen at Collioure*. 1905. Oil, 18 x 22". Perls Galleries, New York

collection of Gauguin's work.[6] The paintings undoubtedly impressed the pair. De Monfreid's archive of letters and manuscripts may even have been the source of Derain's statement to Vlaminck concerning "a new conception of light,"[7] and seeing the Tahitian landscapes may have started Matisse thinking of the subject of the *Bonheur de vivre* (p. 100). Gauguin was too well known to Matisse and Derain, however, for this visit to have been the revelation to them it is sometimes supposed.[8] It was possibly Derain's experience of the flattening light of the south that made him take renewed interest in the flatter forms of Post-Impressionist painting. For Derain's new combination of color infilling and broken touch, the art of van Gogh was as obvious a precedent as Gauguin's. The magnificent *The Mountains,*

Collioure (p. 47) bears interesting comparison with van Gogh's Saint-Rémy paintings of olive trees, examples of which had been exhibited at the Indépendants that spring; the firm, curvilinear, almost Art Nouveau, outlining of the mountains themselves look to Gauguin as well. From Collioure Derain wrote to Vlaminck: "Up to now we have only dealt with coloring. There is a parallel problem in draftsmanship."[9] *The Mountains, Collioure* would seem to have been motivated from this thought: to find a form of drawing both equivalent and appropriate to the flattened areas of color. *The Fishermen at Collioure* (left) reveals little of the overtly curvilinear. The color areas, now more consistently flattened, look to Gauguin even more. Paintings of this kind mark a final liberation from Neo-Impressionism. In

one short summer, Derain had spanned the stylistic range of Post-Impressionist painting and had assimilated his sources in a truly personal resolution that speaks of a real liberation for his art. His form of mixed-technique Fauvism was never as exuberant as Matisse's, but the style of flat-color painting he pursued at Collioure provided the foundation for the dominant Fauve style of 1906.

All this was not managed, however, without intense effort. "I don't mind telling you," he wrote to Vlaminck, "it's no fun at all, but I'm staying on because I'm compelled to buckle down seriously and put my heart into it."[10] Undoubtedly it was Matisse who helped to motivate his young friend, and Derain must have found him a very different colleague from the excitable Vlaminck. "He's going through a crisis just now, in connection with painting," Derain wrote to Vlaminck.[11] It seems to have been the "anxious, madly anxious" Matisse all over again. Just as was the case at Saint-Tropez the year before, Matisse found himself changing his style at least partly because of the example of an artist who was, in the final count, of lesser stature. Matisse's earliest Collioure paintings were in the sophisticated Divisionist style he had begun to adopt at Saint-Tropez, as with the *Woman with the Parasol* (right) or the panoramic *Port d'Abaill, Collioure*. Matisse was clearly dissatisfied with this form, for he soon began to stretch Neo-Impressionist methods almost to the threshold of abstraction, as in the summarily painted *View of Collioure with the Church* (p. 52), and then abandoned the style. In the *Landscape at Collioure* of the summer of 1905 (p. 52), from which he developed the background for the *Bonheur de vivre*, we see a dramatic liberation from the methodical for a new, loose, mixed-technique manner that persisted until early in 1906. The arabesque of the tree trunks may well derive from the paintings of Cross—perhaps specifically from *The Farm, Morning* (p. 100), which Matisse acquired around this time[12]—but comparison of the two works only serves to illustrate the new freedom Matisse had achieved. The arbitrary color breaks of the tree trunks are indebted to Derain, as well as to Cézanne. The paint is applied in certain passages as Neo-Impressionist bricks, but they only appear as such when viewed in the context of Matisse's earlier work. Although evidently derived from a compilation of Post-Impressionist sources, Matisse's Collioure landscapes seem curiously styleless paintings, of an uninhibited directness and spontaneity that make even Derain's contemporary work look calculated in comparison. Whereas Derain transformed the intense light effects of the Côte d'Azur to a pitch of clarity and purity of color that celebrate his delight in this semitropical landscape, Matisse used the same light and same color to create not so much a celebration of landscape per se as the evocation of a scene or setting, somehow more arbitrary, and therefore more abstract, in its relation to the observed world, and at the same time more ideal. While Derain looked outward to the open spaces of coast and mountains, Matisse began to be

Matisse: *Woman with the Parasol.* 1905. Oil, 18⅛ x 14¾". Musée Matisse, Nice

attracted by something more private and enclosed. That autumn, when he further intensified the colors and forms of this scene to vivid orange-and-emerald overhanging trees, punctuated by thick ultramarine trunks, he added a group of pink-and-violet nudes (p. 100 below left). This can certainly not be mistaken for a simple delight in landscape. Instead, Collioure became the setting for a celebration of the *bonheur de vivre.* The *Bonheur de vivre* itself (p. 100 above) was to occupy Matisse during the winter of 1905-06, and to lead him eventually not only into idealized themes but beyond the mixed-technique Fauvism of Collioure. The works that gave Fauvism its name, however, were all created in the spontaneous early style of Collioure.

Matisse's *Open Window* (p. 26), one of the highly controversial exhibits at the 1905 Salon d'Automne, is even more varied in technique than his Collioure landscapes, combining as it does Impressionist and Neo-Impressionist color touches in the view through the window and roughly brushed patches and areas of flat, fairly even tones inside the room. In this particular case, the subject itself may well have suggested such a contrast

(top) Matisse: *View of Collioure with the Church.* 1905. Oil, 13⅛ x 16⅛". The Museum of Modern Art, New York. Extended Loan and Promised Gift from Kate Steichen in Memory of Edward Steichen

(above) Matisse: *Landscape at Collioure* (Study for *Bonheur de vivre*). 1905. Oil, 18⅛ x 21⅝". Statens Museum for Kunst, Copenhagen. J. Rump Collection

of methods to Matisse. And yet the way in which the broad areas of complementaries are pulled apart by the central motif has precedents in his proto-Fauve work. It was noted earlier that one of the links between Matisse's proto-Fauve and "dark period" figure paintings was his use of more or less distinct color zones, divided by the centrally positioned figure. In the Neo-Impressionist *Nude in the Studio* (p. 22) of 1899, the vivid red-and-orange nude stands between the two complementary zones of green and blue. So does Lucien Guitry in the 1903 portrait. "I found my artistic personality by looking over my earliest works," Matisse told Apollinaire in 1907. "There I found something that was always the same and that at first glance I thought to be monotonous repetition. It was the mark of my personality that appeared the same no matter what different states of mind I happened to have passed through."[13] This was undoubtedly one of the constants that he found: a way of arranging composition so that intense colors could not only be laid down side by side, but also held apart, balanced across the flat plane of the canvas, signaling to each other from either side. Carrying the principal motif up the full height of the painting, which he began to do in 1899, became one of his important ways of achieving this, as the *Open Window* reveals.

We see the same way of arranging colors in the Collioure *Portrait of Derain* (p. 14), where the coloristic composition is closer to that of the early figure paintings than to that of the *Open Window.* In the *Open Window* complementary hues balance across the picture; in the portrait the green-blue opposition of the early work is used, except that these zones are divided, not with one but with two central areas. The red of the hat complements the green, and the orange of the face, the blue—while patches of the two background colors are carried across the central motif to interlock the whole work. Derain's companion portrait (p. 14) shows something of the same method, though its colors are quieter than in the Matisse and its touch more evidently Neo-Impressionist in origin. In the *Woman with the Hat* (right), which Matisse painted in Paris in the autumn of 1905, one sees a further extension of this coloristic method. He seems to have begun with a roughly sketched outline drawing and then worked away from it both inside and outside the figure with contrasting patches, rather than defined areas, of color. He set an orange on the neck next to a blue, then overpainted with a more vivid red, possibly after the same red had been used on the basket below, or after greens had come to dominate the more startling violets and ultramarines. It was as if Matisse were "exploring the medium of existence in which the colors float together," Lawrence Gowing has written, "and exploring also a human quality—probing the meaning of the elegance and discovering a moroseness in the modish pose."[14] Matisse's method of working is confirmed by an unfinished 1905 *Portrait of Mme Matisse* (p. 54). Here, only the principal pairings—red against green, orange against blue—have been laid in, but in this bare

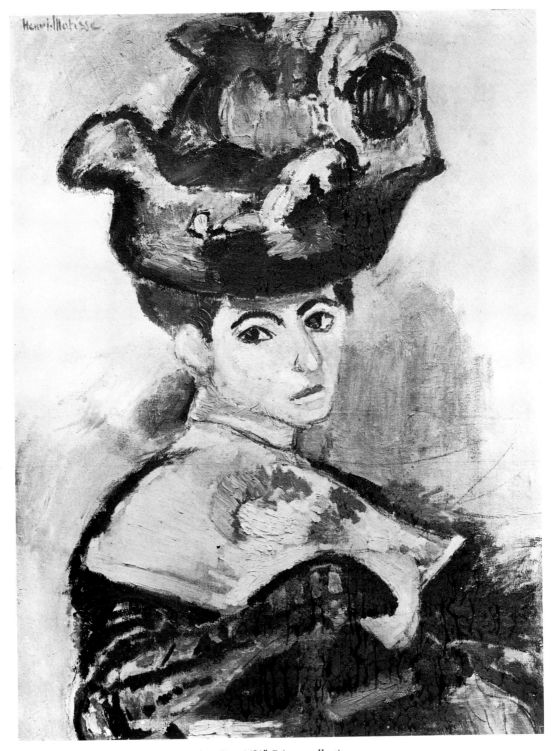

Matisse: *Woman with the Hat.* 1905. Oil, 32¼ x 23¾". Private collection

van Gogh: *Portrait of the Painter with a Pipe.* 1889. Oil, 20⅛ x 17¾". Collection Mr. and Mrs. Leigh B. Block, Chicago

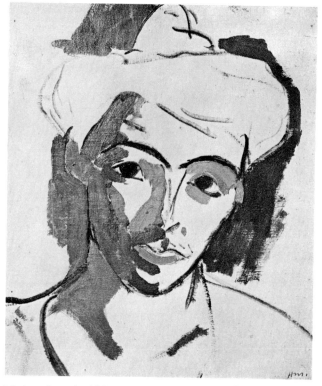

Matisse: *Portrait of Mme Matisse.* 1905. Oil. Musée Matisse, Nice

form we have a glimpse of the quintessential coloristic foundations of Matisse's Fauve style.

Matisse's Neo-Impressionist paintings were not inhibited in color. Indeed, *Luxe, calme et volupté* uses a full spectrum of pure isolated hues with a boldness without precedent in any finished Neo-Impressionist oil. Both the wide spacing of the mosaic form and the startling combination of "unnatural" yellows, lavenders, and reds take this work well beyond the confines of literal description. Compared with this, the Collioure paintings evidence a more restricted palette, but at the same time a more concentrated one. Eschewing the roughly equalized color distribution of most Impressionist and Neo-Impressionist painting, and the allover, regular facture that accompanied it, Matisse settled his art in the contrasts of increasingly spacious areas of complementary colors. Paintings of the Impressionist tradition seem to exude a slow, internal, atmospheric light; Matisse's seem increasingly to reflect light from the flattened, open surface. Flat color areas, especially those developed around the red-green and orange-blue axes, affirm the planarity of the surface as a taut, stretched membrane, very different from the softer, more pliant surface of Impressionist paintings. All of

Matisse's subsequent work was a continuing investigation into the properties of this wafer-thin sheet of the picture surface, which resists optical penetration, inviting the eye to cross and recross it but never to disrupt its unity. Even the excited handling of the *Woman with the Hat* cannot disguise Matisse's absolute insistence upon the tangible painted surface, and that everything be resolved in the terms that it prescribed. Nothing could be more tangible than the surface of an Impressionist painting. That surface, however, invites optical penetration, seeming the covering of a window showing deeper space beyond. The central, "Impressionist" part of Matisse's *Open Window* capitalizes upon that potential, but only to reverse its implications. The window opens to reveal the typically Impressionist scene. What we see through it, however, does not recede. Instead, the scene is advanced toward us by virtue of its handling. The window is opened to the viewer. The emphatic surface of the painting closes off the deeper illusionistic spaces of an earlier art.

At Collioure, Matisse was clearly preoccupied by this subtle balance between the space that surface painting itself allows and that which we inevitably read in representations of any kind. As ever, he tailored his subjects to match and consolidate

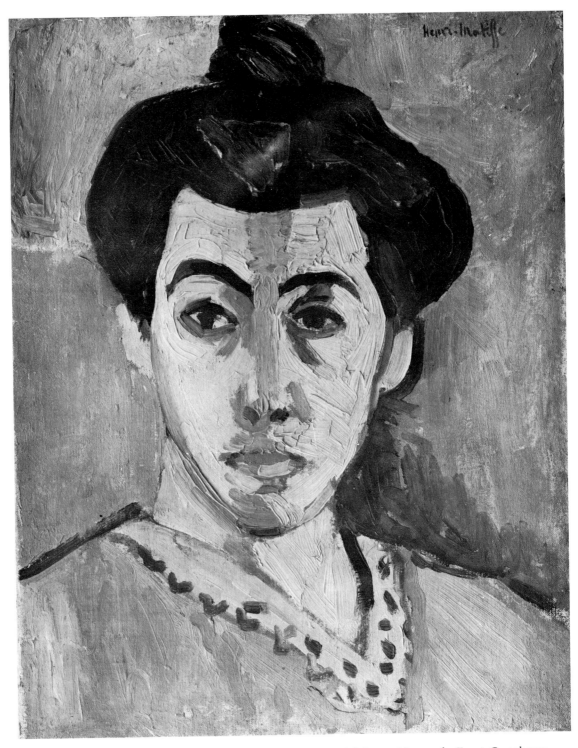

Matisse: *The Green Line (Portrait of Mme Matisse)*. 1905. Oil, 16 x 12¾". Statens Museum for Kunst, Copenhagen

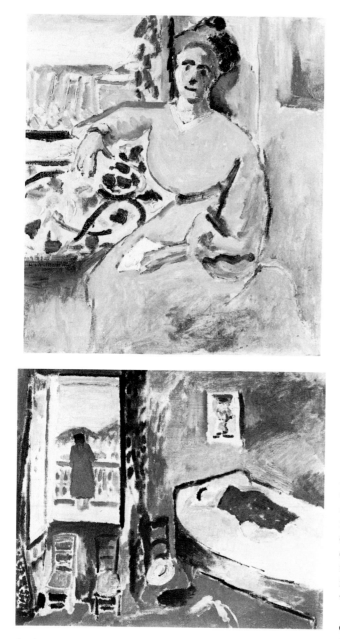

his pictorial interests. Viewing his *Woman before the Window* (left) and *Interior at Collioure* (below) in the context of the *Open Window* (p. 26) demonstrates that one of his important concerns at Collioure was the representation in single paintings of two different worlds: a flattened and restful interior one through which the external world of nature is viewed. The window motif itself becomes an internal picture frame, enclosing a picture within a picture, and nature itself is presented through the mediation of an enclosed decorative space.

The enclosed decorative space of painting itself was reformulated by Matisse in 1905. His discovery of pictorial coherence in the interaction of flat surface colors led to a new form of construction in color that is Fauvism's most important achievement. The fact that Matisse achieved this in a mixed-technique style is no less radical.[15] The use of a single overall technique, or generally uniform facture, is usually the basic prerequisite for a coherent art. Although painters have, of course, traditionally varied their methods of handling from section to section of a painting, overt technical discontinuity has usually been the sign of an immature or an eclectic art. Matisse's earliest examples of a mixed-technique style, such as the *Still Life against the Light* of 1899, may be described in these terms when one compares them with his mature work, but even the discontinuities of his proto-Fauve paintings were willful, not unconscious. He may have been guided to mix techniques as he did by the example of the Nabis, who worked across the full range of Impressionist-based styles, though only rarely within a single painting. In contrast, Matisse's adoption of a mixed-technique style shows once again how he was questioning the foundations of the Impressionism from which he had emerged. For the regularized, allover brushstrokes of Impressionist paintings had identified, in a way more fully than ever before, pictorial coherence and uniformity of facture. This identity became crucial for much subsequent modern painting. Matisse's readiness to break with this most basic of conventions shows not only great daring but great stylistic self-consciousness and self-critical awareness as to the pictorial autonomy of the various individual components of his art. It was by isolating and reformulating autonomous pictorial components that Fauvism was born.

In another sense, however, the immediacy and spontaneity of mixed-technique Fauvism look back to the empiricism of the nineteenth century, to the transitory, single-moment presentations of the Impressionists. Matisse continued with this style in the winter of 1905-06, producing even more spontaneous works, such as the loose and open *Girl Reading* (p. 27) and the heavily impastoed *Gypsy* (p. 64). Within two years, he had begun to reconsider his style yet again. In the "Notes of a Painter," Matisse wrote of the Impressionists as those who register "fleeting impressions" *("impressions fugitives"),* adding: "A rapid rendering of a landscape represents only one moment of its existence. I

(top) Matisse: *Woman before the Window.* 1905. Oil, 12½ x 11¾". Private collection

(above) Matisse: *Interior at Collioure.* 1905. Oil, 23⅝ x 28¾". Private collection, Switzerland

Vlaminck: *The Circus*. 1906. Oil, 23⅝ x 28⅞." Galerie Beyeler, Basel

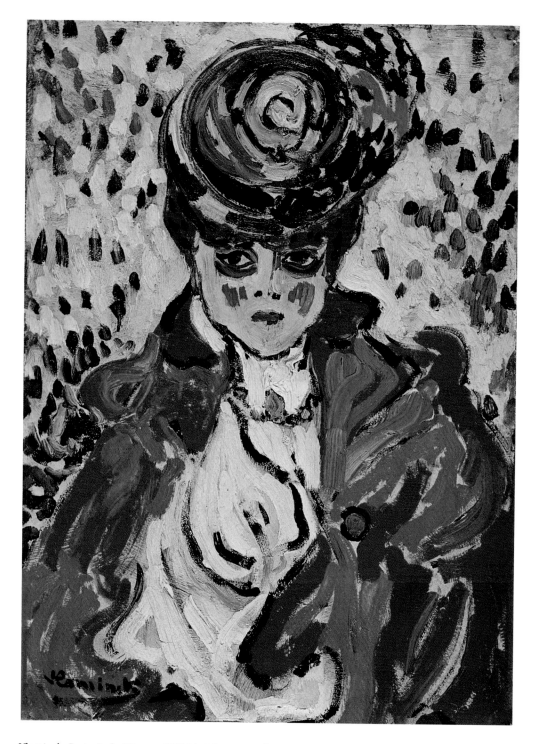

Vlaminck: *Portrait of a Woman.* 1905-06. Oil, 24⅛ x 18." Collection Mr. and Mrs. Nathan Smooke, Los Angeles

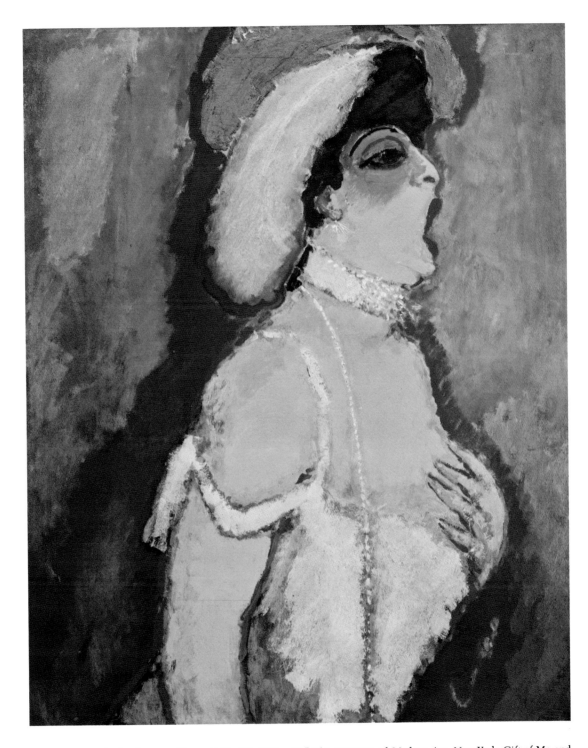

van Dongen: *Modjesko, Soprano Singer.* 1908. Oil, 39⅜ x 32." The Museum of Modern Art, New York. Gift of Mr. and Mrs. Peter A. Rübel

Manguin: *The Vale, Saint-Tropez.* 1905. Oil, 19¾ x 24." Private collection, Paris

prefer, by insisting upon its essential character, to risk losing charm in order to obtain greater stability."[16] In the same place, he wrote of "a time when I never left my paintings hanging on the wall because they reminded me of moments of over-excitement and I did not like to see them again when I was calm. Nowadays I try to put serenity into my pictures." Although the "nowadays" referred to 1908, Matisse was showing himself dissatisfied with the fleeting and the excited even from the autumn of 1905, when he painted the portrait of Mme Matisse known as *The Green Line* (p. 55). It is possible, as Alfred Barr suggests, that Vauxcelles's criticism of the *Woman with the Hat* as having sacrificed form for color[17] influenced the move to a more stable style.[18] Barr also points out, however, that it is more than likely that Matisse found himself reacting against the sketchy character of his early Fauve paintings. It was probably to these early Fauve paintings that he was referring in the "Notes" of 1908. Later, clearly speaking of the second Fauvist style of *The Green Line,* he said that "what created the strict organization of our works was that the quantity of color was its quality."[19] That is to say, to achieve the maximum impact from colors, their precise areas had to be carefully defined. "Order above all, in color," he told his students. "Put three or four touches of color that you have understood upon the canvas; add another; if you can—if you can't set this canvas aside and begin again."[20]

Having thus set aside the unfinished *Portrait of Mme Matisse,* Matisse began *The Green Line.* In painting this work, he would seem to have referred to the portraits of Gauguin and van Gogh, particularly to the latter's 1889 *Portrait of the Painter with a Pipe* (p. 54), which he would have seen in the van Gogh retrospective at the 1905 Indépendants, where his own van Gogh drawings were exhibited.[21] The two paintings make a fascinating comparison.[22] The four principal color zones of the van Gogh —the red and orange background and green and blue garments— correspond to those of the Matisse. But Matisse's use of these colors is at the same time more vehement and more subtle. Whereas van Gogh directly juxtaposed the two sets of complementaries, accentuating their pairing by the horizontal division of the background, only in isolated instances do they meet in the Matisse. Thus pulled apart (and in this, *The Green Line* follows the *Open Window*), they can keep to the same intensity as the earlier Fauve paintings, but without the "over-excitement" —the optical flickering—that adjacently positioned complementaries create. Whereas the van Gogh is resolved by a tonal leveling of the colors, and includes other than pure hues, Matisse's method admitted only pure hues and complex, strident dissonances as well as harmonies. The frontality of the work possibly owes something to Derain's series of full-face portraits, but the strong "green line" that gives it its title is a device typical of Matisse's inventiveness. Reserving the most positive color for an area of shadow not only enlivened the pink and ocher face, raising it to an intensity equivalent to that of the back-

ground, but created an important central axis for the work. It is even more daring than van Gogh's horizontal one, from which it is probably derived, and clarifies the contrasting balance of complementaries on which *The Green Line* is based.

While Matisse was working on *The Green Line,* the reverberations of the Salon d'Automne were beginning to have their effect on younger painters. The autumn of 1905 saw the beginning of the Fauvist movement. To trace its development we must begin with the paintings exhibited in the *cage centrale.*

Matisse's most important submissions, the *Woman with the Hat* and the *Open Window,* have been mentioned already. Derain was represented by nine paintings, including *The Drying of the Sails.* This was reproduced in *L'Illustration* together with Vauxcelles's unkind comments: "M. Derain startles one. He startled one at the Indépendants. I believe him to be a poster artist rather than a painter. The *parti pris* of his virulent imagery, the easy juxtapositions of his complementary colors will seem to some no more than puerile. His paintings of ships, however, would happily decorate the walls of a nursery."[23] This shows that at least the flatness of his work did not go unnoticed. Matisse, in contrast, was described as trying "to force pointillism to greater vibration," having "been misled into eccentricities of color from which doubtless he will recover himself."[24] In short, Matisse was being viewed in the context of his earlier Neo-Impressionism, and Derain, as a "poster artist," that is, in the context of the flat-patterned painting of the Nabis.

Nearly all of the other Fauve works that *L'Illustration* reproduced can be related to one or the other of these two poles: Valtat's *Marine* looks to Neo-Impressionism, Manguin's *The Siesta* and Puy's *Lounging under the Pines* are highly eclectic paintings, whose dependence on Cézanne Vauxcelles noted, but they depend also on the decorative curvilinear outlining of the Nabis. Only Rouault's *Peddlers, Actors, Clowns* now seems out of place in this regard. *L'Illustration*'s presentation, however, is not a true picture of the *cage centrale* itself. From Vauxcelles's review in *Gil Blas,*[25] we see that only three of the six artists *L'Illustration* grouped together were represented in the famous Salle VII: Matisse, Derain, and Manguin. With them were Marquet, Camoin, Vlaminck, and some others. Puy was in Salle III with the older Nabis, including Vuillard and Bonnard; Rouault in Salle XVI with a number of Cézanne-derived realists, as Vauxcelles described them, noting the contrast between Rouault's work and theirs. Valtat appeared in Salle XV, with the then-unknown Jawlensky and Kandinsky, who were deeply influenced by the Fauve canvases they saw there. From this information we may judge just how influential and historically misleading *L'Illustration*'s presentation was in including Rouault and Valtat among the Fauves.

Valtat was mentioned earlier and his relationship to Fauvism described. In terms of background, Rouault's Fauvist association was better justified, for he had been a pupil of Gustave

Rouault: *The Wrestler.* ca. 1906. Oil on paper mounted on canvas, 17 x 10". Perls Galleries, New York

chiaroscuro effects we see both spontaneous brushwork and high color, but the glazed technique and luminous internal glow of his paintings and watercolors separate them from the assertively surface-organized work of the Fauves. The foreground figure of his Salon d'Automne painting bears comparison with Matisse's *Gypsy,* and the standing figures, with some of van Dongen's work. Only in draftsmanship, and then only exceptionally, did Rouault come close to the Fauves. His *Wrestler* of about 1906 (left) is certainly strong in color, but it has none of the purity of color that characterizes true Fauve painting. We see nowhere in the work the acute stylistic self-consciousness that accompanied the occasional wildness of the Fauves. For Rouault, expression resided, to borrow Matisse's phrase, "in passions glowing in a human face!"[27] It was against such a position that Fauvism was directed.

Like Rouault and Valtat, Jean Puy was not, according to Vauxcelles, represented in the *cage centrale,* even though he had been one of the Académie Carrière students and was a member of Matisse's circle. Because he was one of the first to heighten his palette in 1904, after Matisse's example, he must be included among the Fauves, or at least among the practitioners of a pre-Fauvist style. The schematic flattened forms of his Salon d'Automne painting, with its undoubted reference to Manet's *Déjeuner sur l'herbe,* belong not only to Fauvism but to an earlier tradition of surface-organized painting derived from Manet and revised by the Nabis. After 1905 Puy often worked with very delicate colors, and most of his later work admitted increasingly *chiaroscuro* effects.

Matisse's new friendship with Derain, and subsequent association with Vlaminck and the Havrais Fauves, meant a disruption of the original circle of 1900. There is real justification for speaking of that circle as a pre-Fauve grouping, which gradually was replaced by a truer Fauvism from late 1905 onward. If we do so, then Camoin and even Manguin must also be counted pre-Fauves, for, as with Puy, their experiments with color climaxed in 1905. Although they continued to exhibit with the Matisse circle, as Puy did, too, there was less and less in common between their work and that of Matisse's newer, more adventurous friends. Camoin, in fact, "does not recall having been a Fauve," Georges Duthuit has reported[28] At the 1905 Salon d'Automne, however, it was discussion of his paintings that immediately preceded Vauxcelles's evocation of the *fauve* name. Vauxcelles talked of Camoin, Manguin, and Marquet as a flock of migrating birds who had gone in search of the *pays enchanté* of the south[29] While Matisse and Derain were at Collioure, these three had spent the summer at Saint-Tropez, upon Signac's and Matisse's recommendation. And just as the bright southern light liberated Derain, so too Vauxcelles saw it reflected in the canvases of these three. Manguin's Bastille Day paintings of the harbor at Saint-Tropez (p. 78) presage the paintings made by Marquet and Dufy at

Moreau. Even so, he was never a close affiliate of Matisse, did not keep in regular contact with him after Moreau's death, and in 1903 became the first curator of the Gustave Moreau Museum, which sent him further on the introspective path he was marking out for himself. The primitivized Rembrandtesque style[26] he began to develop from around 1902, having previously followed the Dutch master even more slavishly, has—apart from the primitivism—little in common with Fauve art. Beneath the

Manguin: *The Cork Oaks*. 1906. Oil, 15 x 18⅛". Collection André Martinais, Paris

Manguin: *The Sleeping Girl*. 1905. Oil, 13 x 16⅛". Collection Lucile Manguin, Paris

Le Havre on the same holiday a year later (pp. 76, 77). Their treatment, however, was still essentially Impressionist. Although the areas the red flags occupy are greater than in the Fourteenth of July paintings of Manet, Monet, and van Gogh (pp. 78, 79),[30] they do not have the flattened emblematic quality of the 1906 Fauve paintings; without these dramatic foreground accents one would have but charmingly spontaneous Impressionistic paintings. Such a heightened Impressionism also characterizes Manguin's Salon d'Automne painting, *The Siesta*, although Vauxcelles discovered Cézanne's presence there.[31] On the other hand, *The Vale, Saint-Tropez* (p. 60), from that same summer of 1905, shows Manguin using hatched Cézannist brushstrokes as vehicles for far bolder color, so that the surface of the work comes to comprise a flattened irregular patchwork of new decorative intensity. In *The Cork Oaks* of the following year (above) the loose, sketchy brushstrokes are replaced by more solid planes, but with a similar open patchwork effect. Manguin's Fauvism is essentially a coloristically heightened form of Impressionism and Post-Impressionism. Only occasionally, as in *The Sleeping Girl* of 1905 (above right), did he allow himself something less overtly structural in effect, analogous to Matisse's mixed-technique Fauvism. He did not contribute at all to the flat-color Fauvism that developed in 1906.

In certain respects, the third Saint-Tropez vacationer, Marquet, belongs with these pre-Fauves, for like them his palette became more subdued as Fauvism progressed. In Marquet's case, however, this was a slower process, and he worked in company with

Dufy in a bright, flat-colored style in 1906, making a few of the most simplified of Fauve paintings. In 1905, his paintings of Saint-Tropez achieved a vivid spontaneity, both of touch and of color, that seemed to be a direct response to the southern landscape. Vauxcelles commented on the difference between the Paris Marquet of the Indépendants that year, whom he preferred, and the new Marquet of the south, who painted metallic green trees, rose-colored houses, and bright sun-drenched landscapes.[32] Marquet began working at Saint-Tropez in the muted Bonnard mauves that were fast becoming typical of his style, before gradually heightening his color and replacing his usual purplish outlining with a more excited scribbling effect. But, as with most of Manguin's contemporary works, we see here what is basically an extension of Impressionist painting. Marquet was not to reach his most accomplished Fauve style until he followed Matisse's lead once more, as he had done earlier in 1900.

Also still working in the Impressionist tradition was Othon Friesz. He had first been shown in Paris together with his friend Dufy in the Indépendants of 1903, there exhibiting paintings of the Creuse valley with typical Impressionist subtitles describing the season or moment of their creation.[33] By 1905 his drawing style had become loose and spontaneous, as is shown in the port scenes of Antwerp he made that summer. Even when he returned there the following summer with Braque (p. 65), his touch was still essentially the broken allover one of the Impressionists and his color generally subdued, though not without a curious iridescence he was to capitalize upon, again in

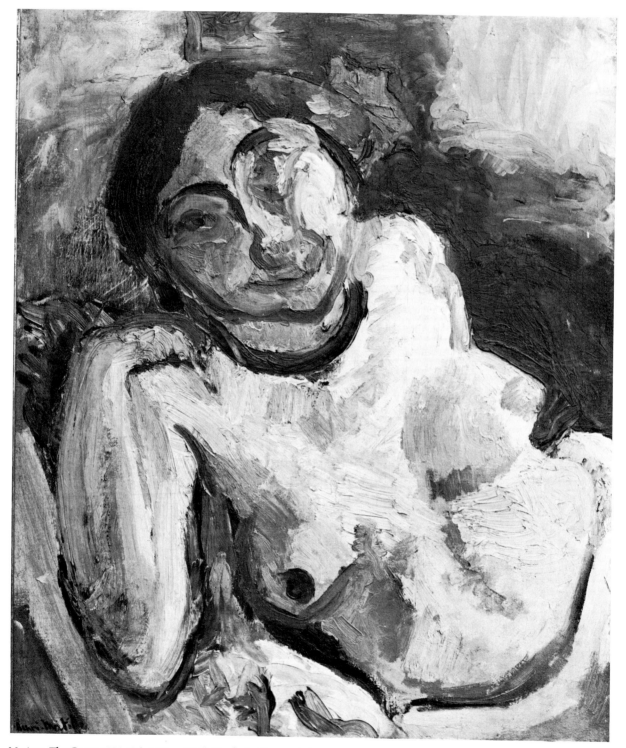

Matisse: *The Gypsy.* 1906. Oil, 21⅝ x 18⅛″. Musée de l'Annonciade, Saint-Tropez

(above) Dufy: *The Railway Wagon*. 1905. Oil, 16 x 12⅝". Private collection, Great Britain

(above left) Friesz: *The Port of Antwerp*. 1906. Oil, 23⅞ x 28¾". Collection Robert Lebel, Paris

(left) Braque: *The Port of Antwerp*. 1906. Oil, 19⅝ x 24". National Gallery of Canada, Ottawa

Braque's company, a year later (pp. 126, 127). Yet even after this liberation had come, in 1907, he was happy to have his friend Fleuret write that he was dedicated to the Impressionist tradition.[34] Friesz was represented in the 1905 Salon d'Automne, though not in Salle VII.

Friesz's close colleague, Dufy, did not show with him, although they had been exhibiting together at the Indépendants since 1903. This was probably because Dufy had begun radically to revise his art following his seeing Matisse's *Luxe, calme et volupté* at the 1905 Indépendants. In fact, his own contribution to that show, *Yacht pavoisée* of 1904, evinces a certain schematic flatness, a space far more compressed than that of, say, Man-

guin's flag paintings, with which it invites comparison, and a harsh solidarity of color that looks more toward the Fauvist style than does Manguin's Impressionist work. Yet Dufy's painting, too, is still based in Impressionism, and the progress he began to make from the summer of 1905 was not achieved without hesitations and second thoughts. For example, he has described the powerful impact of *Luxe, calme et volupté* thus: "I understood the new *raison d'être* of painting, and impressionist realism lost its charm for me as I beheld this miracle of the creative imagination at play, in color and drawing."[35] Nevertheless, when replying to Morice's "Enquête" on the validity of Impressionism later that year, he concluded that for him Impres-

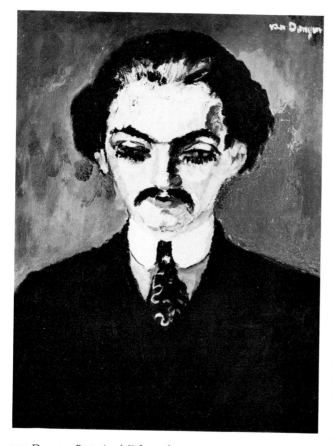

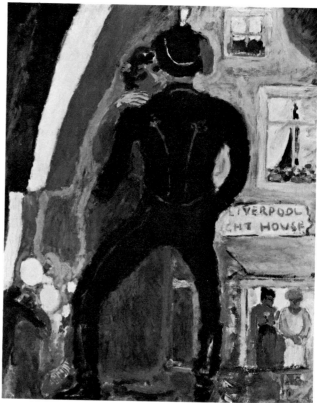

van Dongen: *Portrait of Kahnweiler.* 1907. Oil, 25⅝ x 21¼". Collection Oscar Ghez, Geneva

van Dongen: *The Hussar (Liverpool Night House).* 1906. Oil, 39⅜ x 31⅞". Private collection, Switzerland

sionism was in no way finished.[36] In fact, Dufy showed himself to be an artist particularly open to others' influence through his Fauve years. *The Railway Wagon* of 1905 (p. 65) was undoubtedly motivated by Matisse's mixed-technique Fauvism. His Fauvist paintings of 1906 were greatly affected by Marquet, but also by the open structures of Impressionism, which continued to be relevant to the personal understanding of Fauvism that Dufy finally achieved.

Time and again we are seeing that even as late as 1905 the stylistic foundation of many of the Fauve painters was an Impressionist one. Even the mixed-technique Fauvism of Derain and Matisse at the Salon d'Automne was an extension of the spontaneity of Impressionism as well as a reaction against it at the same time. For the others, it was something they were only just beginning significantly to modify, or were modifying as much as they ever would. Van Dongen is somewhat exceptional in this respect. He, too, had begun his modernist alignment under the aegis of Impressionism, showing works of this style in his one-man show at Vollard's in 1904.[37] He also, as we have

seen, passed through a Neo-Impressionist phase. By 1905, he had found his way into a loose impromptu style analogous to the mixed-technique Fauvism of the Matisse circle, especially in his paintings of nudes (opposite, top). But the main direction of his art was fast becoming geared to the representation of subjects different from those of most of the other Fauves. Van Dongen's paintings of friends and colleagues (above left) and of the nightlife of Montmartre and of similar venues (above and opposite) draw directly upon the example of Toulouse-Lautrec, though admitting newly heightened and improvisational relationships of color.

Such a mixture of Lautrec and expressionist colorism was by no means unprecedented. Picasso's paintings of prostitutes and entertainers of late 1900 and early 1901 form an important precedent for the art of van Dongen,[38] who lived in the Bateau-Lavoir in 1906-07. Van Dongen's iconography links him to Rouault, although each used it to different ends. If for Rouault expression resided in the passions visible in a human face, for van Dongen it resided very often in the violent gesture. His

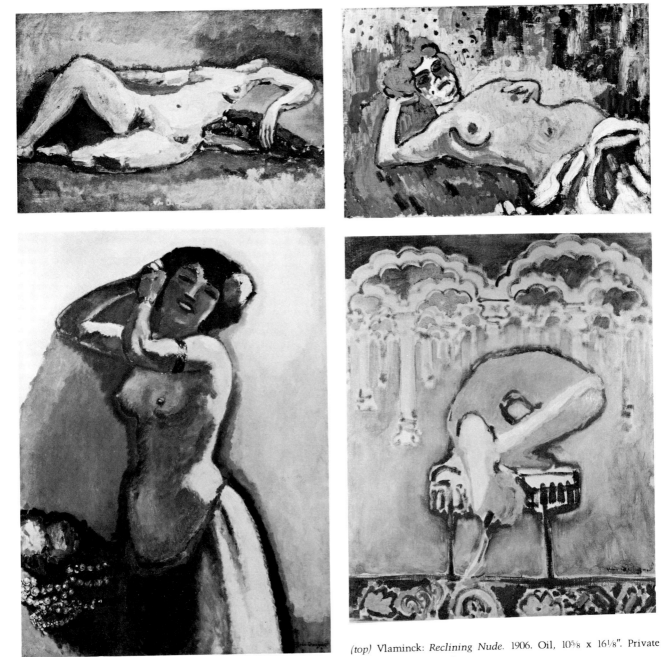

(top) van Dongen: *Reclining Nude.* 1904-05. Oil, 15¾ x 25⅝".
Whereabouts unknown

(above) van Dongen: *The Dancer.* ca. 1905. Oil, 51¼ x 38¼". Private
collection, Switzerland

(top) Vlaminck: *Reclining Nude.* 1906. Oil, 10⅝ x 16⅛". Private
collection, Switzerland

(above) van Dongen: *"Caoutchouc" at the Cirque Médrano.* 1905.
Oil, 25½ x 21¼". Collection Evelyn Sharp, New York

67

Picasso: *Old Woman with Jewels*. 1901. Oil on cardboard, 26⅛ x 20½″. Philadelphia Museum of Art. Louise and Walter Arensberg Collection

Vlaminck: *Dancer at the "Rat Mort."* 1906. Oil, 28¾ x 21¼″. Private collection, Paris

carnal and expressionist obsessions made him perhaps the wildest of the Fauves, but because of this an atypical one.

Van Dongen seems to have been temperamentally akin to Vlaminck, so it is not surprising that they came to be on especially good terms. Vlaminck's 1906 rendering of *The Dancer at the "Rat Mort"* (above right) seems indebted to the Dutchman, whom he first met that year, if not also to the early Picasso in works like the *Old Woman with Jewels* of 1901 (above). Vauxcelles introduced Vlaminck's notice in his review of the 1905 Salon d'Automne with the witticism, "M. Devlaminck [*sic*] épinalise,"[39] remembering one of Vlaminck's submissions to the spring Salon des Indépendants, the *Girl with a Doll*,[40] which reminded Vauxcelles of the popular illustrated broadsheets, the so-called *images d'Epinal*, which Vlaminck collected.[41] Another of his Indépendants paintings, the *Quai Sganzin at Nanterre* (p. 36), shows that he, too, was working in an Impressionist style right up to the beginning of Fauvism. His

Salon d'Automne painting, *The Pond of Saint-Cucufa* (p. 72), is also Impressionist-based, but in it Vlaminck exaggerated and enlarged his brushstrokes into the individual color blocks of the Fauves' Neo-Impressionist manner. Although the rendering of the foliage is muted and tonal in effect, the bright accents of sky, water, and foreground point directly to the charged, emotive landscapes that were among the highlights of the developed Fauvist style. One also sees echoes of the 1905 van Gogh retrospective in this work, confirming that it was this exhibition and not that of 1901 that liberated him from his Impressionist past. Vlaminck's oeuvre has still not been extensively studied and poses problems of chronology even more acute than in the case of, say, Derain.[42] Vlaminck himself only rarely dated his works, and since he did not exhibit before 1905, it is difficult to test the often very early attributions that have been made, many of which accept Vlaminck's own word that he invented Fauvism in 1900. We saw earlier in the *Man with the*

Derain: *Dancer at the "Rat Mort" (Woman in a Chemise)*. 1906. Oil, 39½ x 32½". Statens Museum for Kunst, Copenhagen. J. Rump Collection

Pipe that his style of 1900 was still founded in *chiaroscuro*, for all its vehemence of brushstrokes. The style of his first exhibited paintings seems to indicate that he did not consistently begin to use vivid color in an assertively surface manner until the winter of 1905-06.[43]

To conclude this summary of the state of Fauvist art by late 1905, we should merely mention that the youngest Fauve, Braque, was only just beginning to make proficient paintings. "Matisse and Derain showed me the way," he said, with reference to their paintings at the Fauve Salon.[44] His own *Ship in the Port of Le Havre* of the summer in 1905 may seem, in retrospect, to contain hints of Fauvist color, but its primary importance for Braque is that it reveals a new confidence and broad grasp of design, indebted in part to Cézanne, that contrast sharply with the clumsy and tentative work he was making in Paris earlier that same summer. It was not, however, until the summer of 1906, when he worked with Friesz at Antwerp, that

Braque began to paint in something approaching a Fauve style, and not until he saw the Fauves at the 1906—not 1905—Salon d'Automne that this style was securely established.

Braque first exhibited with the Fauves at the 1906 Indépendants, showing seven landscapes that he later found wanting and destroyed. This was the first time the complete Fauve group appeared together. After their *succès de scandale* at the 1905 Salon d'Automne, the Fauves regrouped in November at Berthe Weill's. Camoin, Derain, Dufy, Marquet, Manguin, Matisse, and Vlaminck were represented. At the 1906 Indépendants, they were joined by Friesz, Puy, and van Dongen as well as Braque. The highlight of the exhibition was Matisse's *Bonheur de vivre* (p. 100). Whereas he had sent several paintings, all relatively small and of mixed technique, to the Salon d'Automne, this was a large definitive statement comparable to *Luxe, calme et volupté*, which he had sent to the Indépendants the previous year. Paul Signac, the vice-president of the Salon, who had bought the earlier picture and had, indeed, influenced its creation, was astounded—and offended—by the new Matisse. "Matisse [seems] to have gone to the dogs," he wrote to the painter Charles Angrand. "Upon a canvas of two and a half meters he has surrounded some strange characters with a line as thick as your thumb. Then he has covered the whole thing with flat well-defined tints, which—however pure—seem disgusting.... It evokes the worst Ranson (of the 'Nabi' period), the most detestable *'cloisonnismes.'*"[45] Signac saw the *Bonheur* not only as a rejection of the Neo-Impressionism of his circle, which it was, but as Matisse's defection to the camp of the Nabis and therefore as a betrayal of friendship. He even picked a fight with Matisse after the opening.[46]

With the *Bonheur de vivre*, Fauvism was thus publicly separated from the Neo-Impressionist circle. One might have expected that the Nabi critics would now take Matisse into their fold. Denis, however, kept inflexibly to his opinion of Matisse, formed by his view of *Luxe, calme et volupté*, which was that Matisse, though a highly gifted and promising painter, was too much a theoretician.[47] This became a frequently repeated charge. Although Vauxcelles had criticized Matisse's Salon d'Automne submissions for being too informal, he, too, warned him now of becoming theoretical and abstract.[48] This is only explicable if one remembers Denis's highly influential standing as a critic. What he had said about Matisse was becoming the standard response to Fauvism among many other writers. Hence, Gide had written of Matisse's Salon d'Automne work that, despite its informality, it was "un produit de théories."[49] Morice, likewise, found "l'abus de théories" in Derain, Vlaminck, and Manguin at the 1906 Indépendants.[50] Denis had recognized "a school of Matisse," "the most alive, the newest, the most debated," at the 1905 Salon d'Automne, and although he had then repeated the "theoretical" charge—and clearly felt threatened by the attention Matisse's group was receiving—his review of that Salon

Derain: *The Old Tree*. 1904-05. Oil, 16¼ x 13". Centre National d'Art et de Culture Georges Pompidou. Musée National d'Art Moderne, Paris

linked together theory and abstraction in a way far more subtle than that used by his followers.[51] In Alfred Barr's words, "he was one of the few who discerned that Matisse's shocking color and unconventional drawing which so disturbed other critics were only the phenomena of a deep and powerful impulse toward abstraction."[52] Matisse's painting, Denis had said, was even more abstract than that of van Gogh on the one hand or the decorations of Eastern art on the other: "It is something still more abstract; it is painting outside every contingency, painting in itself, the act of pure painting.... Here is in fact a search for the absolute. Yet, strange contradiction, this absolute is limited by the one thing that is most relative! Individual emotion."[53] These are words more appropriate to the *Bonheur de vivre* than to the paintings exhibited in 1905, for by the time of the 1906 Indépendants Matisse's Fauvism was tipping away from the world of nature toward the imaginative and the abstract. Even so, it was certainly not theoretical or calculated, nor did it exclude sensibility, instinct, and "everything which the rational mind of the painter had not controlled," as Denis claimed. Matisse had been upset by these charges in 1905. Doubtless

annoyed to find that they were being repeated at the Indépendants, he confronted Denis there, led him up to his painting, "and asked him to examine it minutely and tell him whether the feat of calculating all those relations would not be a far more extraordinary thing than composing them intuitively. On this confrontation, Denis admitted that it would be."[54] But it is equally obvious that Denis was not prepared to undergo a volte-face and admit Matisse into the Nabi fold. With the *Bonheur de vivre* and the 1906 Indépendants Fauvism was separated both from the Neo-Impressionists and from the Nabis, the two established Post-Impressionist alternatives for advanced art. The group identity of the Fauves was inevitably strengthened.

From the time of the 1906 Indépendants, the Havrais painters began to develop their true Fauve styles, working together from the same motifs as first Matisse and Marquet, then Matisse and Derain, had done before. Although Marquet contributed to this new period of joint Fauve activity, Matisse and Derain generally did not. Having worked together at Collioure in 1905, they now went their separate ways. Derain continued to paint for a while with Vlaminck at Chatou, reworking subjects similar to those he had treated earlier, such as *The River Seine at Chatou* (p. 71), which looks back to *The Old Tree* (left) of the Indépendants of 1905. Since Collioure he seems to have had less in common with his exuberant colleague, Matisse apparently having cured him of his anarchist sympathies.[55] In late 1906 Derain left Chatou for Paris. Whereas Vlaminck continued to pursue an emotional, charged style, Derain, like Matisse, came to appreciate the virtues of the classical and the calm.

Lacking his usual partner, Vlaminck did not contribute significantly to the collaborative activity of 1906. From the autumn of 1905 his move to artistic maturity was swift and decisive; by the next spring he had become the third major Fauve painter. In the autumn of 1905 or the early spring of 1906, he painted a masterpiece of his new style, *The Houses at Chatou* (p. 72),[56] a work that recalls van Gogh but that manages to find in that most personal of painters the stimulus for something equally personal. We see in *The Houses at Chatou* the oranges and brick-reds of van Gogh, his fine gray-greens, the cursive drawing style with abrupt dark accents, and even a van Gogh subject, but Vlaminck his *modeled* the surface, creating what is almost a flat upright relief, with uniformly intensified, emphatically contrasted, unshaded hues. The space of the picture is narrow. The subject, a worker—in which van Gogh found intrinsic expression—is transformed into something pictorially self-justifying. This kind of surface treatment had been prepared for by the Impressionist tradition, but had only rarely been linked to such explosive color. "I heightened all my tones," Vlaminck said, "and transposed all my feelings I was conscious of into an orchestration of pure colors."[57]

Vlaminck's concern with the immediate led him to base his painting around a combination of the three primary colors,

Derain: *The River Seine at Chatou.* 1905. Oil, 27⅞ x 43⅝". Kimbell Art Museum, Fort Worth

especially the cobalts and vermilions with which, he said, he wanted "to burn down the Ecole des Beaux-Arts,"[58] and "to express my feelings without troubling what painting was like before me."[59] As many commentators have pointed out, this sometimes led to a pursuit of self-expression in itself, indifferent to aesthetic standards. Vlaminck admitted as much, indeed, boasted of it: "I wanted to reveal myself to the full, with my qualities and my defects."[60] It has been written of him that he relied entirely on first impressions, finding no place in his art for revisions of any kind, "for he did not distinguish between art and life—and the experiences of life cannot be changed and corrected, only repeated in a different form."[61] This is aptly said, but by no means the last word on Vlaminck, especially the Vlaminck of 1906.

Vlaminck may theoretically have rejected conventional discipline, but his paintings of 1906 reveal not only the artist more

instinctively attuned to the substance of paint than any Fauve except Matisse, but also the one who managed to consolidate and find continued new expression in the broken Impressionist-derived touch that the others rejected. This makes Vlaminck, in one sense, the most conservative of the major Fauve painters, for with only rare exceptions he did not move on to the flat color-zone method that was the second important Fauve style. Yet he was the single member of the group who managed to sustain the sheer spontaneity of the original Fauve vision, and who achieved the emphatic pictorial openness and expansive flatness characteristic of the second Fauve style within the limitations of the first. That Vlaminck managed to do this was largely because of three essential attributes of his art: its restricted palette, dominated by the primary colors; its emphatically modeled surface; and his instinctive, though erratic, sense of composition and displacement of color, on which the

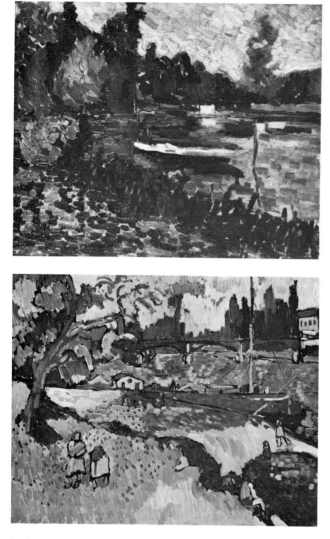

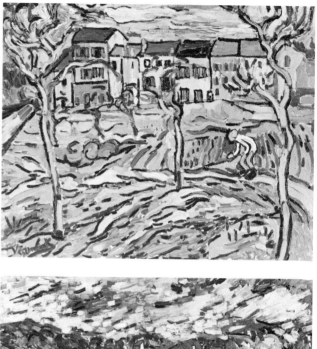

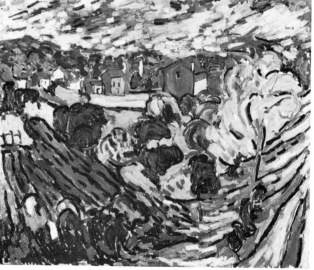

(top) Vlaminck: *The Pond at Saint-Cucufa.* 1905. Oil, 21¼ x 25⅝".
Collection Boris Fize, Paris

(above) Vlaminck: *The Bridge at Chatou.* 1906. Oil, 25½ x 32".
Private collection, France

(top) Vlaminck: *The Houses at Chatou.* 1905-06. Oil, 32 x 39⅝". The
Art Institute of Chicago. Gift of Mr. and Mrs. Maurice E. Culberg

(above) Vlaminck: *Landscape at Chatou.* 1906. Oil, 25⅝ x 29".
Stedelijk Museum, Amsterdam

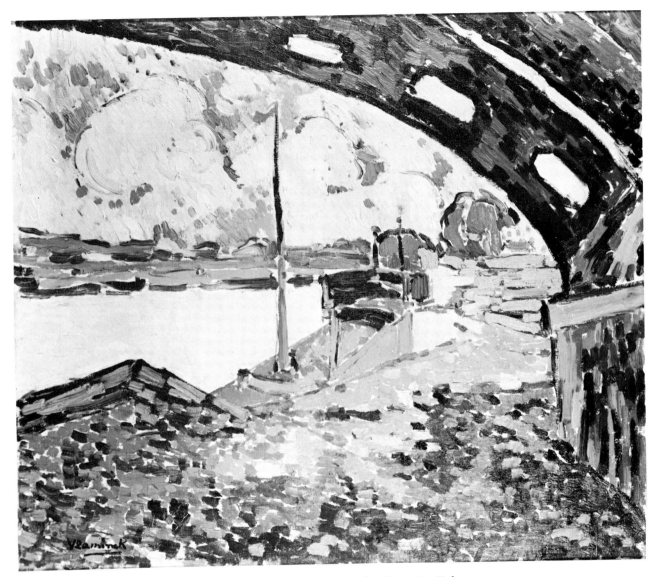

Vlaminck: *Under the Bridge at Chatou.* 1906. Oil, 21¼ x 25½". Collection Evelyn Sharp, New York

quality of his Fauve paintings ultimately depends. Primary colors, the "pure colors straight from the tube" that Vlaminck prided himself on using,[62] tend to establish themselves as flat surface planes far more than mixed hues and so especially do red and blue or red and the "psychological" primary, green.[63] This often presents problems, for it can easily strand the primaries in their own separate parts of the picture, rendering it incoherent. When Matisse first sought to use such fierce contrasts, his Fauvist "idea was to place blue, red and green *side by side* and assemble them in an expressive, constructive way" (italics added).[64] As we have seen, he found it possible also to

pull them apart, capitalizing upon their individuality so that they signaled their opposition across his paintings. Vlaminck's method was usually different from this. Instead of, say, a red signaling across to a green, as in Matisse's *Green Line,* Vlaminck would place a red next to a green, or a red next to a blue, and these would join themselves visually to identical combinations across the painting. In some of Vlaminck's paintings, this scheme produces an unfortunate evenness of effect. Repeated high-key contrasts together may provide a superficial pictorial unity but they finally seem monotonous. In many of his 1906 paintings, however, Vlaminck displayed remarkable compositional sophis-

Vlaminck: *Landscape at Chatou*. 1906. Oil, 21½ x 25⅝". Private collection, Basel

tication. For example, in the *Landscape at Chatou* (p. 72) he divided the work into zones of primaries, the green matching the red, modified by ochers and pinks, across the foreground, and separated this contrast from the blue of the sky by an intermediary zone of yellow trees.[65]

The treatment of the sky in *Landscape at Chatou* seems more naturalistic than the rest of the composition, due to the heavy dosing of white paint it contains. Several of Vlaminck's landscapes contain similar skies, and some seem inconsistent because of them.[66] Only in paintings such as *The Circus* (p. 57) and *The Bridge at Chatou* (p. 72) does the sky seem as abstract in treatment as the rest of the work. In the latter painting, its treatment is clearly influenced by the vertically striated skies of Derain's London paintings of the spring of 1906, such as *Charing Cross Bridge*. It may not have been until the autumn that Vlaminck picked up this method. Vauxcelles noted "mosaics" in the paintings of bridges and motifs of the Seine that Vlaminck made in the summer of that year.[67] Some of these mosaic-like works, for example, *Under the Bridge at Chatou* (p. 73), still have somewhat naturalistic skies. The mosaic form itself, however, suggests that after Vlaminck had worked close to van Gogh from the autumn of 1905 (in *The Houses at Chatou*), he returned to the color-block method of *The Pond at Saint-Cucufa* in the summer of 1906, before seeking to combine the two methods in "block-and-swirl" landscapes like *The Circus* and *The Bridge at Chatou*. This, however, may be too logical a sequence for such an impulsive painter. His *Dancer at the "Rat Mort"* (p. 68) can be fairly securely dated to late 1906, for Derain had just moved from Chatou to Paris after a summer painting in the south. Vlaminck visited his new studio, and

there they painted two dancers they had invited to lunch.[68] For a period they continued to paint from the figure together. Derain's flat-patterned approach to the dancer (p. 69) could not contrast more strongly with the turbulent and dramatic treatment of his friend.

Although Vlaminck combined blocks and swirls of color and an excited handling, which relates his work to the first Fauvist style of Derain and Matisse, his was not a true mixed-technique manner. He rarely combined touches and areas of color, despite his zoning methods, whereas his different marks are close enough to each other in character to coalesce in a single thickly impastoed surface. Vlaminck's mature art, therefore, belongs stylistically where it emerged chronologically: between the mixed-technique Fauvism of 1905 and the second, flat-color style, which developed in 1906, created in the period of the latter manner (and possessing its characteristic allover flatness) with the *malerisch* touch derived from the first.

While Vlaminck spent the summer of 1906 working around Chatou, Friesz and Braque were in Antwerp, and Dufy and Marquet on the channel coast at Trouville, Honfleur, Sainte-Adresse, and Le Havre.[69] From 1901 to 1904 Dufy had regularly spent his summers in this area, painting the striped bathing-tents on the beach and the boardwalk of the Marie-Christine casino at Sainte-Adresse. Dufys from 1902 show a refined Boudin-like harmonious style; by 1904 the same subject was treated in a spontaneous Impressionist manner (p. 75 top left); the 1906 painting at the casino boardwalk (p. 75 top right) reveals Dufy's version of mixed-technique Fauvism, with broken touches in the foreground and flatter, more even tones above. His *Posters at Trouville* (p. 76) contrasts vividly with the pre-1905 paintings. Instead of finding in the beach-tent a form and atmospheric coloring that make it resemble one of Monet's Haystacks, it is now rendered with a summary poster-like clarity appropriate to the images that surround it. This may be ascribed to the influence of Marquet, whose painting of the same subject (p. 76) is generally sharper in outlining and more open and expansive in feeling than Dufy's. Since 1904 (the period of his Manet-derived *Portrait of Rouveyre*) Marquet had been consistently flattening the spaces of his paintings. From the summer of 1905 he had begun to enliven his color. Now, in this all too brief summer of 1906, he brought flatness and heightened color together to paint in the developed Fauve manner (p. 95). He subsequently muted his palette again, and like Camoin, Manguin, and Puy did not belong to the later development of Fauvism.

Although Marquet's Sainte-Adresse and Trouville paintings were flatter and more firmly structured than Dufy's, in some senses Dufy's were the more adventurous, both pictorially and iconographically, and had important repercussions for the future. They show that Dufy, despite his indebtedness to his friend, remained attached to the looser pictorial structures of Impressionism. His *Fête nautique* of 1906 (p. 94)[70] evokes the

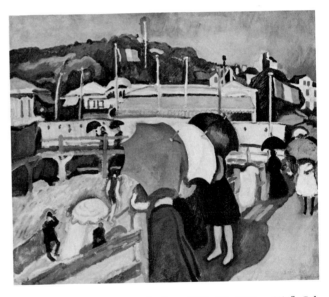

(top) Dufy: *Beach at Sainte-Adresse.* 1904. Oil, 25⅝ x 31⅞″. Centre National d'Art et de Culture Georges Pompidou. Musée National d'Art Moderne, Paris

(above) Dufy: *Trouville.* 1906. Oil, 21¼ x 25⅝″. Private collection, Switzerland

(top) Dufy: *Sainte-Adresse—The Jetty.* 1906. Oil, 25½ x 31½″. Collection Mrs. Harry Lynde Bradley, Milwaukee

(above) Dufy: *Sunshades (The Three Umbrellas).* 1906. Oil, 23½ x 29″. Collection John A. and Audrey Jones Beck, Houston

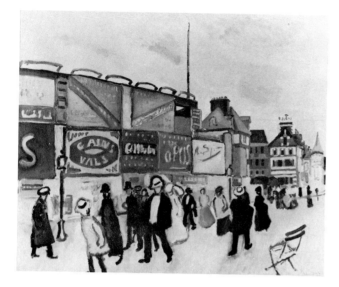

(above) Marquet: *Posters at Trouville,* 1906. Oil, 25⅝ x 32″. Collection Mr. and Mrs. John Hay Whitney, New York

(above left) Dufy: *Posters at Trouville.* 1906. Oil, 25⅝ x 34⅝″. Centre National d'Art et de Culture Georges Pompidou. Musée National d'Art Moderne, Paris

(left) Marquet: *The Fourteenth of July at Le Havre.* 1906. Oil, 31⅞ x 25⅝″. Musée de Bagnols-sur-Cèze

(opposite) Dufy: *Street Decked with Flags at Le Havre.* 1906. Oil, 31⅞ x 25⅝″. Centre National d'Art et de Culture Georges Pompidou. Musée National d'Art Moderne, Paris. Bequest of Mme Raoul Dufy, 1962

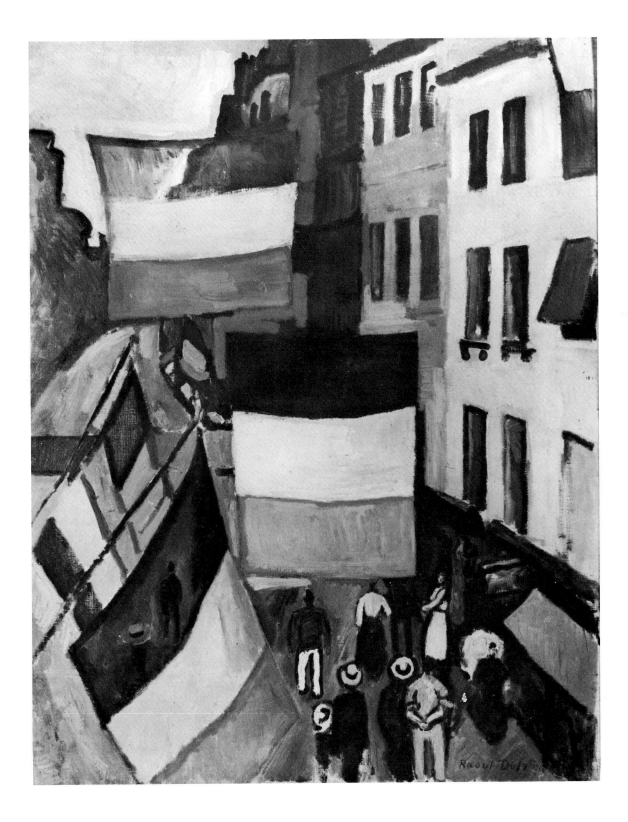

Manguin: *The Fourteenth of July at Saint-Tropez, the Harbor—Left Side.* 1905. Oil, 24⅜ x 19¾". Galerie de Paris

van Gogh: *The Fourteenth of July.* ca. 1886. Oil, 17⅜ x 15⅜". Collection Jäggli-Hahnloser, Switzerland

bustling throng of paintings such as Renoir's *Moulin de la galette.* When Dufy looked to the ocean for his subjects, his spatially floating colorism was further developed in the isolated arcs, curves, and even circles of color he began to use[71] These led through the marines and landscapes of 1907 to some remarkable café scenes of early 1908, which will be discussed later for their influence upon Delaunay's style.

In 1906, Dufy's painting, like that of many other Fauves, was mainly dominated by the search for a more stable kind of structure. For all the decorative exuberance of *Trouville* and *The Three Umbrellas* (p. 75), these are rigorously constructed paintings. Indeed, their very clarity as decorations depends upon their boldness of design. In *Old Houses at Honfleur* (p. 93), Dufy found almost abstract decorative possibilities in the flattened grid of the houses and their reflections, just as Braque was beginning to do with similar subjects in Paris (p. 89). Both Braque's and Dufy's paintings reveal that architectonic solidity of design was not excluded from Fauvist methods; their paintings are among the works that demand revision of the viewpoint

that Fauvism held no lesson at all for the Cubism that eventually supplanted it. What is more, Dufy prepared iconographically for Delaunay, Léger, and the Cubists who painted the urban scene. While Marquet stood back from the Trouville posters, blurring their lettering so that they became unreadable, Dufy had no such inhibitions. He introduced a rare note of vernacular realism into the Fauvist circle, but one that would only be exploited later.

When one turns to the dramatic Bastille Day paintings that Marquet and Dufy made at Le Havre (pp. 76, 77), not only does one see that Dufy surpassed his colleague in boldness, in the foreground placement and vivid coloring of the flags, but that Dufy's flags have an emblematic and epic quality far more stirring than the merely celebratory (and hence still Impressionist) one of Marquet's. In addition, one sees that Dufy, in one passage, has represented figures within the flag image itself. Although the motivation here was still an Impressionist one—to render the transparency of the colored fabrics—the effect it creates, an admixture of man and his street environment,

was one to be developed by Léger, Delaunay, and the Futurists.

The number of flag paintings in the Fauve room of the 1906 Salon d'Automne was enough to cause critical comment[72] For many of the Fauves, however, to paint intrinsically colorful subjects was but a way of brightening and intensifying their pictures without losing their attachment to natural appearances. From the very beginning it had been the method adopted by the more conservative Fauves to match the brilliance of their leaders' color, without having to go through the same process of abstraction that Matisse, Derain, Vlaminck, and now Dufy were beginning to consider.

In the summer of 1906, Braque and Friesz were not even at the stage of colorful subjects. Their views of Antwerp from the same terrace (p. 65) have a summary nervousness of brushstroke, with only occasional touches of intense color. The boldness of design is Fauvist, as are the *port de plaisance* subjects (which contrast with Friesz's paintings of the ships of commerce from the identical vantage point the previous summer)[73] It was only when the pair traveled south, as their colleagues had done before, that their color was fully liberated from the atmospheric and the Impressionist and that their Fauve styles were completely established.

Leaving Antwerp, Braque stopped in Paris in September-October of 1906, and certainly saw the Salon d'Automne, which showed that Fauvism was increasingly being recognized as the force it already had become. Among the highlights of the exhibition were the powerful Fauve landscapes of Vlaminck and Derain: Vlaminck's paintings of Chatou, and Derain's paintings produced in London that spring and in L'Estaque that summer, which showed that he, like Matisse, had consolidated the flat, high-color, and decorative high Fauvist manner. There was also at the Salon a major Gauguin retrospective, far larger than those at the 1903 Salon d'Automne and at Vollard's in 1905. This review of Gauguin's work must have hastened the younger Fauves to follow Matisse and Derain on the path of decorative art.

In 1906, it was by no means certain that Matisse himself would continue along this path. His work of that year has yet to be convincingly discussed, but it is clear that he did not immediately capitalize upon the achievement of *The Green Line* and the *Bonheur de vivre*. This may be explained in several ways. If we consider *The Green Line* as a new move toward structure, provoked by his uncertainty about the more spontaneous first Fauve style, we might conclude that he was also uncertain about having abandoned that style. If we find the *Bonheur de vivre* to be a turning point in Matisse's career, we must also count it a highly experimental work, a summation of his recent experiments, which he now temporarily put to one side. Perhaps he regretted the sacrifice of touch that painting such large flat areas involved. This view would be supported by the paintings exhibited at the Druet Gallery in March and

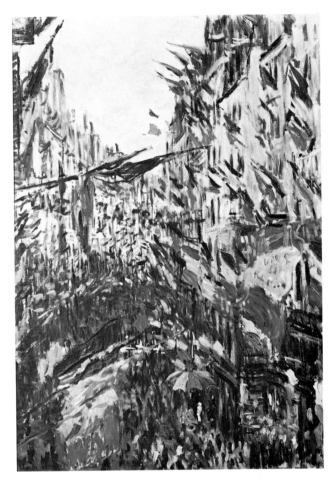

Monet: *Rue Saint-Denis, Festival of the Thirtieth of June.* 1878. Oil, 24¼ x 13″. Musée des Beaux-Arts et de la Céramique, Rouen

April of 1906. Some, such as *Girl Reading* (p. 27), return to mixed-technique Fauvism; others go even further back, to the broken Neo-Impressionist-derived touch of the early Collioure paintings of 1905, though they were probably made around the same time as the *Bonheur de vivre*. When Matisse returned to Collioure in the summer of 1906, he was still by and large consolidating earlier developments. His *Pastoral* and *Nude in a Wood* (p. 101) reworked the *Bonheur* theme itself[74] Beside these, however, appeared some surprisingly primitive and simplified works, such as *Pink Onions*, which he tried to pass off to Puy as the work of the Collioure postman[75] Others are clearly indebted to Cézanne, for example, the dramatic still life, *"Oriental" Rugs* (p. 138). But this is also, in its Pointillist touches and flat patches of color, a work indebted to his own Fauve manner of the previous summer. So, too, is *Marguerite Reading* (p. 80), a

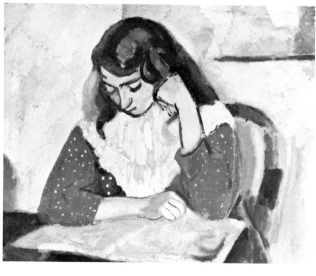

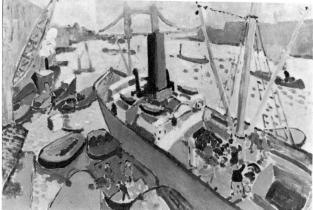

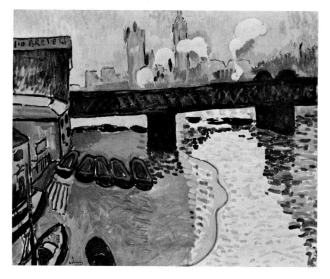

(above) Derain: *The Pool of London.* 1906. Oil, 26 x 39″. The Trustees of The Tate Gallery, London

(top left) Matisse: *Flowers.* 1906. Oil on cardboard, 12¾ x 9½″. San Francisco Museum of Modern Art. Bequest of Harriet Lane Levy

(top right) Matisse: *Girl Reading (Marguerite Reading).* 1906. Oil, 25⅝ x 31″. Musée de Peinture et de Sculpture, Grenoble. Agutte-Sembat Bequest, 1923

(left) Derain: *Charing Cross Bridge, London.* 1906. Oil, 32 x 39½″. Collection Mr. and Mrs. John Hay Whitney, New York

more structured second version of the subject of *Girl Reading.*
Only in the two versions of *The Young Sailor* (pp. 81, 96) did
Matisse begin to escape from the doubts of that year. The first
picture is as sketchy and as heavily treated as *Woman with the
Hat,* but it contains a new linear emphasis. When refined in
the second work in the winter of 1906-07, this new linearity
developed a fluid lyrical appeal far more resolved than that of
the *Bonheur de vivre.* The second version of *The Young Sailor*
marked Matisse's move into the high decorative style of the
following year.

For the third summer in succession Matisse was anxious
about the direction of his art, while Derain had continued and
consolidated his flat-color style. At Vollard's suggestion, he
had returned to London in the spring of 1906,[76] and there
eschewed the Neo-Impressionist fireworks of his previous visit
to work simultaneously in two or three associated, almost
equally successful manners. Perhaps the least well known is
the manner of *Regent Street* (p. 45), whose energetic crowds and
busy traffic suggest that Derain was looking at *The Illustrated
London News* or other sources of popular imagery. His painting
of *Hyde Park* (right), in contrast, is far more leisurely in subject
and elegant in treatment, surrendering the Fauve vigor of the
proletariat for refined "Nabiesque figures, art nouveau flour-
ishes and Gauguinesque pinks."[77] This and his other com-
parable views of wide London streets brought Derain very close
to the Gauguin-Nabi tradition. And yet the flat pink paths,
complementary green grass, and recurring yellow or mauve
skies achieve a self-sufficiency as color, enjoyed and celebrated
for its own sake, that makes the spring of 1906 one of the high
points of his Fauve career. Certainly, the powerful river scenes,
such as *Charing Cross Bridge* and *The Pool of London* (p. 80),
with their patterns of vivid red-blue pairings, are—along with
Vlaminck's similar works, such as *Tugboat at Chatou* (p. 83)—
among the masterpieces of Fauvist painting.

The Pool of London was finally completed when Derain
returned to Paris,[78] where he continued to work in the same
vivid manner in paintings such as the magnificent *Seine Barges*
(p. 82). Comparison with a similar subject treated by van Gogh
(p. 83) shows how Derain transformed his Post-Impressionist
inheritance into something more essentially decorative. Derain's
very concern for the decorative, however, meant that Gauguin's
work continued to be relevant for him, and when he moved to
L'Estaque for the summer of 1906, it was to extend further the
Gauguinesque aspects of his style. A series of L'Estaque land-
scapes made from a single vantage point (pp. 84–86) prepared for
the panoramic *Turning Road, L'Estaque* (p. 114), which bears
direct comparison with the forms of Gauguin's Tahitian land-
scapes, creating an idealized and somewhat sultry setting very
different from the topicality of the London paintings. Even the
preparatory L'Estaque paintings seem removed from the con-
temporary world in a way new to Derain's landscapes. We will

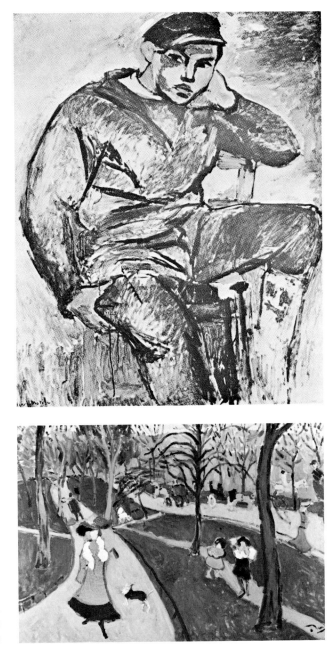

(top) Matisse: *The Young Sailor, I.* 1906. Oil, 39½ x 31". Private col-
lection, Oslo

(above) Derain: *Hyde Park.* 1906. Oil, 26 x 39". Collection Pierre Lévy,
France

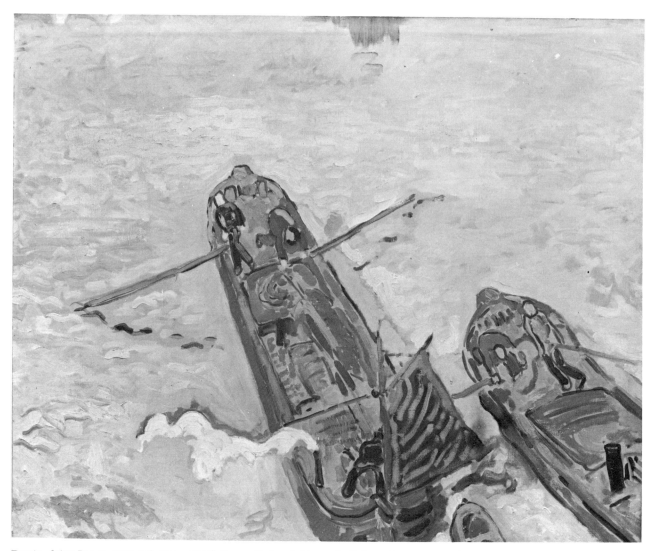

Derain: *Seine Barges.* 1906. Oil, 31¼ x 38¼". Centre National d'Art et de Culture Georges Pompidou. Musee National d'Art Moderne, Paris

need to look again at these works in the context of his allegorical figure compositions, the so-called *L'Age d'or* and *The Dance,* for in the summer of 1906 Derain began to infuse the whole of his art with a mood of ideal and primitivist isolation that had previously been reserved for large subject paintings. Subject paintings soon came to be his principal concern. On a purely stylistic level, however, we see in Derain's L'Estaque landscapes even more unnatural color than before, linked to areas of purely decorative infilling and strongly curvilinear forms. *Three Trees, L'Estaque* (p. 86) bears interesting comparison with paintings by Serusier and van Gogh.[79] It is evident that draftsmanship was coming to have a new significance for Derain. What is more, the extended horizontal grid of the background and

especially the treatment of the foreground trees look clearly to Cézanne. Now that the Fauvist color-breaks on the tree trunks are used over comparatively broad areas and are rendered with vertical hatched strokes, their Cézannist derivation becomes newly evident. Whereas Manguin's contemporary *Cork Oaks* (p. 63) shows how Derain's original color-break method was being picked up by the other Fauves, the crisper and firmer patterning of the three trees in Derain's painting indicates his growing concern with structure.

It is likely that Derain discussed his new ideas with Vlaminck when they worked together later in 1906. If so, that is probably the date of Vlaminck's development toward a more linear, flat-patterned style. *The Village* (p. 88) is the closest Vlaminck

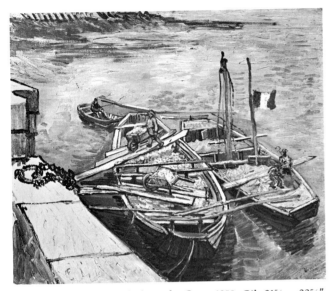

Vlaminck: *Tugboat at Chatou.* 1906. Oil, 19¾ x 25⅝". Collection Mr. and Mrs. John Hay Whitney, New York

van Gogh: *Boats Moored along the Quay.* 1888. Oil, 21⅝ x 23⅝". Museum Folkwang, Essen

came to the Gauguinesque and bears comparison with Derain's *The Turning Road, L'Estaque;* Vlaminck's *Red Trees* (p. 87) extended the hatched strokes and firm outlining of Derain's *Three Trees.* Vlaminck gradually, though not consistently, began to dispense with broken Divisionist strokes and thickly impastoed handling for vertical Cézannist hatchings, and before long was checking the intensity of his color in the process. This soon meant a loss in power for his art. In the winter of 1906-07, however, when Vlaminck was finely balanced between vivid Fauve color and new structural concerns, he created one of the most astonishing of all Fauve paintings, *Flowers (Symphony in Colors;* p. 125).[80] Liberated from the horizontal format of landscape and from an evenly impastoed surface, Vlaminck entered, for a brief moment, an area of nearly abstract color composition, but only to abandon it the next year for a far more conservative version of Cézannism. Just as the flat Gauguinesque style of 1906 Fauvism had been a component of the original broken-touch Fauvism of 1905, indebted to Seurat and van Gogh, similarly the flat-color Fauvism of 1906 contained within itself the seeds of the Cézannist style that was to develop from 1907.

In 1906, however, the most important Fauve practitioner of that late manner was just beginning to come to terms with the style of 1905. Having seen the Fauves assembled at the 1906 Salon d'Automne, Braque painted two versions of the Canal Saint-Martin in Paris,[81] one of which showed abstract (and almost proto-Cubist) possibilities in the reflections in the water (p. 89). In October, Braque left Paris for L'Estaque, probably on Derain's suggestion. Like the previous Fauve visitors to the

Midi, he immediately heightened his palette. His paintings of the harbor at L'Estaque (p. 89 above right) exaggerate the abrupt rectangular blocks and horizontal forms first visible in the Antwerp harbor views of the summer, creating his more sturdily structured version of the Neo-Impressionist Fauvism the others had already explored. In color, however, they are no less exuberant than any other Fauve work. Braque's initiation to Fauvism produced what are perhaps his most uninhibited paintings, of a vigor and heatedness matched only by Vlaminck. When Braque turned to landscape, his forms became more curvilinear (p. 90). He continued his Neo-Impressionist-based Fauvism into the spring of 1907, thus lagging well over a year behind his colleagues. Even so, *The Little Bay at La Ciotat* (p. 89), which Braque painted in the spring, reveals a form of broken-touch Fauvism taken almost to the point of abstraction: with isolated blocks and spots of contrasting primary colors scattered across a resistant flat surface that has been opened out and organized by the drawing around its edges.

Braque exhibited his paintings of L'Estaque at the Indépendants of 1907 and, encouraged by their reception,[82] returned immediately to the south, to La Ciotat, where he was joined for the summer by Friesz. By then, Braque had put Divisionism behind him. At La Ciotat, the two friends created their own decorative Fauvist style, Braque keeping to the golden-toned base of the spring painting but simplifying the forms into soft undulating patterns, Friesz taking the curvilinear to the restless arabesques of Art Nouveau (pp. 91, 127) and occasionally combining it with Neo-Impressionist-derived forms (p. 92). Friesz's work that summer was flat in being calligraphic. The iridescent

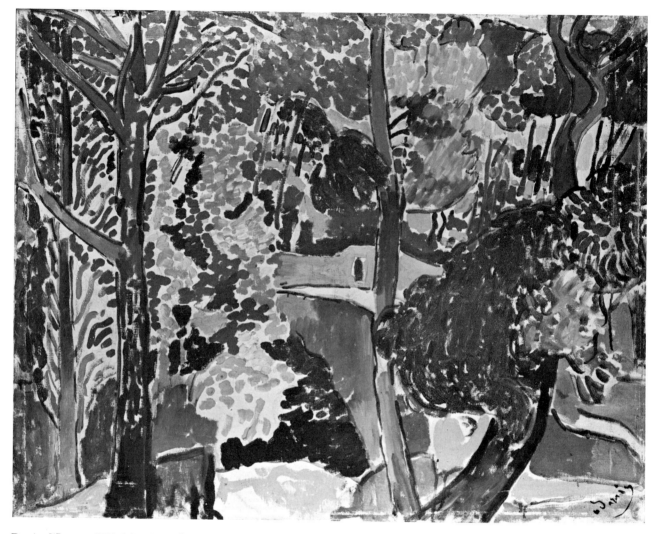

Derain: *L'Estaque.* 1906. Oil, 28½ x 36". Private collection

allover tonalities of Friesz's Antwerp paintings were now condensed and concentrated into a colored surface handwriting of excited flourishes. Braque's work was simply flat. That is to say, whereas Friesz's calligraphy lies over a space that finally demands reading as something recessive and concave, Braque's painting is constructed in height, not in depth. His *Landscape at La Ciotat* (p. 126) spreads up the canvas, keeping close to the surface at all times. What is more, the forms Braque used, though as curvilinear as those of Friesz, are far more uniform in effect. We see here the seeds of an allover pattern of stylized drawing and the beginning of an equalized distribution of lights and darks. Developed over the next year, Braque's interest in this

direction decisively terminated his short affiliation with Fauvism.

While Braque and Friesz were working at La Ciotat, Derain was at nearby Cassis, writing enviously to Vlaminck of his two happy colleagues and of the crisis that had beset his own art.[83] Compared with his vivid Gauguinesque paintings of the previous summer, the Cassis work is somber and restrained (p. 124). Large flat areas bounded by outlining remain in some paintings, but the color is naturalistic in origin, the shapes angular, the lines heavy and thick. The mood is far from the exuberance of his Fauve style. Indeed, Derain's Cassis landscapes are "post-Fauve" paintings. Early in 1907, he turned to figure painting. At the Indépendants that year he exhibited the *Dancer at the "Rat*

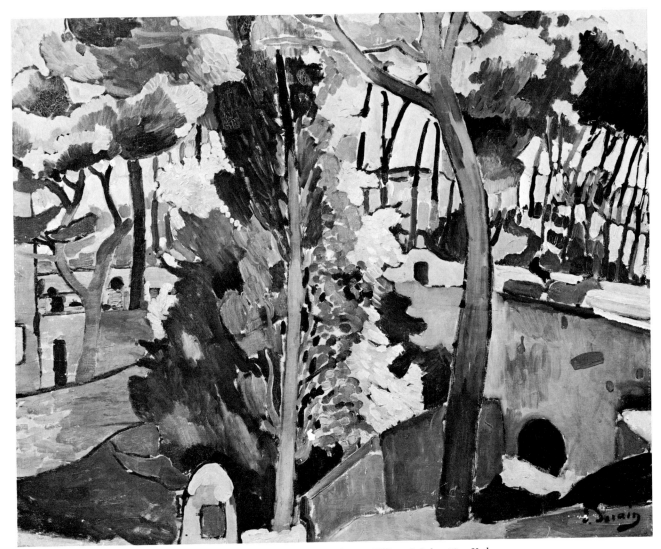

Derain: *Landscape at L'Estaque.* 1906. Oil, 32⅜ x 40". Collection Mr. and Mrs. William S. Paley, New York

Mort" painted in late 1906, the final masterpiece of his flat-color Fauve manner, and a large dramatic *Bathers* (p. 116) of early 1907, which still had some of the intense coloring of Fauvism but linked it to tonally modeled and angular forms derived from Cézanne. This was Derain's final act of rivalry with Matisse, whose *Blue Nude* (p. 117) appeared in the Indépendants as well.

By the time of this exhibition the Fauvism of Matisse and Derain was as good as over. By the 1907 Salon d'Automne it had ended for the others as well. The spate of figure compositions produced by the Fauves that year is as good a sign as any that the focus of their art had radically changed, turning away from landscape and from the joyful celebration of its light and color to

something more calculated, conceptual, and classically restrained. How this came about is the subject of the next chapter. It should be noted here, however, that Matisse's Fauve art, though joyful and celebratory like that of his companions, also contained these "post-Fauvist" characteristics from the very start.

Unlike his Fauvist colleagues, Matisse was not a painter of landscape to any major extent. "What interests me most," he declared in "Notes of a Painter," "is neither still life nor landscape but the human figure."[84] His 1904 paintings of Saint-Tropez prepared for the broken-touch, Neo-Impressionist-derived forms of Fauvist landscape painting. His Collioure landscapes of 1905 helped to initiate the mixed-technique form of

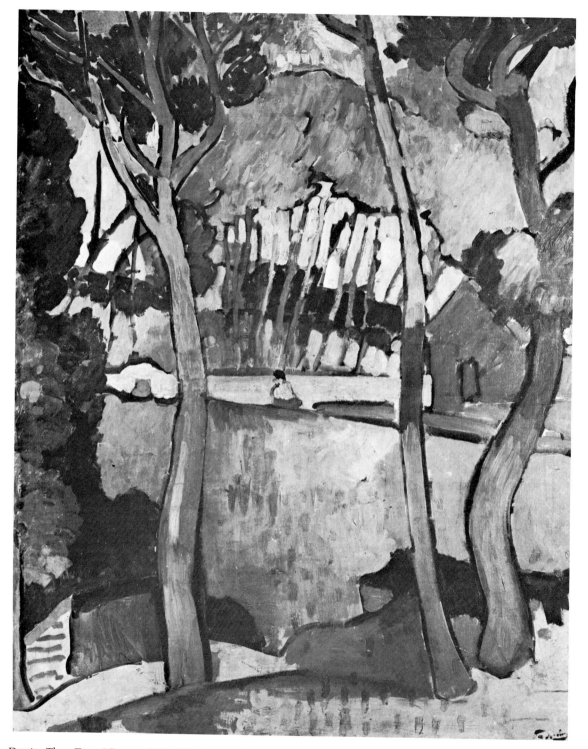

Derain: *Three Trees, L'Estaque*. 1906. Oil, 39½ x 31½". Art Gallery of Ontario, Toronto. Gift of Sam and Ayala Zacks, 1970

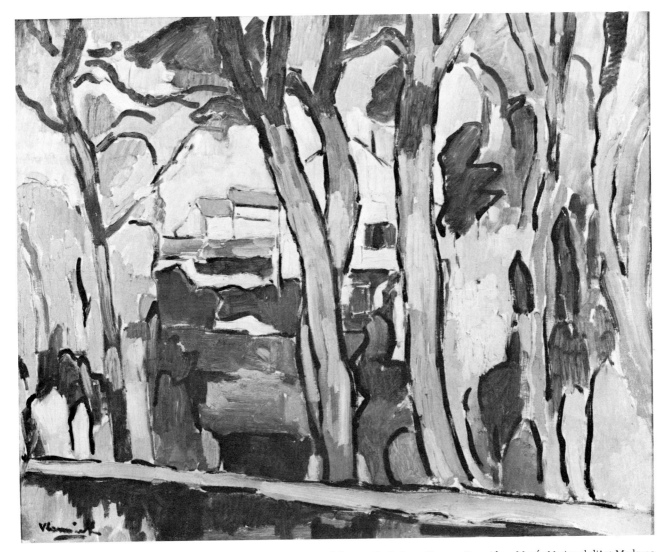

Vlaminck: *The Red Trees.* 1906-07. Oil, 25⅝ x 31⅞". Centre National d'Art et de Culture Georges Pompidou. Musée National d'Art Moderne, Paris

the Fauvist landscape. Even so, for Matisse himself both of these summers led to the production of large figure compositions: *Luxe, calme et volupté* and *Bonheur de vivre.* Although he did not come to concentrate on large figure paintings until Fauvism was over, his detachment from the bustling external world was already evident in his Fauvist art. In this sense—but in only this sense—he is marginal to the Fauvist movement, for its greatest achievement was the painting of landscape. The centrality of landscape to Fauvism shows its basic indebtedness to the *plein air* tradition of the Impressionists. The mood of the Fauvist landscape, its real *celebration* of landscape, of the delights of a colorful vacationers' world, is an intensified Impres-

sionist one—*intensified* because the sparkling, carefree, and somehow innocent picture of the world the Impressionists presented was transformed in Fauvism to something more excited, more dynamic, and also more knowing, stylistically more self-aware. This is not in any way to minimize the Impressionists' own consciousness of the physical properties of their medium but rather to acknowledge that though the Fauves located themselves in nature as fully as did the Impressionists, they did so with a new awareness that their very representation of nature might stand in competition with what it described. The spots, blocks, and lines and areas of color, which in Impressionist paintings can be viewed as autonomous pictorial components,

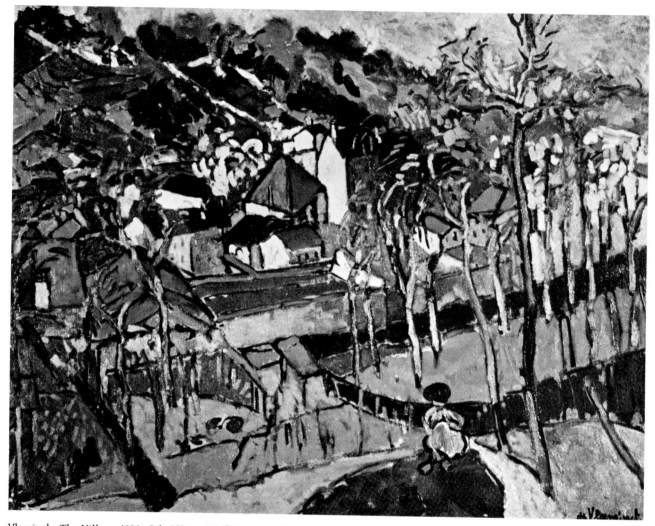

Vlaminck: *The Village.* 1906. Oil, 35½ x 46½″. Private collection

force themselves to be viewed thus in Fauvist ones to an alto-gether unprecedented degree. Hence, the new sensitivity to the styles and forms of representation that we see in Fauvism; hence, too, the rapidity of development through different styles and forms, as if the Fauves were testing the conventions of art and of representation at one and the same time. The artist, Matisse insisted in 1908, "must feel that he is copying nature—even when he consciously departs from nature...."[85] This consciousness in pictorial decisions and self-awareness with regard to feeling marks Fauvism as the first movement of twentieth-century art.

The attachment of Fauvism to nature is a link to the nineteenth century, but not in itself a decisive one, for twentieth-century art has continued to affirm its relationship to the natural world though not usually by representation per se. More important is the fact that the components of the Fauvist styles are nineteenth-century ones. All art, of course, can be described in terms of past styles, but Fauvism enforces this reading, and does so precisely because of its stylistic self-consciousness. We can see very clearly the various Post-Impressionist currents that the Fauves combined in a purified, simplified way. The color blocks, which for the Neo-Impressionists registered volumes, exist as scintillating surface patterns. The flat areas of Gauguin and van Gogh are combined for purely pictorial effect. "What prevents Gauguin from being situated among the Fauves," Matisse wrote, "is that he does not

(above) Braque: *L'Estaque.* 1906. Oil, 19¾ x 23⅝". Centre National d'Art et de Culture Georges Pompidou. Musée National d'Art Moderne, Paris

(above left) Braque: *Canal Saint-Martin, Paris.* 1906. Oil, 20 x 24¼". Collection Mr. and Mrs. Norbert Schimmel, New York

(left) Braque: *The Little Bay at La Ciotat.* 1907. Oil, 14¼ x 18⅞". Centre National d'Art et de Culture Georges Pompidou. Musée National d'Art Moderne, Paris

construct space by color, which he uses as an expression of feeling."[86] Fauvism found justification enough in "the purity of the means."

If Fauvism at its best never subordinated its pictorial means, it was often less subtle in feeling than the Post-Impressionist currents it used. Its self-consciousness could mean a loss in emotional or psychological power, or at least that its emotion could not indefinitely be extended. Perhaps it was for this reason that Matisse sought out the inherently emotive subject matter of figure painting, and that many of the Fauves eventually followed him, as if the pictorial purity they had discovered came to demand a subject matter equally ideal. Fauvism

may be understood as an attempt to extend and surpass Impressionism coloristically, without falling into the literary and theoretical forms of Post-Impressionist colorism, that is to say, of late nineteenth-century Symbolism. Hence, the Fauves' first affiliation was with Neo-Impressionism, because that style most purely used high color in an Impressionist context. Yet the Neo-Impressionists were no more immune to emotive subjects than were the Nabis. The Fauves, too, were affected by the Symbolist and the literary. Beside the "pure" Fauvist landscapes—small-scale works in the Impressionist mold—ran another Fauvist tradition, dedicated not to the celebration of the contemporary world, but to the pastoral, the primitive, and the ideal.

Braque: *The Great Trees, L'Estaque.* 1906-07. Oil, 32⅝ x 28". The Museum of Modern Art, New York. Promised Gift of Mr. and Mrs. David Rockefeller

Friesz: *Landscape at La Ciotat.* 1907. Oil, 13 x 16⅛″. Private collection, Switzerland

Friesz: *Fauve Landscape with Trees.* 1907. Oil, 12⅝ x 16″. Private collection, Switzerland

Dufy: *Old Houses at Honfleur.* 1906. Oil, 23⅝ x 28¾." Private collection, Switzerland

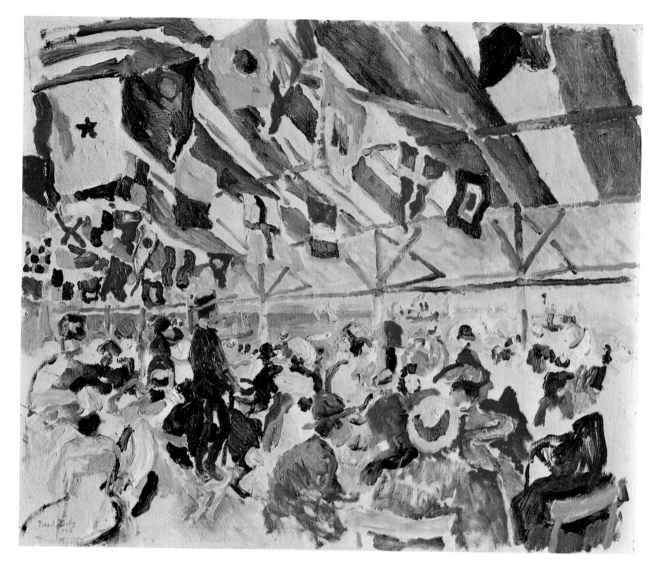

Dufy: *Fête nautique.* 1906. Oil, 23¾ x 28¾." Galerie Beyeler, Basel

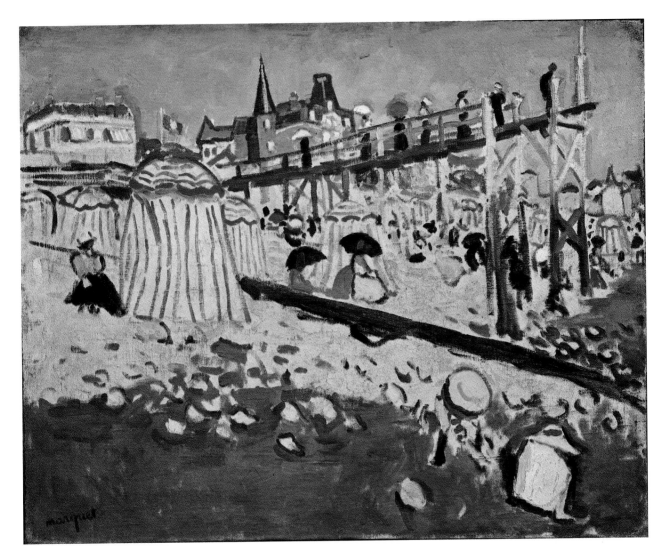

Marquet: *The Beach at Sainte-Adresse.* 1906. Oil, 25¼ x 31⅛." Collection Boris Fize, Paris.

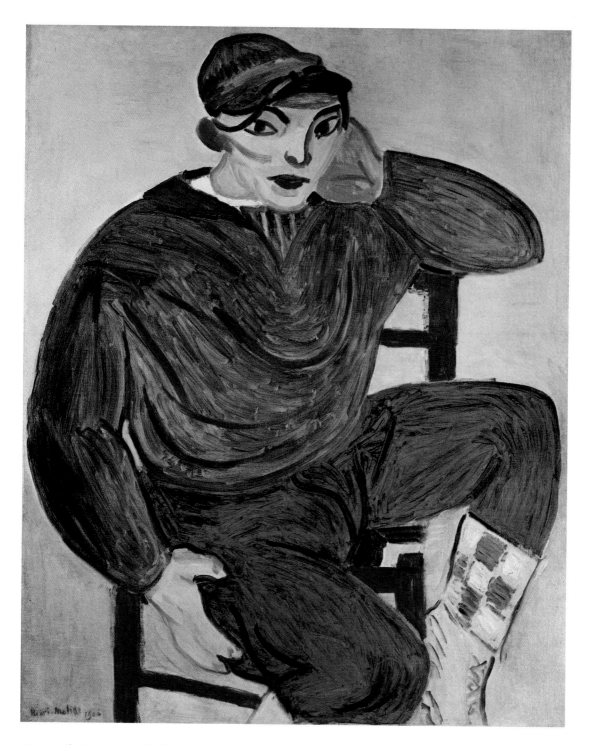

Matisse: *The Young Sailor, II.* 1906-07. Oil, 39⅜ x 31⅞." Collection Mr. and Mrs. Jacques Gelman, Mexico City

The Pastoral, the Primitive, and the Ideal

The world presented in the Fauvist landscape is a contemporary one. Be it Collioure or Chatou, La Ciotat or London, it is a world either of bustling activity or of a vividly remembered holiday. It is an immediate world, a picture of life that exactly matches the immediacy of its depiction. Beside this, however, runs a parallel current, which seems at first sight to repudiate the other, for far from celebrating the present it looks nostalgically toward the past, dreaming of the happiness of a far-off Golden Age. This is the world of Matisse's *Luxe, calme et volupté* and *Bonheur de vivre*, of Derain's *L'Age d'or*, and of similar Fauve paintings, where a vivid present is replaced by the timeless and the ideal. These are not totally contradictory and separate worlds, which is not merely to say that both the topicality of the Impressionists and the idealism of the Symbolists were equally available to the Fauves. For some of the Fauves their pursuit of immediacy was matched by a desire to render it permanent, to create in the Fauve landscape itself the setting of a Golden Age.

The first important representation of this alternative Fauve world was *Luxe, calme et volupté* of 1904-05. The last was the series of Bathers made by the Fauves in 1907 and 1908. Of the latter, Matisse's (most notably *Le Luxe*) extended and consolidated the original impulse, whereas those made by the other Fauves sought permanency not in the realm of the idyllic but in that of the monumental. We have, on the one hand, the beginning of a grand decorative tradition developed from Fauvism, and on the other a repudiation of Fauvism for the Cézannist and in some cases the Cubist. How Cézannism and proto-Cubism affected Fauvism in its final period will be important here. It should not be supposed, though, that it is with purely external stimuli that we are concerned, for the parting of the ways in 1907 and 1908 developed from a common source. Both ways were broadly classical ones. What we are dealing with is the metamorphosis of an original Neo-Symbolist current into a Neo-Classical one, and with the catalyst that helped to provoke that change, namely, the discovery of primitive art.

In Gauguin's manuscript transcription of *Noa-Noa*, he doubly underlined a phrase used by his friend and collaborator, Charles Morice: *Le Rêve du bonheur.*[1] Matisse was similarly attracted to apposite phrases: *Luxe, calme et volupté* and *Bonheur de vivre*. *Bonheur de vivre* signifies something different from *Joie de vivre*[2] The latter is a vitalist Fauve title, suggesting the gaiety and exuberance we saw in the landscapes discussed in the previous chapter. The "happiness of living," by contrast, points to a more stable form of contentment, of well-being and calm. *Luxe,*

calme et volupté is derived from Baudelaire's thrice-repeated couplet in *L'Invitation au voyage:*

> *Là, tout n'est qu'ordre et beauté,*
> *Luxe, calme et volupté.*

This is certainly very far from "the wild beasts." Order, not excitement, is linked to beauty. The image is of a still, serene, sensuous world, dedicated to luxury and pleasure. The picture bearing this title (p. 25) is not yet totally removed from the contemporary world. It is a *déjeuner sur la plage*, of female bathers picnicking on the beach at Saint-Tropez. It is also an idealization of this subject. The insistent abstract rhythms and frozen units of color impose a mood of stillness upon the work. To achieve this effect, Matisse drew upon previous Neo-Impressionist compositions, both the major paintings of Seurat, which settled even strenuous images into a classical silence, and the landscapes with figures by Signac (p. 99) and Cross, Matisse's companions when he painted this work. Cross often included bathers and occasionally more idealized nymphs in his Côte d'Azur landscapes;[3] Matisse also drew upon other traditions: Cézanne's Bathers;[4] Puvis de Chavannes's untroubled landscapes with figures (p. 99);[5] and the paintings of nymphs and bathers that filled both progressive and academic salons[6]

In *Bonheur de vivre* (p. 100), the theme was both extended and changed. Now, curvilinear rhythms overlay diagonal ones. There are no topical references, though there are more allusions to contemporary and past art: to the Arcadian pastorals and bacchanals of the classical tradition, from Bellini and Giorgione to Poussin and Ingres;[7] and to more recent versions of the same theme, most notably by Maurice Denis (p. 101) and his friends[8] and also by some of Matisse's[9] The sources are various. If *Luxe, calme et volupté* evokes paintings of the island of Cythera, the *Bonheur* looks particularly to Rococo *fêtes champêtres*, and to Ingres's classicized version of this theme in his *L'Age d'or* (p. 101). Ingres's "display of sensuous indolence, tinged with nostalgia for a lost classical world of erotic freedom,"[10] must certainly have affected Matisse's work. We see the presence of Ingres not only in various details, including the pair of foreground lovers derived from *L'Age d'or*, but in the overall sensuous outlining and enclosed embryonic forms. Matisse later went to see Manet's *Olympia* when it was hung beside Ingres's *Odalisque* in the Louvre. He preferred the older work, because "the sensual and willfully determined line of Ingres seemed to conform more to the needs of painting."[11] One must suppose that he meant more than the arabesque per se. The Manet and Ingres paintings

Matisse: Study for *Luxe, calme et volupté.* 1904. Oil, 12¾ x 16″. Collection Mr. and Mrs. John Hay Whitney, New York

represent essentially different types of women, and different artistic ideals: one, the exposed harlot that belongs—like the artist, as Baudelaire insisted—to the harsh external world; the other, something more protected and idealized.

When Matisse returned to the idealization of Ingres, it was not to rehabilitate the figures in the trappings of the *haute bourgeoisie* but to return them to their Arcadian source. Through the latter part of the nineteenth century, Ingres's classical theme had been extended mainly within the conservative limits of salon art, and there in vulgarized forms. The moderns, in contrast, had

secularized it, to produce paintings such as Manet's *Déjeuner sur l'herbe,* Seurat's *Sunday Afternoon on the Island of La Grande Jatte,* and Renoir's series of Bathers. Matisse, however, removed the nymphs from their modernist *embourgeoisement,* returning them to a setting that was more ideal. *Luxe, calme et volupté* combines topical and idealized references: contemporary details are balanced against the Arcadian mood and poetic title. In the *Bonheur de vivre,* the withdrawal from secular iconography is complete. There is also an important thematic change in this second painting: the dance amid the calm, and the

musicians who permit it. Music permits dance, but demands attentive calm. This representation of an ideal world was also a symbol of Matisse's art. We see both the dancers who celebrate the *bonheur de vivre*, concentrating the energy of Fauvism into a circle of dance within a Fauvist setting, and those who restfully enjoy it, in the same contemplative repose that Matisse felt his own art, like music, demanded. This is the nearest thing to a manifesto that Matisse provided: art itself is both symbol and creator of the *bonheur de vivre.*

The relation to music was emphasized in the "Notes of a Painter," and linked to a special relationship to nature:

I cannot copy nature in a servile way. I must interpret nature and submit it to the spirit of the picture. From the relationship I have found in all the tones there must result a living harmony of colors, a harmony analogous to that of a musical composition.[12]

Both the submission of nature to art and the musical analogy itself link Matisse's ideals to those of the Symbolists. Although the "Notes" were not written until 1908, Matisse's turn to Baudelaire for the title of *Luxe, calme et volupté* shows that he was looking to that current much earlier. The *Bonheur,* of course, derives from Gauguin as well as from Ingres. Matisse was certainly aware of Gauguin's paintings and theories, and was influenced by them, as were the other Fauves. When the Symbolists left the realist modern world to evoke the atmosphere of an earlier Golden Age, they went beyond the confines of a simply classical past to learn from exotic and primitive cultures as well. Matisse was beginning to do the same. His turn away from nature to something more abstract was mediated by a turn to the popular theme of the Golden Age as it existed in both the classical and Symbolist traditions. Nature or imagination—not nature or abstraction—was the choice he initially faced. It was the move to imaginary subjects that liberated him from a close dependence upon nature and prepared for the increasing abstractness that followed.

For Signac, we remember, the *Bonheur de vivre* was reminiscent of *cloisonnisme* and of the work of the Nabi Paul Ranson. If we look at contemporaneous work by Ranson, we can find generally similar subjects; Ranson's earlier work had similar heavy outlining.[13] The *Bonheur,* however, cannot simply be considered a late Symbolist painting. The style and subject matter of Ranson and his associates belong as firmly to the hothouse atmosphere of the *fin de siècle* as Matisse's use of them repudiates the cloying abundance of that period. Insofar as it is Symbolist, the *Bonheur* belongs to the revised Symbolism that was being created in the early years of the twentieth century. The Fauves were in contact with contemporary Neo-Symbolist circles, notably those associated with the journals *Vers et Prose* and *La Phalange*.[14] The writers in these circles sought, in a way not too dissimilar to Matisse, a revitalization of the old Symbolist forms and theories, a

(top) Signac: *Au temps d'harmonie*. 1893–95. Oil. Mairie de Montreuil

(above) Puvis de Chavannes: *Pleasant Land*. 1882. Oil, 10⅛ x 18⅝". Yale University Art Gallery, New Haven. The Mary Gertrude Abbey Fund

repudiation of its doctrinal basis for a new open eclecticism, which looked both to pure Symbolism and to the classical, or Neo-Classical, as well. Like them, Matisse was "afraid of [Symbolist] doctrines like catch-words."[15] This was a common point of view. In 1904, Gide said that Symbolism itself should be seen as a classicizing impulse.[16] In 1906, Apollinaire found Racine, Baudelaire, and Rimbaud equally important to him.[17] At a banquet organized by *La Phalange* in 1908, which Matisse and Derain attended, the editor of the journal, Jean Royère, proclaimed that Mallarmé represented the classicism of the present.[18] All this suggests that while Symbolism was still a continuing force in the first decade of the twentieth century, it was not simply the traditional, theoretical Symbolism of *correspondances* and *ressemblances,* but something more pragmatic and open, espe-

Matisse: *Bonheur de vivre*. 1905-06. Oil, 68½ x 93¾". The Barnes Foundation, Merion, Pennsylvania

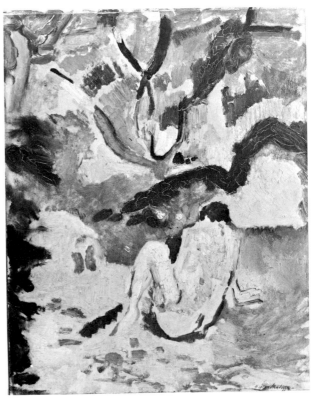

(above) Matisse: *Nude in a Wood.* 1906. Oil on panel, 16 x 12⅞". The Brooklyn Museum. Gift of Mr. George F. Of

(top left) Denis: *Danse d'Alceste (Paysage de Tivoli).* 1904. Whereabouts unknown

(center left) Ingres: *L'Age d'or* (detail). 1862. Oil on paper mounted on panel, 18⅞ x 24¾". Fogg Art Museum, Harvard University, Cambridge, Massachusetts. Bequest of Grenville L. Winthrop

(left) Goya: *Blindman's Buff.* 1789. Oil, 8'9⅞" x 11'5¾". Museo del Prado, Madrid

(opposite, bottom left) Matisse: *Landscape* (Study for *Bonheur de vivre*). 1905. Oil, 16½ x 21¾". Private collection

(opposite, bottom right) Cross: *The Farm, Morning.* 1892-93. Oil, 25½ x 36⅛". Private collection, France

cially toward the new classical impulse that was affecting the art of the period. Whereas in 1890 Maurice Denis sought to isolate the Symbolist aesthetic from Impressionism, Neo-Impressionism, and academicism in the *Définition du néo-traditionnisme*,[19] by the turn of the century he was writing of "the French tradition," which he saw as a classical one, in the line of "le grand Poussin" and was on the lookout for anything that seemed to extend it.[20] This was to predispose him to the late work of the Fauves, to the Cézannist works of Braque, and to the far more available classicism that Friesz developed in 1907-08. As for true Fauve art—indeed, for most contemporary art—it was either anarchic or theoretical. Classicism meant equilibrium, particularly between nature and durable beauty. Cézanne's resurrection as a classicist in 1907 was justified in these terms. To Denis, Matisse seemed to have left nature behind. *Luxe, calme et volupté* was "le schéma d'une théorie."[21]

Matisse's annoyance at Denis's criticism[22] was not merely due to his having suffered a lengthy reproach from the major contemporary critic. It was also because Denis had misunderstood a picture that was created from a point of view not far from his own, for Matisse, too, was seeking a form of classicism that had its origins in nature and one that was durable and stable in its own way. Like Denis, he was developing his classicism from Symbolist sources, by looking to the classicism that lay behind Symbolism itself, namely to the work of Puvis de Chavannes. "Puvis de Chavannes," said Gauguin, "is a Greek, I am a savage."[23] Matisse was neither, but he looked to both. At first sight, Puvis's bleached compositions seem to belong to an opposite tradition to Matisse's highly colorful ones. We must remember, however, that Puvis had been the principal torchbearer of the classical tradition in the late nineteenth century, the principal exponent of a calm and idealized art. He had exerted enormous influence upon younger artists and had, moreover, nominated Matisse to membership of the Société Nationale in 1896. Matisse was certainly very familiar with his work. Faced with the problem of making large decorative figure compositions, Matisse would naturally turn to the great painter of decorations, who had been honored by a retrospective exhibition in the Salon d'Automne of 1904. Both *Luxe, calme et volupté* and the *Bonheur de vivre* look back to paintings by Puvis,[24] while both develop from the spontaneity of the Fauve approach to something planned and deliberated in effect. The *Bonheur* itself was apparently created, after Puvis's traditional fashion, from a full-sized cartoon.[25] Matisse continued to use this method, notably in the tempera version of *Le Luxe* (p. 135), which is itself clearly indebted to Puvis in composition.[26]

Even within such a deliberated method, however, Matisse managed to hold onto the spontaneity of drawing Puvis lacked, whereas the coloristic freedom of his work is something essentially post-classicist. This freedom from naturalistic color was prepared for by Symbolism, from which Matisse took a revised form of the notion of *correspondances* between colors and specific emotions (*e.g.*, "the icy clearness of the sour blue sky will express the season [of autumn] just as well as the tonalities of leaves")[27] and the general idea that the artist does not merely reproduce the outside world but creates an emotive structure that is analogous to it. "To copy the objects in a still life is nothing," he told his students; "one must render the emotions they awaken in him."[28] "You are representing the model, or any other subject, not copying it," he said, "and there can be no color relations between it and your picture; it is the relation between the colors in your picture which are the equivalents of the relation between the colors in your model that must be considered." The world of the picture, Matisse insisted, should always be kept in contact with that of the outside world, but through the emotions it evokes: "I am unable to distinguish between the feeling I have for life and my way of expressing it."[29] Writing in 1901 about his Marquesan landscape, Gauguin had stated: "Here, poetry creates itself and in order to suggest it in a painting, it is enough to let one's self go in a dream."[30] Significantly, when Matisse referred to the art of balance, purity, and serenity he desired, it was as something of which he dreamed.

The typically Fauve notion of the contrast of colors producing light was also prefigured by Gauguin and the Symbolists, and Derain's revelation in this regard at Collioure may have been the direct result of his conversations about Gauguin with de Monfreid that summer.[31] Derain's so-called *L'Age d'or* (opposite)[32] has been ascribed to the Collioure period, and cited as evidence of his interests in classical themes, paralleling those of Matisse. Derain wrote to Vlaminck from Collioure of a large, complicated, and very different kind of picture that he was making.[33] It may well be to *L'Age d'or* he was referring. If this is so, then Derain's picture probably motivated Matisse's preliminary work on the *Bonheur de vivre*. There are, however, certain anomalies, both stylistic and iconographic, that make it difficult to date *L'Age d'or*. It has been dated as early as 1903.[34] This is certainly too soon. The very blatant Neo-Impressionism of the work, however, is of a kind that Derain seems generally to have overcome by the summer of 1905, while the angularity of the contours and harsh frenetic forms seem out of keeping with other Collioure work. Since the character of drawing varies from section to section, it seems likely that the painting was worked on over a considerable period of time. The dance and bather themes it combines were important ones to Derain, evoking similarly ambitious compositions in 1906 and 1907. The format of *L'Age d'or*, however, derives from sketchbook studies made by Derain after Rubens's series depicting the life of Marie de' Medici and Delacroix's *Massacres at Chios* in the Louvre (p. 104), from which he took the contrast of silhouetted and smaller figures.[35] "Delacroix especially deserves attention and understanding," Derain wrote in 1903. "He has opened the door to our era."[36]

102

Derain: *Composition (L'Age d'or)*. 1905. Oil, 69½ x 74½". The Museum of Modern Art, Tehran

Derain: Study after Rubens's *Reconciliation of Louis and Marie.* ca. 1904. Conté crayon(?) on paper, 11¾ x 7⅞". Centre National d'Art et de Culture Georges Pompidou. Musée National d'Art Moderne, Paris

Derain: Study after Delacroix's *Massacres at Chios.* ca. 1904. Conté crayon(?) on paper, 11¾ x 7⅞". Centre National d'Art et de Culture Georges Pompidou. Musée National d'Art Moderne, Paris

After the Bath (p. 105) is also undoubtedly a study for *L'Age d'or,* predicting the three major figures. The contrast of flat dark-toned foreground and more spacious background in this work relates it to *The Bridge at Le Pecq* of 1904-05 (p. 38), even to the jagged contour dividing the two zones. *After the Bath* probably belongs to the same period. It seems likely, however, that the immediate impetus for *L'Age d'or* came from Matisse's Neo-Impressionist figure composition *Luxe, calme et volupté,* which it resembles in technique. What is more, the essentially diagonal foreground orientation, though prefigured in *The Bridge at Le Pecq,* is also strongly reminiscent of Matisse's painting. This suggests, then, that *L'Age d'or* was begun late in 1904 or early in 1905, certainly not much later than the spring of 1905, when

Luxe, calme et volupté was exhibited at the Indépendants. It may have been completed at Collioure or, more likely, back in Paris the following autumn.[37] In Derain's sketchbook there is a study (p. 107) that explores dance imagery similar to that appearing in the background of *L'Age d'or.* It is far more fluid in treatment than the other studies mentioned above and probably looks to Ingres for inspiration. This undoubtedly later study, however, cannot be securely related to *L'Age d'or* and may well belong to Derain's second large figure composition, *The Dance* (p. 115). Nevertheless, Derain does seem to have looked at Ingres's work while painting *L'Age d'or,* though probably toward the end of its execution. The left-hand dancer and reclining nude at the right in the painting appear to be

derived from Ingres's *Turkish Bath* (right), which was exhibited at the Salon d'Automne of 1905. Derain was a confirmed museum-goer who at one time visited the Louvre every day. When he attempted large figure compositions, it was only natural for him to turn to historical prototypes.

Painted between the autumn of 1904 and 1905, *L'Age d'or* should be viewed not only as deriving from Matisse's first important figure composition, *Luxe, calme et volupté*, but also as influencing the second, the *Bonheur de vivre*. The enclosed setting of the *Bonheur de vivre* is closer to *L'Age d'or* than to the open landscape of *Luxe, calme et volupté*. Likewise, in the Derain the pair of figures on each side of the left-hand tree, the reclining figure to the right, and the central dance motif were also repeated in different forms in Matisse's painting. The contrast of dancing and reclining figures is basic to Matisse's work. Despite all these connections, however, the harsh primitivism of the Derain could hardly be further from the ideal forms of the Matisse. *L'Age d'or* is a posthumous title. Far from positing a classical Golden Age, Derain gives us the *joie* not the *bonheur de vivre*. If painted at Collioure, it is more *fauve*, more wild, in its conception than any of the landscapes he made there. By contrast, Matisse was at his most *fauve* when painting from nature and from the model, finding calm in the works of his imagination.

The Dance (p. 115), Derain's second major figure composition, is even more difficult to place. Presumably, it either follows *L'Age d'or*, representing as eccentric a reaction to Gauguin's frieze-like Tahitian landscapes as the earlier picture was to Neo-Impressionist landscapes with figures, in which case it was begun in the late summer of 1905 and completed in Paris that winter; or, more likely, it belongs with the Gauguinesque L'Estaque landscapes of a year later. If this is so, it was Derain's last attempt to find new scope in Fauvism before he went on to Cézannist figure compositions in early 1907. In either case, *The Dance* represents Derain's turn from Neo-Impressionism to Symbolism, and replaces the primitivized classicism of *L'Age d'or* with images and forms more exotically primitive in origin. It was once given the title *Fresque Hindoue*.[38] Although this exaggerates its Eastern connections, it is most usefully viewed in the context of the Fauves' interest in non-Western cultures.

Non-European art has long been a source of inspiration for Western painters. Within the modern era, the Impressionists and Post-Impressionists were significantly affected by their knowledge of Japanese woodblock prints. The Fauves, too, looked to this source for pictorial ideas. Derain, we remember, was noted for his *japonisme* at the Indépendants of 1905.[39] The Fauves' first broad knowledge of more exotic cultures, however, came from Gauguin, whose work was significantly affected by Egyptian painting and Indian and primitive sculpture. Gauguin's "primitivism" was evident in the idols and totems he depicted in some of the Tahitian landscapes. The stylized figures beside the idols

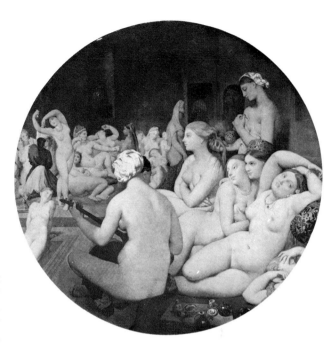

(top) Ingres: *The Turkish Bath*. 1862–63. Oil, 42½" diameter. Musée du Louvre, Paris

(above) Derain: *After the Bath*. 1904. Oil. Whereabouts unknown

Derain: *Bacchic Dance.* 1906. Watercolor and pencil, 19½ x 25½″. The Museum of Modern Art, New York. Gift of Abby Aldrich Rockefeller

were also indebted to exotic sources, as were his carved sculptures and those of his disciples[40] Derain's *Dance* is reminiscent of some of the more frieze-like of Gauguin's Tahitian paintings, particularly of sections of *Faa Iheihe* (p. 108) and similar works; the serpent, of course, is a familiar Gauguin motif.

At L'Estaque in the summer of 1906, Derain was clearly affected by Gauguin's work, as is demonstrated in the panoramic *Turning Road* (p. 114), the summation of that summer's work. Whereas the paintings that preceded it (pp. 84-86) bring to a climax Derain's sheer celebration of landscape in vivid color, *The Turning Road* itself is clearly a subject composition, despite the smallness of the figures. Although the landscape is the main subject, it is also a dramatic setting for narrative figure juxtapositions of a

kind that Derain was to develop in *The Dance.* We can even discover the prototype for the seated figure of *The Dance* in the L'Estaque painting.

There are other likely sources for *The Dance* that deserve mention. A watercolor *Bacchic Dance* (above), securely dated to 1906,[41] was probably an early layout of this subject, as was the drawing of dancers (p. 107) mentioned in connection with *L'Age d'or.* Derain's contemporary woodcarvings (p. 107) and woodcuts are stylistically similar to *The Dance*.[42] The figure types themselves in the painting are reminiscent of the Indian stone reliefs that impressed Gauguin, and of Romanesque sculptures and frescoes in churches of the south of France[43] They also recall Bakst's designs for the Russian Ballet exhibited at the Salon

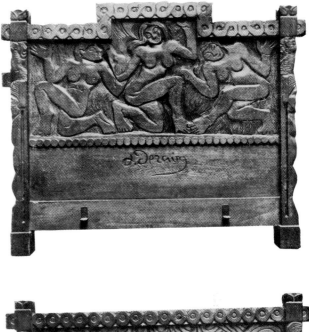

Derain: Study for *The Dance*. 1906. Conté crayon(?) on paper, 11¾ x 7⅞". Centre National d'Art et de Culture Georges Pompidou. Musée National d'Art Moderne, Paris

Derain: Carved panels for bed. ca. 1906-07. Wood. Whereabouts unknown

d'Automne of 1906. These facts further tend to confirm that *The Dance* was painted late in 1906. But despite these exotic sources, Derain was still looking to the Louvre for inspiration. The right-hand figure is modeled directly after the black servant in Delacroix's *Women of Algiers* (p. 108).[44]

By the autumn of 1906, then, Derain had turned away from the elegance and lyricism of his London and early L'Estaque paintings, away from their carefully adjusted and decorative palette to a new concept of the decorative, one that admitted the primitive and the emotive in quite a new way. In retrospect, one wonders whether Derain's ambitions were not always basically attuned to an imaginary, expressive, even expressionist kind of painting, rather than to the relaxed and hedonistic form

he developed under Matisse's influence and then began to question when he worked alone in 1906. His obsession with the monumental art of the past would seem to suggest so. So, too, would the direction of his painting from 1907. Even in the spring of 1906 he had recorded his dissatisfaction with the fugitive, ephemeral side of modern painting, wanting instead something "fixed, eternal and complex."[45] His specific concern, which showed itself from the very beginning of his painting career, was whether to make paintings that "belong to our own period" or ones that "belong to all time."[46] Unlike Matisse, who recognized the same dilemma but sought a modern *and* durable art, Derain seems to have thought these to be mutually exclusive possibilities. By the summer of 1906, nature and imagination

(top) Gauguin: *Faa Iheihe*. 1898. Oil, 21¼ x 66½". The Trustees of The Tate Gallery, London

(above) Delacroix: *Women of Algiers*. 1834. Oil, 70⅞ x 90⅛." Musée du Louvre, Paris

(right) Matisse: *The Dance*. 1907. Wood, 17⅜" high. Musée Matisse, Nice

appeared to him to be irreconcilable. "To sum up," he wrote to Vlaminck, "I see myself in the future painting compositions, because when I work from nature, I am the slave of such stupid things that my emotions are on the rebound...."[47] "The grouping of forms in light," he continued, was to be his new concern. Form and mass rather than color provided the logic for his later work.

Like Derain, Matisse turned to Gauguin's interpretation of the primitive to extend his dance theme. His unique woodcarving (above right), formed of low-relief dancing figures around a cylinder, is remarkably close in conception to works by Gauguin, which Matisse could have seen in the de Monfreid collection or at the 1906 Salon d'Automne.[48] As for the dancers themselves, however, they bear only limited comparison with Gauguin's overtly primitivized style and are, despite their unusual vigor, essentially descendants of those in the *Bonheur de vivre*. Both Matisse and Derain partook of a decorative primitivism derived

from Gauguin. Their concepts of decoration were, nevertheless, very different. Derain's highlighted the self-expressive and at times self-indulgent side of his art. His turn away from direct contact with nature brought on an indecisiveness in 1906-07. By contrast, Matisse had been if not indecisive then inconsistent throughout the principal Fauve years, and his turn to the decorative consolidated his art. We see in another of Matisse's 1907 dance images, a ceramic vase (p. 109), an extension of the *Bonheur de vivre*.

Matisse's interest in ceramics, an interest he shared with the other Fauves, may also have been stimulated by Gauguin, whose Pont-Aven ceramics were exhibited in 1905 and those made in Brittany in 1906.[49] The Fauves, however, collected the native pottery of Provence, while Matisse included North African ceramics in his still life *Pink Onions*, of 1906. Vollard had been exhibiting Gauguin's ceramics, and in 1906 he encouraged the ceramicist André Metthey to let the Fauves use his workshop.[50]

108

Matisse: Vase. ca. 1907. Ceramic, 9¼" high. Private collection

The results of this collaboration, shown at the Indépendants and Salon d'Automne of 1907, attracted considerable attention, Vauxcelles talking of a revival of popular art[51] Of those who made ceramics—Matisse, Derain, Rouault, Puy, Valtat, van Dongen, and Vlaminck—many adopted forms from their own paintings. Derain's designs show the most concern for creating images specifically appropriate to the new medium. Vlaminck's work is the nearest to true popular art. Well before the Fauve period, Vlaminck had been interested in popular and folk art. He collected the *images d'Epinal*, was fascinated by the paintings of untutored local villagers, by the art of children, by the carved puppets at country fairs. These, he said later, prepared him to appreciate African art[52] Whereas the majority of the "primitive" sources the Fauves used had been used also by artists of the preceding generation, African carvings had not. This new "discovery" of the primitive is therefore of special importance; and not least because the Fauves' very receptiveness

to it demonstrates that Fauvism itself was fast coming to an end.

As with much else in Fauvism, the specific details of the discovery of African sculpture are not clear[53] Vlaminck claimed that he saw two or three (his accounts vary)[54] African sculptures in 1905 at a bistro in Argenteuil, and that a friend of his father's gave him two Ivory Coast carvings together with a large mask (p. 119), which Derain insisted upon purchasing from him. According to Vlaminck, when Derain showed it to Matisse and Picasso, they, too, were impressed and began to collect primitive art[55] That Vlaminck was probably the first of the Fauves to own African sculpture is very likely, given his longstanding interest in the eccentric and unusual. Derain had equally longstanding interests, however, in visiting museums, including the Musée du Trocadéro. Vlaminck's account of the discovery mentions his and Derain's familiarity with this collection[56] It was probably Derain who first took Vlaminck (ever the unwilling museum visitor) to see the collection, and who transformed his appreciation of the work there from the level of curiosity in "barbaric fetishes" expressive of an *"art instinctif"* to an understanding of their formally expressive significance[57]

It is often said that the Fauves' only interest in primitive art was for its emotional, "barbaric" connotations (which certainly conforms to the legend of wild beasts), whereas the Cubists first appreciated its formal qualities[58] Picasso himself, however, confirms that he "went for the first time, at Derain's urging, to the Trocadéro Museum. . . . It depressed me so much I wanted to get out fast, but I stayed and studied."[59] Derain's correspondence affirms that he was impressed by the formal qualities of the works he saw in ethnographic collections[60] Matisse, too, viewed them in these terms, and helped the other Fauves do likewise[61] "Since Matisse pointed out their 'volumes' all the Fauves have been ransacking the curio shops for negro art," wrote Gelett Burgess, after interviewing several of Matisse's colleagues in 1908[62] Derain's admiration of primitive art dated at the very latest from the spring of 1906, for he wrote enthusiastically of his discoveries in London at that time[63] Although he was then painting far from primitivist pictures, this seems to suggest that the latent primitivism of *L'Age d'or*—probably completed in the autumn preceding this visit—remained with him through this "nonprimitive" period, to reappear in *The Dance* the following autumn, where it was reinforced by the new Gauguinesque style that had begun to emerge in London. That is to say, Derain's particular interpretation of the primitive was largely dependent upon the character of his developing art. Even in late 1907 Derain, though full of admiration for African sculpture, was unable fully to use its lessons in his work. There is only a hint of African art in *The Dance*, in the face of the left-hand figure, though the whole work could not have been created without an awareness of the expressive power of the primitive.

In 1908, Burgess interviewed Derain and found what he

thought were African forms in his recent sculptures: "Notice his African carvings, horrid little black gods and goddesses with conical breast, deformed, hideous. Then, at Dérain's [sic] imitations of them in wood and plaster. Here's the cubical man himself, compressed into geometric proportions, his head between his legs."[64] The photograph of Derain in his studio that Burgess reproduced (right) shows this "cubical man," the *Crouching Man*, and resting on it, the *Standing Figure* (p. 111)[65] Behind Derain is also plainly visibly a reproduction of Cézanne's *Five Bathers* (below)[66] It was the new interest in Cézanne, brought out by the 1907 exhibitions following his death, that showed to the Fauves a way of using African sculpture in their work—once their paintings began to show the influence of Cézanne. The first wave of Fauvist primitivism was motivated by Gauguin; the second belongs to what is usually described as "Cézannism."

Before considering the impact of Cézanne in 1907, and the way his art helped to bring the primitivism of the Fauves to a climax, we will recapitulate the developments that could be seen in the Indépendants of 1907, which was the last Fauve exhibition before the apotheosis of Cézanne that year fully began.

The Indépendants of 1907 marked both the high point of Fauvism and the moment when it began to disintegrate. It was, paradoxically, the first time that the name *les fauves* became popular. After its first use in 1905, it had not been applied to the group again until the Salon d'Automne of 1906, when Vauxcelles and Maurice Guillemot both briefly mentioned the *salle des fauves*[67] By 1907, however, it was in common use. Realizing that his quip had caught on, Vauxcelles counted twenty-five painters at the Indépendants who he thought had been touched by Fauvism, among them:

M. Matisse, fauve-in-chief; M. Derain, fauve-deputy; MM. Othon Friesz and Dufy, fauves in attendance; M. Girieud, irresolute, eminent, Italianate fauve; M. Czobel, uncultivated, Hungarian or Polish fauve; M. Béreny, apprentice-fauve; and M. Delaunay (fourteen year old—pupil of M. Metzinger...) infantile fauvelet....[68]

The inclusions and omissions that we now find surprising show not only how broad the outlines of Fauvism could seem, even to a seasoned observer, but more particularly that the Le Havre Fauves were now attracting more attention than Matisse's colleagues from Moreau's studio, who had become increasingly conservative. Furthermore, Fauvism itself had been recognized as enough of a movement, and had received enough publicity as such, to attract new converts.

Other converts were noted by Jean Puy in the 1907 Salon d'Automne, including Le Fauconnier and Braque.[69] By the end of the year the first full-length study of Fauvism had appeared, by Michael Puy in the November 1907 issue of *La Phalange*, and in the December issue of the same magazine there was an interview with Matisse by the new critic of the avant-garde,

(top) Derain in his studio, ca. 1908

(above) Cézanne: *Five Bathers.* 1885-87. Oil, 25¾ x 25⅝". Kunstmuseum, Basel

Derain: *Standing Figure.* 1907. Stone, 38″ high. Estate of Mme André Derain

(top) Derain: *The Crouching Man.* 1907. Stone, 13 x 11⅛″. Museum des 20. Jahrhunderts, Vienna

(above) Brancusi: *The Kiss* (first version). 1907. Stone, 11″ high. Museum of Art, Craiova, Romania

Picasso: *Figure.* 1907. Carved wood, 32¼" high. Estate of the artist

Maillol: *Night (La Nuit).* 1902. Terra cotta, 7⅛" high. Collection Mrs. Henry F. Fischbach

Guillaume Apollinaire.[70] But Apollinaire's comments show that a new, post-Fauvist Matisse was beginning to emerge. "We are not in the presence of some extremist venture," he wrote; "the essence of Matisse's art is to be reasonable."[71] It is clear that, to enlightened critics at least, Matisse's reputation was finally secure. Writing of his work in the 1907 Salon d'Automne, Vallotton noted that it "seems to arouse some controversy," but added, "I say *some* because really it seems to me that the time for invectives is over."[72] He concluded the review with the statement that Matisse "will most probably create a school," although by then it must have been clear to all the critics that a school—Fauvism—was already in existence. Vallotton, however, may have had something else in mind; for even the inventor of the *fauve* name, Vauxcelles, was beginning to speak of Matisse (and Derain, too) in a different way. Having listed the Fauves at the 1907 Indépendants, as quoted above, Vauxcelles added: "A movement which I believe to be dangerous stands out. A chapel has been founded where two imperious priests officiate, Derain

and Matisse. . . . This religion charms me hardly at all."[73] When compared with their previous work, and with that of the other Fauves in the Salon, the contributions of Derain and Matisse were indeed far less charming. Matisse was represented by his *Blue Nude* (p. 117)—that "masculine nymph," as Vauxcelles called it—and Derain, by the first of his large Bathers compositions (p. 116).[74] "The barbaric simplifications of Monsieur Derain," Vauxcelles wrote, "don't offend me any less. Cézannesque mottlings are dappled over the torsos of bathers plunged in horribly indigo waters." Derain and Matisse, however, were not starting a new "religion" together. Though there is some evidence that these two paintings were made in competition with each other,[75] they point in radically different directions. Matisse's *Blue Nude* was the first of his paintings of large-scale figures, and though still a Fauve work, provoking Vauxcelles to comment on its ugliness, it began the move in his art toward the development of a grand decorative style. Derain's move was in a direction opposite to the decorative, as Vauxcelles's mention of

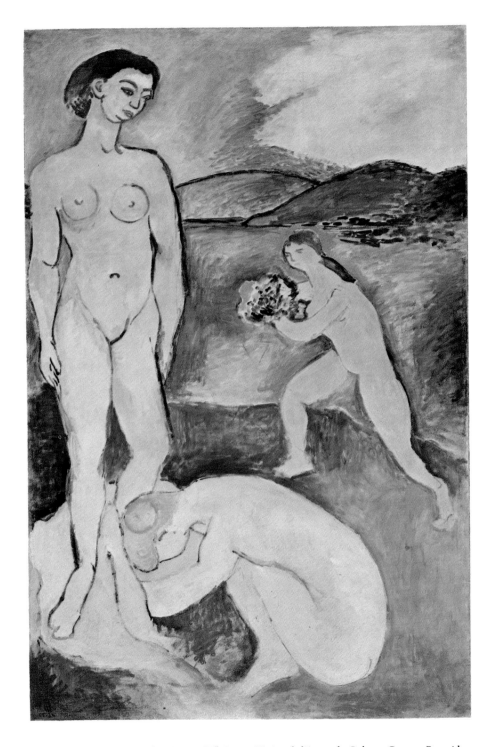

Matisse: *Le Luxe, I.* 1907. Oil, 82¾ x 54¾." Centre National d'Art et de Culture Georges Pompidou. Musée National d'Art Moderne, Paris

Derain: *The Turning Road, L'Estaque.* 1906. Oil, 51 x 76⅞." The Museum of Fine Arts, Houston. John A. and Audrey Jones Beck Collection

Derain: *The Dance.* 1906. Oil, 72⅞ x 82¼." Private collection, Switzerland

Derain: *Bathers.* 1907. Oil, 51¼ x 75⅞." Private collection, Switzerland

Matisse: *Blue Nude (Souvenir de Biskra).* 1907. Oil, 36¼ x 55¾". The Baltimore Museum of Art. The Cone Collection

the barbaric and Cézannesque indicate. It would not be long before Matisse had separated himself from his former collaborators, and before Apollinaire, who attributed the invention of Fauvism to Matisse and Derain, would be linking Derain's name with that of Picasso in the invention of Cubism.[76]

Fauvism and Cubism are usually viewed as the two opposite poles of early twentieth-century art: the instinctive versus the reasonable; color versus monochrome; free form versus structure; the fragmented versus the stylistically coherent; wildness versus sobriety. Certainly, they led in opposite directions. They had, however, common sources, the most important of which was Cézanne. The last phase of Fauvism and the first of Cubism overlapped in the Cézannism of 1907.

The course of Fauvism can be conveniently described by way of the principal Post-Impressionist influences on its development. The year 1904-05 saw the Fauves working under the inspiration of Seurat and to a certain extent of van Gogh. This produced the broken-touch and then mixed-technique Fauvist

styles in which Matisse and Derain worked during this period, with the other Fauves following them. The year 1906-07 was the time of flat-color Fauvism and of Gauguin's primary influence, with the decorative and Nabiesque affecting the adventurous members of the group. In 1907-08 Cézanne was rediscovered, and Fauvism as such went into its demise. We should be wary, however, of attributing the end of Fauvism too simply to the influence of Cézanne. Cézanne's art was valued by the Fauves and was recognized in their own work from the start. Discussing the very first Fauve group exhibition at the 1905 Indépendants, Vauxcelles called Matisse and his circle "disciples of Cézanne."[77] In 1907, in the first study of Fauvism, Michel Puy declared that for six or seven years Matisse had been educating his colleagues in the lessons of Cézanne's work.[78] Yet, from the time of the important Cézanne exhibitions in the year following his death—the watercolors at Bernheim-Jeune's in June 1907 and the retrospective of fifty-six works at the Salon d'Automne—there emerged a new interpretation of Cézanne's art, which

Matisse: *Reclining Nude, I.* 1907. Bronze, 13½" high x 19¾" long. The Museum of Modern Art, New York. Acquired through the Lillie P. Bliss Bequest

helped separate the Fauves from their leader, of Cézanne as a classicist and rationalist in the true French tradition.

The desire to define and locate a typically French tradition runs through Parisian critical writing of the Fauve period. We have already noted Denis's complaints in 1904 that Matisse was losing his grasp on that tradition because of his "theoretical" bias. In 1905, Denis wrote of Cézanne as one who had come to exemplify that classical tradition, but this was by no means the only interpretation of Cézanne nor the one that was most popular.[79] Strangely, it was one of the Fauves, Camoin, who helped to give it currency. Replying to Morice's "Enquête" of 1905, he paraphrased letters he had received from Cézanne and spoke of him as being "profondément classique" and of his expressed ideal "à vivifier Poussin sur la nature."[80] Despite the fact that Cézanne had not written in these terms, the Cézanne-Poussin link became quickly established. Vauxcelles was soon repeating the phrase in his reviews,[81] and by the time of the 1907 exhibitions, it was Cézanne the classicist who began to affect contemporary art.

The extent to which Cézanne suddenly became important again after these retrospectives may be gauged against Vauxcelles's comments on the "pre-Cézanne" Indépendants of 1907. "The influence of Cézanne is on the wane," he noted, adding, "certain earlier Salons, in particular those of 1904 and 1905, could have borne as a banner...'homage to Cézanne!'"[82] The principal influences that Vauxcelles now saw on younger painters were of Gauguin, Derain, and Matisse. That is, for Vauxcelles Cézanne's presence had been prominent in the early Fauve years, but had now been replaced by the flat-color style

of Gauguin and the leading Fauves. This was not a mistaken point of view. Although early Fauvism looked to Seurat and van Gogh, many Fauve pictures were painted in flat brushstrokes, each conceived as a flat colored plane, parallel to the plane of the canvas, and each with a certain degree of autonomous impersonality, showing that Cézanne's lesson was there as well. By the time of the Salon des Indépendants of 1907, Vauxcelles saw this strain disappearing. It was still there, in fact, in the hatched strokes of Derain and Vlaminck's landscapes and in the general gridded format of Derain's *Three Trees, L'Estaque* (p. 86); only it was subsumed within a Gauguinesque manner.

Matisse's *Blue Nude* looks back to one of the reclining figures from *Bonheur de vivre* and beyond that to *Luxe, calme et volupté*, while Derain's *Bathers* extends the theme of his *Dance* and *L'Age d'or*.[83] Both *Blue Nude* and *Bathers* also refer to Cézanne's series of Bathers, including the painting Matisse owned (p. 121 top left), as does Picasso's *Demoiselles d'Avignon* (p. 121), which was taking form during this period.[84] Derain turned away from his flat-color style of 1906 for angular facet planes and for a newly sculptural effect. We see the beginning of this process in *Three Figures Seated on the Grass* of 1906–07 (p. 120), where he used high Fauvist color to lay out forms that were beginning to settle into geometric arrangements. In Derain's *Bathers* itself, of early 1907, Fauvist color persisted in part of the work, but was now giving way to tonal rendering as he accentuated the sculptural at the expense of the two-dimensional. The left-hand bather was to be repeated in sculpture as the *Standing Figure* (p. 111). Although this work suggests Gauguin-derived primitive sources, its new angularized form relates it to the Cézannist context of the *Bathers*.

Derain's *Bathers* was completed before the Cézanne retrospectives of 1907 and before Picasso's *Demoiselles d'Avignon*. It demonstrates that although the retrospectives did undoubtedly accelerate the movement toward "sculptural" painting, they did not initiate it. The Fauves had always been "premature Cézannists."[85] Cézanne's work had been shown regularly at the Salon d'Automne since 1904. Derain clearly did not need to await the public discovery of Cézanne before tackling a painting of this kind, nor did he have to await the example of Picasso. It has been suggested that Derain was able to see preliminary drawings for the *Demoiselles*, which influenced his work.[86] The opposite viewpoint—that Picasso was indebted to the Derain—is more easily supported; for it is highly unlikely that Picasso would have shown work in progress to Derain, and Derain's shocked reaction to Picasso's painting was hardly that of one who had advance knowledge of its composition.[87] Both Derain and Picasso were working independently out of Cézanne in the same period. Picasso's seeing Derain's *Bathers* may well have affirmed his conviction of the potential in this approach. Beyond this, however, we need not look for affinities between the two works. Cézannism and primitivism together were being devel-

oped simultaneously within the most adventurous sectors of the Parisian avant-garde.

The central figure in Derain's *Bathers* reveals simplifications in the treatment of its head that indicate an appreciation of African sculpture. In this it follows the left-hand figure in *The Dance*. Both may well be derived from the mask that Derain purchased from Vlaminck (right), although the head in the *Bathers* is also related to the block-like forms of French Congo sculpture, which Derain probably knew.[88] Only in his few pieces of stone sculpture, however, did Derain embrace something more completely primitive in form. The works photographed in his studio at the time of Burgess's interview in 1908 were clearly influenced by Gauguin woodcarvings, several of which had been included in the Gauguin retrospective at the Salon d'Automne of 1906. They are also, like the similar works of this period by Picasso (p. 112),[89] stimulated by African art.[90]

As we saw in the context of *The Dance*, it was the particular modern paintings that influenced Derain that in their turn specified his interpretation of the primitive. Whereas Gauguin's paintings allowed him to appreciate and use curvilinear exotic sources, Cézanne opened his eyes to African art. However, the *Crouching Man* shows the situation to be somewhat more complicated. It reveals primitive sources, but should also be seen in the context of certain idealized sculptures that were being made around this same time. Since the summer of 1905 at Collioure, Derain and Matisse had become friendly with Maillol, who lived nearby at Banyuls.[91] Maillol's *Crouching Woman*, subsequently known as *The Mediterranean* in acknowledgment of its southern classical beauty, had been shown at the Salon d'Automne of 1905, where Denis acclaimed it as a major example of the new classicism he was encouraging.[92] Although the primitive man and classical woman belong to quite different worlds, there are, nevertheless, some general similarities between Derain's block-like figure and the compact enclosed forms that Maillol was creating, both in *The Mediterranean* and in works like *Night* (p. 112). The primitive and classical past were not mutually exclusive. Cézanne's simplifications opened modern painting to primitive sources even while he was being acclaimed a classicist. Denis was to include the Cézannist primitivism of Friesz and Braque in his classical pantheon in 1908.

This mixture of the primitive and the classical, it might be noted here, was by no means limited to the Fauve circle. Brancusi's 1907 and 1908 versions of *The Kiss* (p. 111) belong to the same ethos. But it was the Fauves who revealed it most, albeit to varying degrees. After interviewing Friesz in 1908, Burgess told his readers not "to call [Fauvism] any longer a school of Wild Beasts. It is a Neo-Classic movement, tending towards the architectural style of Egyptian art, or paralleling it, rather, in development."[93] He concluded that "this newer movement is an attempt to return to simplicity, but not necessarily a return to any primitive art." Even so, the "not necessarily" reveals how

African mask, Gabon. Wood whitened with clay, 18⅞ x 11¾". Estate of Mme André Derain

strongly the primitive and the classical were linked. While Friesz had undoubtedly emphasized to Burgess the classical over the primitive (by this time he was being encouraged by Maurice Denis), Burgess was not one to miss the "African-carved gods and devils of sorts" that decorated his studio. From late 1905 until the spring of 1908, Friesz and Matisse both had studios in the secularized Couvent des Oiseaux. It was probably Matisse, as Burgess suggests, who interested Friesz in the "volumes" of African art. Moreover, Matisse himself was now making sculpture partly stimulated by primitive and classicist sources. He was in close contact with Maillol; some of his small bronzes of this period bear comparison with Fang sculpture.[94] In 1908, he discussed one of his African statuettes in his sculpture class.[95]

As we have seen time and again, it was Derain and Matisse who led the other Fauves to constantly new stimuli. Derain was the discoverer of sources and ideas, the youthful experimenter always open to change; Matisse changed just as often through his Fauve period, but consolidated all the while. Derain's *Bathers* is overtly a primitivized Cézannist work; Matisse's

Derain: *Three Figures Seated on the Grass.* 1906-07. Oil, 15 x 21⅝". Musée d'Art Moderne de la Ville de Paris

Blue Nude is only implicitly so. Whereas Derain turned directly to angular faceting and harsh stylization, Matisse saw, in his new interest in volumes, another way of revealing the expressive potential he found in the human body. It was, in early 1907, a sculptural way, as the directly related sculpture, *Reclining Nude, I* (p. 118), reveals. In painting, Derain illustrated the sculptural, but Matisse presented an astonishing demonstration of the capacity of two-dimensional surface to connote the three-dimensional without sacrificing anything of its own essential identity. As the eye follows the rounded forms they open and push out across the plane. Matisse's realization of the motif—hand following eye across the surface of forms, rendering them in terms of the flatness that eyesight itself imposes—shows a more profound understanding of Cézanne than almost any stylistically Cézannist painting of this period.

Derain's later figure compositions, though indebted to Cézanne, took an increasingly conservative bent. After exhibiting his first *Bathers* at the Indépendants of 1907, Derain spent the summer in Cassis painting landscapes. Back in Paris in the winter of 1907-08, he returned to the figure and produced a composition of three nudes for the 1908 Indépendants.[96] According to Kahnweiler, there were several other "pictures with life-size figures" made at this time, but Derain was dissatisfied with them, and burned them in 1908.[97] Even so, he continued in a similar vein, sending yet another *Bathers* to the 1908 Salon d'Automne and painting more figure compositions in 1909.[98] Stylistically, this group of works exhibits the same primitive and Cézannist sources as the first *Bathers.* Yet the pictorial space became increasingly deeper and the forms more continuously modeled, setting these paintings apart from the thematically similar works produced by Picasso and Braque from identical sources. Because he was "the first painter to combine in a single work the influences of both Cézanne and Negro art," Derain must be considered "a true forerunner of Cubism."[99] But if Derain influenced Picasso during the birth of Cubism, he had, in the final analysis, but a peripheral relationship to that move-

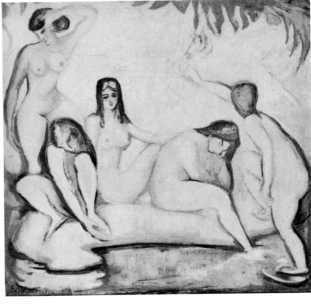

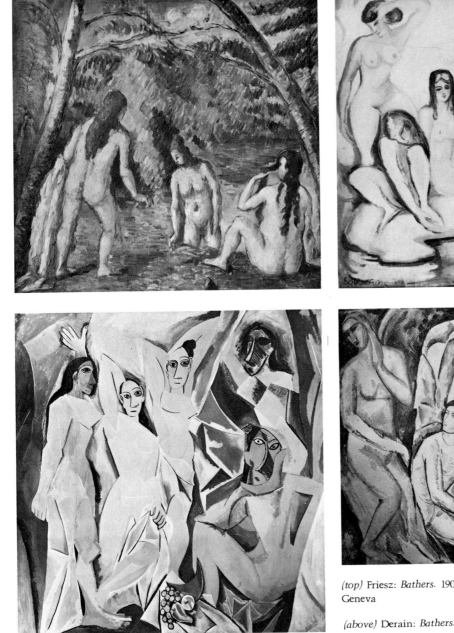

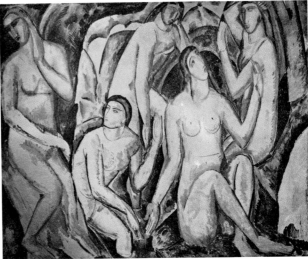

(top) Friesz: *Bathers*. 1907. Oil, 45½ x 48″. Collection Oscar Ghez, Geneva

(above) Derain: *Bathers*. 1908. Oil, 70⅝ x 91¼″. National Gallery, Prague

(top) Cézanne: *Three Bathers*. 1875-77. Oil, ca. 19¾ x 19¾″. Musée du Petit Palais, Paris

(above) Picasso: *Les Demoiselles d'Avignon*. 1907. Oil, 96 x 92″. The Museum of Modern Art, New York. Acquired through the Lillie P. Bliss Bequest

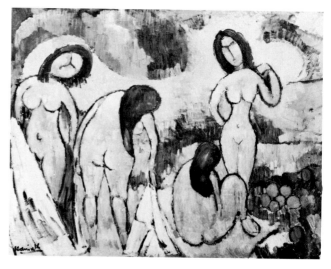

Friesz: *Travail à l'automne*. 1907-08. Oil, 79 x 98". Nasjonalgalleriet, Oslo

ment. Once he abandoned Fauvism, he began to abandon modernism as well, searching for the durable and eternal in a far more conservative form.

In the closing period of Fauvism, however, Derain continued to be an important influence on the other Fauves. While at Cassis in the summer of 1907, he was in contact with Friesz and Braque at nearby La Ciotat. That summer Friesz began his series of figure compositions, painting his *Creek at La Ciotat* and sending a *Bathers* (p. 121) to the Salon d'Automne. The latter painting turned completely away from the Art Nouveau calligraphy and violent color of the La Ciotat landscapes to a simplified Cézannist style.[100] This total volte-face suggests an external stimulus, which must certainly have been Derain. Before that summer, Friesz's art had been further from Cézanne than that of any of the Fauves. By October, Fleuret was writing that Cézanne was the dominant influence upon Friesz's painting.[101] By 1908, he had collected "huge portfolios of reproductions of Cézanne's pictures."[102] Friesz himself said later that once he became preoccupied with composition and with volume, Fauvism had to be sacrificed, that drawing replaced color as his primary concern.[103] That year his rejection of Fauvism was completed, and Friesz embraced a form of classicism that though indebted to Cézanne was far more conservative in intent. Writing of his *Travail à l'automne* (above) exhibited at the 1908 Indépendants, Vauxcelles noted that Friesz was now working in "the true French tradition, that of Le Nain, Millet and Cézanne."[104] Predictably, Denis singled out Friesz for special attention now that the classicist revival he had long hoped for seemed finally to have arrived.[105]

Denis also applauded Braque's work for its classical virtues.[106]

(top) Vlaminck: *Bathers*. 1908. Oil. Private collection, Switzerland

(above) Friesz: *The Terrace*. Oil. 1907. Whereabouts unknown

Braque: *View from the Hôtel Mistral, L'Estaque.* 1907. Oil, 32 x 24". Private collection, New York

Derain: *Landscape near Cassis*. 1907. Oil, 18⅛ x 21⅝". The Museum of Modern Art, New York. Mrs. Wendell T. Bush Fund

Braque's Fauvism had always been calmer and more structured in effect than Friesz's, as we saw when considering their La Ciotat landscapes. Indeed, from the time of his earliest Fauve paintings, such as the *Canal Saint-Martin* of autumn 1906 (p. 89), the rigor and simplification of Braque's compositional methods continually asserted themselves. His *Still Life with Pitchers* (p. 128), dated to 1906,[107] combined brilliant Fauvist color with a treatment of volumes already making constructive use of Cézanne. The regularized pattern of banked curves in his *Landscape at La Ciotat* (p. 126) certainly owes something to Cézanne's example, as does the hatched treatment of parts of this painting. Once again, contact with Derain at Cassis may have prompted, or more likely confirmed, Braque's new interest in Cézannist forms. Derain's Cassis landscapes (above) continued to include the large open shapes of his earlier painting, though now within rectilinear-based contours, while high Fauve color was replaced by a somber palette of dark greens, browns, and ochers. The new mood of sobriety may also have affected Braque. Although his color was still Fauvist at La Ciotat, he soon followed Derain's example and based his work around an axis of browns and greens, in the first Cubist paintings he made the following year.

The first clear presentiment of Cubism appears in Braque's *View from the Hôtel Mistral, L'Estaque* (p. 123).[108] On their way back to Paris in the autumn of 1907, Braque and Friesz stopped off at L'Estaque and there painted companion views from their hotel terrace. Friesz's is somewhat more structured and Cézannist than his summer work (p. 122). Braque's, however, turned

almost entirely away from curvilinear forms and Fauvist color for emphatically regularized drawing, hatched diagonal brushstrokes, a restrained palette, and a flattened architectonic surface. Only the spotlight of high color at the top of the painting ties it to Braque's Fauvist past. The outlines no longer are light and broken but heavy and rigid, oriented to an implied vertical-horizontal grid. The first Cubist landscapes that Braque made the following year consolidate the impetus of this painting.[109]

Braque completed *The Hôtel Mistral* upon his return to Paris. There, like many of the other ex-Fauves (as they must now be described), he began to paint from the figure. In 1907, probably just before he left for La Ciotat, he had painted two Fauvist nudes, with exaggerated skin tones, complementary shadows, and flecked Neo-Impressionist brushstrokes (p. 129 left).[110] That winter he returned to the similarly posed (though now standing) model. The resultant painting, the *Grand Nu* (p. 129 right), is unmistakably indebted to the exaggerated contours of Matisse's *Blue Nude*, but looks even more directly to the *Demoiselles d'Avignon*.[111] In November 1907, Kahnweiler had introduced Braque to Picasso. Braque's initial reaction to the *Demoiselles* was as alarmed as Derain's;[112] but as the *Grand Nu* reveals, its lesson was more securely understood. The flattened, overlapping, and ambiguous planes of the background derived from Picasso's painting. So, too, did the primitivism of the face, the shifting perspective effects, the harshly angular forms, and the narrowly telescoped, yet sculptural space. Braque's departure from Fauvism was abrupt. He discussed the work with Burgess. He wanted, he said, "to create a new sort of beauty...in terms of volume, of line, of mass, of weight."[113] He added, however: "I want to expose the Absolute, and not merely the factitious woman"; and "Nature is a mere pretext for a decorative composition, plus sentiment. It suggests emotion, and I translate that emotion into art." These are Symbolist-Fauvist concepts used to justify a proto-Cubist art. They certainly come close to Matisse's contemporary ideas, from which they are probably derived.

In "Notes of a Painter" Matisse wrote of his concern with the absolute, that "underneath this succession of moments which constitutes the superficial existence of things...it is yet possible to search for a truer, more essential character."[114] He wrote also of his need to interpret nature in a decorative way. The "Notes" describe Matisse's turn away from Fauvism, to a very different kind of "decorative composition" from Braque's. It is significant, however, that despite their differences, both could be justified in broadly similar terms: as a turn away from nature to decoration and away from the facts of nature to the ideal. Both are generally Neo-Platonic and classicist stances. Although we must recognize a stylistic division between Matisse and the other Fauves after 1907 and speak of Matisse extending the lessons of Fauvism and of the others as abandoning them, we may also justifiably delineate a post-Fauvist classicism and idealism to which the more adventurous of the Fauves all moved.

Vlaminck: *Flowers (Symphony in Colors)*. 1906–07. Oil, 39 x 26." Collection Charles R. Lachman, New York

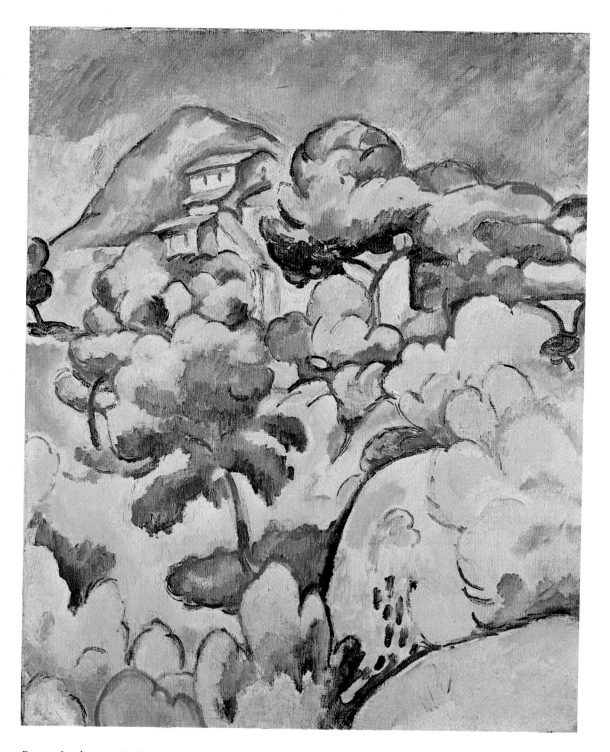

Braque: *Landscape at La Ciotat.* 1907. Oil, 28 x 23½." The Museum of Modern Art, New York. Purchase

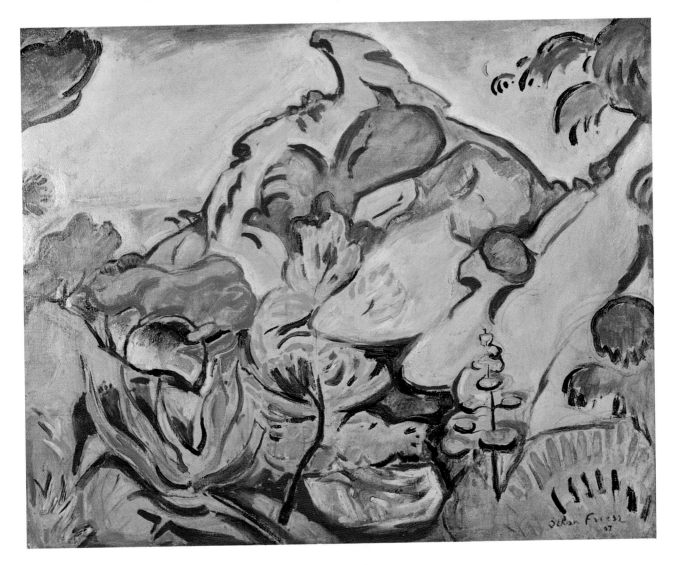

Friesz: *Landscape at La Ciotat.* 1907. Oil, 24½ x 30¾." Collection Pierre Lévy, France

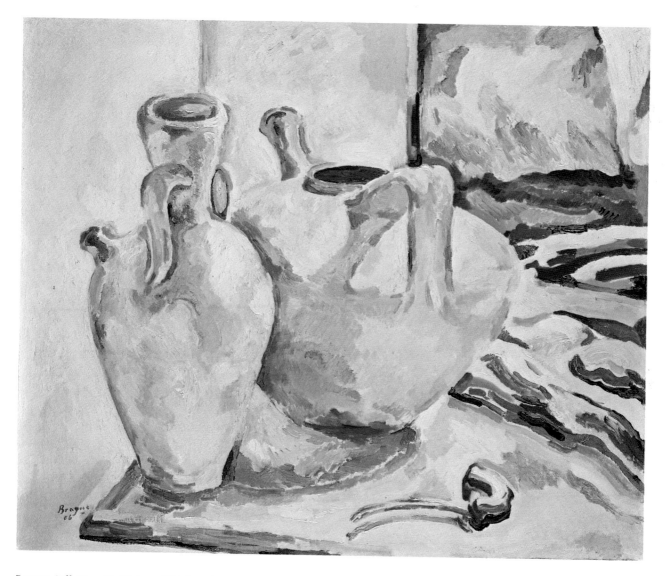

Braque: *Still Life with Pitchers.* 1906–07. Oil, 20¾ x 25." Private collection, Switzerland

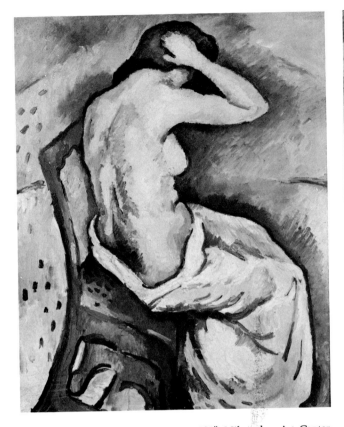

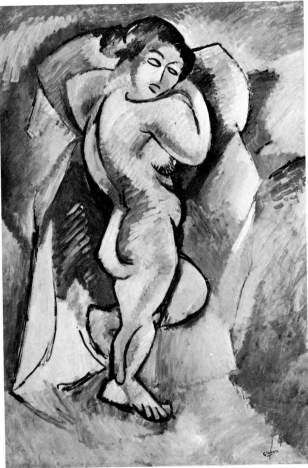

Braque: *Seated Nude.* 1907. Oil, 24 x 19¾". Milwaukee Art Center Collection. Gift of Harry Lynde Bradley, 1953

(right) Braque: *Grand Nu.* 1907-08. Oil, 55¾ x 40". Galerie Alex Maguy, Paris

Of Matisse's early colleagues, only the Chatou and Le Havre painters contributed to the new development. Of these, Vlaminck and Dufy have yet to be mentioned in this respect. Vlaminck was only marginally affected by the fashion for bathers compositions, though significantly by Cézanne; Dufy, not at all by the bathers vogue and only marginally by Cézanne. Vlaminck's single *Bathers* (p. 122)—almost certainly motivated by Derain's compositions—dates from 1908, and combines faces derived from African masks (p. 119).[115] soft Cézannist contours reminiscent of Friesz, and a treatment of broad planes that looks specifically to Derain's version of Cézannism. Only in his landscapes did Vlaminck begin to practice a first-hand Cézannist, and occasionally Cubist-influenced, style. Through Derain, he joined the circle around Picasso late in 1906, undoubtedly attracted by its boisterous, aggressively vanguard stance, quite different from that of Matisse. He also acquired two Picasso paintings of 1907.[116] From the time of his contact with the Picasso circle, Cézannist elements began to enter his art, though probably at first as reflections of the changes that Derain was undergoing, as we saw in the case of *The Red Trees* of 1906-07 (p. 87). Within a year, Vlaminck's palette darkened to natural tones and his brushstroke became the regularized Cézannist one, far more neutral and dispassionate in effect than in any of his previous paintings. This did not last. He abandoned Fauvism, he said later, "worried because, confined to the blue and red of color merchants, I was not able to be more forceful, and I had reached a maximum degree of intensity."[117] Feeling that he had exhausted the expressive properties of his Fauve style, Vlaminck would undoubtedly have been attracted to the primitivized Cézannism of Derain and Picasso in 1907, at this time an almost expressionist art. By now, however, he was a confirmed landscape painter, and Cézannism in a landscape context

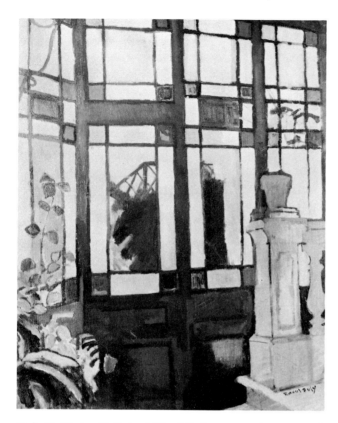

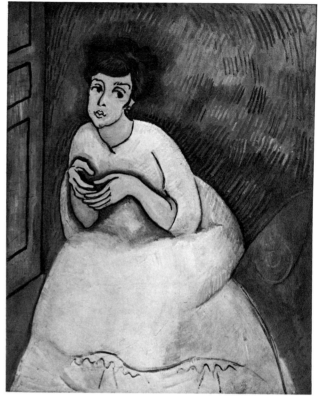

Dufy: *Vestibule with Stained-Glass Window.* 1906. Oil, 31½ x 25¼". Perls Galleries, New York

Dufy: *The Woman in Rose.* 1907-08. Oil, 31⅞ x 25⅝". Centre National d'Art et de Culture Georges Pompidou. Musée National d'Art Moderne, Paris

tended to reduce rather than enlarge the expressionist features of his art. He was, moreover, out of place in the intellectual discussions of the Picasso circle. "This sort of speculative thinking was utterly alien," he wrote later. Having been eclipsed by Derain in Matisse's esteem, Vlaminck now found a similar situation with regard to Picasso. When Apollinaire came to find a special place for the Fauves in *Les Peintres cubistes,* calling them "Cubistes instinctifs," the name of Vlaminck was not mentioned![18]

Dufy's relationship to the emerging Cubist circle was somewhat more complicated. Indeed, his identity as a Fauve was not without its contradictions, for he did not pass through the usual development from broken-touch, Neo-Impressionist-influenced painting to flat-color areas derived from Gauguin. The fact that he had not been attracted by Neo-Impressionism and had not, therefore, used a regularized brushstroke technique possibly made him more or less immune to Cézannism as well. Although he worked with the flat-color areas of the 1906 Fauve style, when painting beside Marquet, there was nothing of Gauguin's influence in his work either. And even while producing these flat emblematic pictures, he was pursuing a far more open and

atmospheric kind of art in the contemporary marines and landscapes with terse curves and floating circular motifs mentioned above. In fact, many of the flatter paintings are enlivened by busy, jostling figures, giving his work a sense of Impressionist activity largely absent from that of other Fauves; for Dufy had moved into his Fauve manner directly from an Impressionist foundation, as the *Fête nautique* (p. 94) of 1906 demonstrates, and never entirely surrendered its principles. He used Fauve methods—patches of bright color—to extend an Impressionist vision, and added to them a linear style of generalized curves and shorthand marks to accent and enliven the atmospheric surfaces. Occasionally, this linearism coalesced into something more geometric in character, as with *Vestibule with Stained-Glass Window* of 1906 (above left). *Jeanne among Flowers* of 1907 (p. 131) even reveals a certain incipient Cubism, though this also is indebted to Matisse![19] Matisse's influence is very evident in *The Woman in Rose* of early 1908 (above), whose broad, flat, curvilinear forms probably derived from the simplified decorative style that Matisse was beginning to consolidate by then. From the same period, however, comes Dufy's sketch and fin-

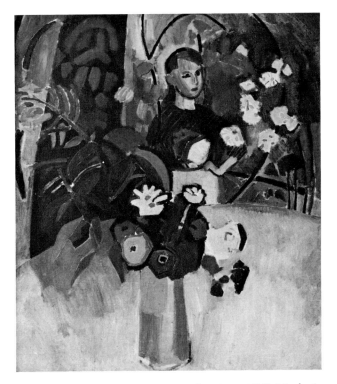

Dufy: *Jeanne among Flowers.* 1907. Oil, 35½ x 30¾". Musée des Beaux-Arts, Le Havre

ished painting *The Aperitif* (pp. 132, 133), where the floating curves and circles developed from 1906 find a truly remarkable, and nearly abstract, resolution.

The exact dates of these two paintings are not certain. They were painted at L'Estaque in 1908, but whether before or after his more famous works there (p. 133 right), which show the influence of Braque's Cézannesque style (p. 133 top left), is not certain. They have Cubist affinities, but with the coloristic Cubism of Delaunay rather than with the monochromy of Braque and Picasso. At the Indépendants of 1907, Delaunay and Metzinger were listed by Vauxcelles among the Fauve contingent[20] These two met in 1906, and that same year Delaunay painted a superficially Fauvist self-portrait—a conventionally modeled head tinted with Fauvist color (p. 142)—and on the reverse side of the same canvas a *Landscape with Disk* (p. 40), a Neo-Impressionist work but one created with a knowledge of Fauvist methods[21] Although Dufy himself did not work in Fauvist Neo-Impressionism, he was in contact with those who did, even introducing Severini to the theories of Signac[22] There was certainly also contact between Dufy and Delaunay, for they both exhibited at Berthe Weill's and both were friendly with Apollinaire and with the Douanier Rousseau[23] Dufy's development of floating circular motifs probably influenced Delaunay's move into his mature art, for although his first disk painting, the 1906 landscape mentioned above, is closer to the spectral suns of Derain's 1906 London pictures than to Dufy, his subsequent more lyrical and animated works of parallel color bands in floating spaces look back to the Dufy of *The Aperitif* and similar works.

Dufy's *The Café Terrace* of 1908 laid out the basic composition of *The Aperitif,* but in a flat, frieze-like manner comparable to that he used when working with Marquet[24] The sketch for *The Aperitif* deepens the central space, beginning to float both figures and objects in an open centripetal continuum. The treatment of the background foliage contains hints of a Cézannist hatched technique, but is also highly reminiscent, particularly on the right, of the background of Matisse's *Blue Nude,* which Dufy would have known. The trees of the finished painting, however, are far more sculptural, though still decorative, while the incident they frame floats freely within them. These are important paintings, not only qualitatively, but also in revealing that the linear decorative style of Matisse and the heavy, primitive Cézannism of Derain were by no means the only post-Fauvist options. The brilliant eclecticism of Dufy helps to indicate the complexity of Parisian art in 1907-08, as different structural alternatives to Fauvism were being explored.

When Braque joined Dufy in L'Estaque, the Cézannist alternative dominated. Dufy's *Green Trees* (p. 133) contains simplified, sculptural tree forms similar to those of *The Aperitif,* but the lively curvilinear swell of that painting has been tightened into a new angularized form, and the color severely reduced to ochers and dark hatched greens. Braque's companion painting (p. 133) is even more subdued, but is more authentically Cézannist as well, not merely simplifying and geometricizing forms, but also interrelating and intersecting them so that they seem transparent. The faceted treatment of the planes, antiperspectival drawing organized around a general grid format, Cézannist *passage,* muted palette, and sense of internal light make this and similar works produced at L'Estaque the first true Cubist paintings[25] When Braque sent them to the Salon d'Automne that year, they went before the jury of which Matisse was a member. He rejected them, apparently complaining to Vauxcelles of Braque's "petits cubes."[126] Braque withdrew his works and exhibited them in November at Kahnweiler's. In his review of the show, Vauxcelles spoke of reductions "à des cubes."[127] By the time he referred to Braque's "bizarreries cubiques" at the 1909 Indépendants,[128] the name had caught on, and Vauxcelles had baptized Cubism as he had done Fauvism in 1905. Fauvism was now finally ended. It had ended as a style in 1907 as amorphously as it had emerged; now it ended as a movement and as a group, and in as public a way as it has begun. "The feeling between the

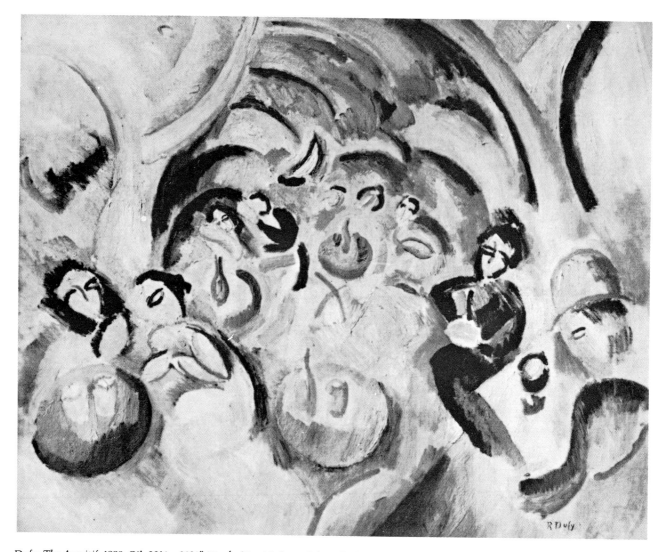

Dufy: *The Aperitif*. 1908. Oil, 23¼ x 28⅜″. Musée d'Art Moderne de la Ville de Paris. Gift of Girardin, 1953

Picassoites and the Matisseites became bitter," Gertrude Stein later recalled. "Derain and Braque had become Picassoites and were definitely not Matisseites."[129] The "era of the Sketch" is over, noted Vauxcelles,[130] while Denis celebrated the new classicism that had finally arrived, even quoting Apollinaire's interpretation of Braque in support.[131] The informed journalist, the conservative, and the avant-garde writer thus all found common ground in their recognition of a new art "plus noble, plus mesuré, mieux ordonné, plus cultivé."[132]

The polarization of the avant-garde in Paris that took place from 1908 left Matisse isolated from his former colleagues. We should be wary, however, of viewing this as entirely a one-sided move. Clearly, the growth in esteem and popularity of Picasso contributed to the ending of Fauvism, but Matisse himself had also been developing away from his Fauve style. Whereas those who abruptly abandoned Fauvism in pursuit of the classical were not, with the single exception of Braque, as successful in their new styles as in the ones they had left, Matisse independently realized the very ambition to which the others aspired: a revived classicism, a timeless, monumental, and ideal art.

After exhibiting the *Blue Nude* at the 1907 Indépendants, Matisse appears to have taken stock of his artistic position. The *Brook with Aloes* (p. 134), painted at Collioure that summer, was Matisse's last Fauve landscape, but one whose flattened decora-

Dufy: *Green Trees*. 1908. Oil, 31⅞ x 25⅝". Private collection, France

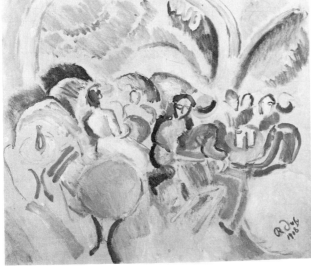

(top) Braque: *Houses at L'Estaque*. 1908. Oil, 28¾ x 23½". Kunstmuseum, Bern. Hermann and Margrit Rupf Foundation

(above) Dufy: *Café at L'Estaque*. 1908. Oil, 17¾ x 21⅝". Centre National d'Art et de Culture Georges Pompidou. Musée National d'Art Moderne, Paris. Bequest of Mme Dufy, 1962

tive style and subdued color turned from the excited handling of previous Collioure landscapes toward something calmer and more deliberately harmonic. Later that year he told Apollinaire how he had looked back over his earlier work and there found the mark of his personality in everything he had done, regardless of its differences.[133] Up until then, as we have seen, the different styles had been evident indeed. Now "I made an effort to develop this personality by counting above all on my intuition and by returning again and again to fundamentals. When difficulties stopped me in my work I said to myself: "I have colors, a canvas, and I must express myself with purity'...."[134] The results of this new preoccupation with fundamentals were evident in an important change in Matisse's procedures. Exhibited at the Salon d'Automne were full-sized paintings, each labeled *esquisse* (sketch) in the catalogue. One of these, *Le Luxe, I,* has been aptly described as a "dark fauve" work![135] Matisse was now using the spontaneous and intuitive methods of Fauvism only as a starting point for the expression of the purity he desired.

Le Luxe, I (p. 113) is nearly seven feet high. In subject it is a bathers composition. In theme and motif it is similar to the *Bonheur de vivre,* and to *Luxe, calme et volupté* before it. It is,

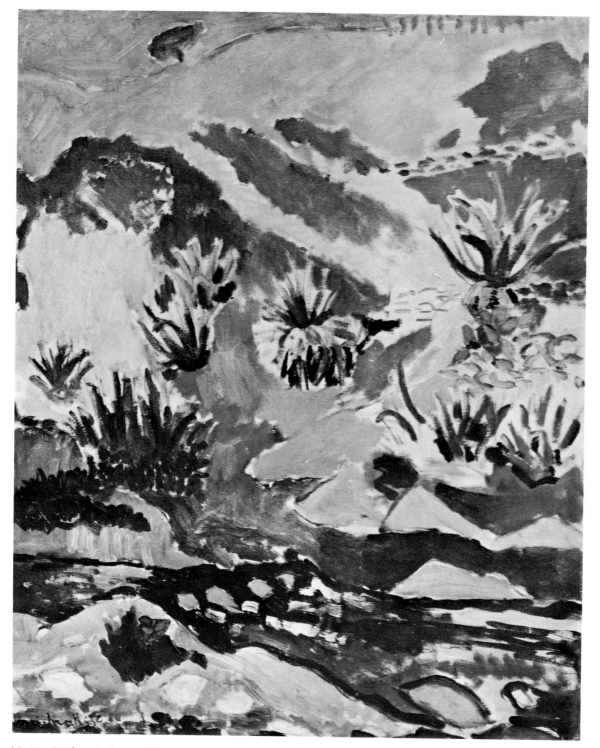

Matisse: *Brook with Aloes, Collioure.* 1907. Oil, 28⅞ x 23⅝". Private collection, U.S.A.

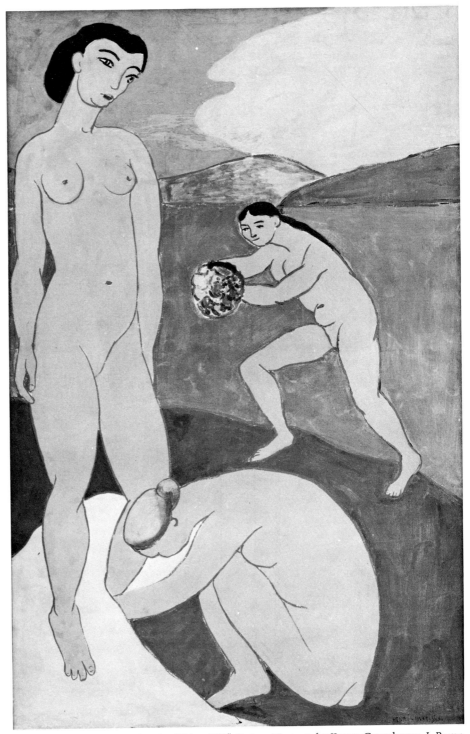

Matisse: *Le Luxe, II.* 1908. Casein, 82½ x 54¾". Statens Museum for Kunst, Copenhagen. J. Rump Collection

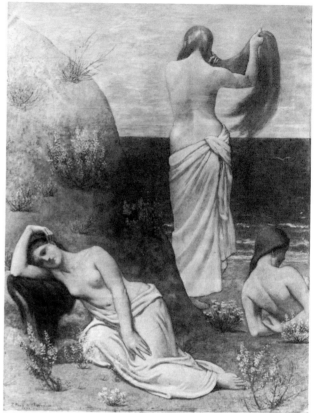

(above) Puvis de Chavannes: *Girls by the Seashore.* 1879. Oil, 24 x 18½". Musée de Louvre, Paris. Camond Bequest

(left) Matisse: Study for *Le Luxe.* 1907-08. Charcoal on paper, 9' 1⅛" x 54". Centre National d'Art et de Culture Georges Pompidou. Musée National d'Art Moderne, Paris

however, far more tentative a work in draftsmanship than either of these; and Félix Vallotton, writing in *La Grande Revue,* assumed that "the hypnotic and broken draftsmanship [was] adopted by M. Matisse as the only line that can record without betrayal the meanderings of his sensibility."[136] The color is also muffled and varied in its application, combining flat, nearly even zones with scrubbed, sketchy areas and sections of broken strokes. This mixed-technique form identifies it as a Fauve painting. It is also, potentially at least, an anti-Fauve one: in its grandness of design, new decorative clarity, its turn from diverting incident. Certainly, the second version, *Le Luxe, II* (p. 135), probably from early 1908,[137] exaggerates these characteristics to achieve a newly direct calm and simplicity, compared with which even the *Bonheur de vivre* seems an energetic painting. Turning once more to Puvis de Chavannes for subject (above),

method, and materials,[138] Matisse created the first of his life-sized figure compositions in his grand decorative style. "Suppose I want to paint the body of a woman," Matisse wrote, possibly thinking about *Le Luxe:*

First of all I endow it with grace and charm but I know that something more than that is necessary. I try to condense the meaning of this body by drawing its essential lines. The charm will then become less apparent at first glance but in the long run it will begin to emanate from the new image. This image at the same time will be enriched by a wider meaning, a more comprehensively human one…[139]

"A rapid rendering of a landscape represents only one moment of its appearance," Matisse said of the art of the Impressionists,

though he could equally well have been thinking of the Fauves. "I prefer, by insisting upon its essentials, to discover its more enduring character and content, even at the risk of sacrificing some of its pleasing qualities."[140] This is a turn beyond Fauvism. What he went on to say might stand as a manifesto of his new ideal:

Underneath this succession of moments which constitutes the superficial existence of things animate and inanimate and which is continually obscuring and transforming them, it is yet possible to search for a truer, more essential character which the artist will seize so that he may give to reality a more lasting interpretation.[141]

If the two versions of *Le Luxe* demonstrate that Matisse's revisions of his first intuitions were leading him toward a flat, decorative style, then the "sketch" *Music* (right), also shown at the 1907 Salon d'Automne, reveals that even in his first intuitions Matisse had abandoned the stylistic inconsistencies of his Fauve manner. This work points directly to the painting *Music* (below right), of 1910, and marks the beginning of the post-Fauvist period of high decorative art. At this moment Matisse started painting still life once again. The *Blue Still Life* of 1907 (p. 139) is obviously far from the decorative style of *Le Luxe* and *Music*, but it is equally far from Fauvism. When compared with the *"Oriental" Rugs* (p. 138) of the previous year, it shows a turn from the "rapid rendering" and animated surface of Fauvism to a calmness analogous to that of the decorative paintings, but one in which Cézanne's presence is strongly felt.

Other still lifes of 1907 and 1908 show Matisse combining and testing the decorative against the Cézannist: deepening pictorial space but emphasizing patterning (*Still Life with Asphodels*, 1907); avoiding the decorative for the sculptural (*Sculpture and Persian Vase*, 1908); and collapsing sculptural forms with the pressure of the decorative patterns on which they are placed (*Still Life in Venetian Red*, 1908, p. 139). In the last of these works it seems as if painting itself, as Matisse now understood it, was expelling the sculptural, was banishing everything other than the sheerly optical, of its own accord. As ever, his method was first to create and then to reflect, to draw conclusions from what the painting itself demanded. "My reaction at each stage," he said later, "is as important as the subject.... It is a continuous process until the moment when my work is in harmony with me."[142] "I am simply conscious of the forces I am using, and am driven on by an idea that I really grasp only as it grows with the picture."[143] Never has this been better demonstrated than in the painting that marked his final farewell to the Fauve style: the *Harmony in Red* of 1909 (p. 140). It began as *Harmony in Green*, was repainted as *Harmony in Blue* and exhibited as such at the Salon d'Automne of 1908, then repainted yet again in 1909 to become the *Harmony in Red*.[144] The still-life subject is comparable to that of the *Blue Still Life* of 1907, but refers back even more directly to *The Din-*

(top) Matisse: *Music (Sketch).* 1907. Oil, 28¾ x 23⅝". The Museum of Modern Art, New York. Gift of A. Conger Goodyear in honor of Alfred H. Barr, Jr.

(above) Matisse: *Music.* 1910. Oil, 8'5" x 12'1½". The Hermitage, Leningrad

Matisse: *"Oriental" Rugs*. 1906. Oil, 35 x 45¾". Musée de Peinture et de Sculpture, Grenoble. Agutte-Sembat Bequest, 1923

ner Table (p. 17), which had been Matisse's provocative contribution to the Société Nationale of 1897. This new painting was as much the masterpiece of his new decorative style as *The Dinner Table* had been of his initial modernist alignment. In *Harmony in Blue* modeling and perspective were almost banished, and the pictorial space flattened and patterned to set up a tense equilibrium between the horizontal plane of the table and the vertical one of the wall. In *Harmony in Red,* table and wall are joined in one vivid surface of color. Not only did Matisse put Fauvism behind him here; he also left behind the conventional forms of easel painting itself, for a tapestry-like hanging, soaked and steeped in color. Using that traditional subject of tactile possession—laying a table[145]—Matisse created his first major image of purely visual understanding, of the existence of things embedded in the substance of color itself.

The *Harmony in Blue* was one of the highlights of the retrospective exhibition that Matisse received within the Salon d'Automne of 1908.[146] Even as late as this, however, he was not immune to criticism for his Fauve attributes. Indeed, the 1908 Salon d'Automne saw perhaps the most vicious attack that Fauvism ever received. Writing in *La Revue Hebdomadaire,* M. J. Péladan, who had been the founder of the Rosicrucian Salon in the 1890s, accused the Fauves as a whole of charlatanism, of being "ignorant and lazy…[trying] to offer the public colorlessness and formlessness," and Matisse himself of not having any respect for "the ideal and the rules."[147] Moreover, he attacked the jury of the Salon for allowing the paintings to be hung. The morgue, he commented, had recently been closed to public view. The same should happen to the Salon d'Automne. "The spectacle of unhealthy shams constitutes a danger of infection. One

ought not to make a spectacle of epilepsy, likewise feigning, likewise painting."[148] Desvallières asked Matisse to reply to this both as leader of the Fauves and as a jury member.[149] His reply was the "Notes of a Painter."[150] "Rules," he insisted, "have no existence outside of individuals." But he emphasized the rules he himself believed in, and spoke of his own ideal, of "an art of balance, of purity and serenity, devoid of troubling or depressing subject matter, an art which could be for every mental worker, for the businessman as well as the man of letters, for example, a soothing, calming influence on the mind, something like a good armchair which provides relaxation from physical fatigue." This famous passage is hardly the manifesto of a *fauve*. Indeed, the "Notes of a Painter" confirms that, by 1908, Matisse's Fauve period was over. "I do not think exactly the way I thought yesterday," he wrote. "Or rather, my basic idea has not changed, but my thought has evolved, and my mode of expression has followed my thoughts." His basic idea was "expression" itself. "Expression, for me, does not reside in passions glowing in a human face or manifested by violent movements. The entire arrangement of my picture is expressive." This repudiation of anything violent or excessive was a rejection of one side of Fauvism. He also wrote of his dissatisfaction with the sketch-like manner of his early Fauve years: "Often when I start to work I record fresh and superficial sensations during the first session. A few years ago I was something satisfied with the results. But today...I think I can see further....There was a time when I never left my paintings hanging on the wall because they reminded me of moments of over-excitement....Nowadays I try to put a sense of calm into my pictures and re-work them until I have succeeded." Matisse discussed his discontent with the fleeting character of Impressionism and his preference for the calm and equilibrium of classical art. This is confirmed by a story told by Maurice Sterne of Matisse's first day of teaching at the school he had opened at the beginning of that year. "When Matisse entered the room he was aghast to find an array of large canvases splashed with garish colors and distorted shapes. Without a word he left the atelier, went to his own quarters in the same building, and returned with a cast of a Greek head...told his students to turn their half-baked efforts to the wall and start drawing 'from the antique'."[151] This, then, was how he treated these would-be Fauves.

It was from the Salon d'Automne of 1908, which provoked the "Notes of a Painter," that Matisse excluded Braque's Cubist pictures and confirmed the dissolution of the Fauve group. The *Harmony in Blue* from the same exhibition was sold to Sergei Shchukin. In March of 1909, Shchukin commissioned from Matisse the panels *Dance* and *Music,* which mark the consolidation of his grand decorative style. By the end of 1909, Matisse had left Paris and was living at Issy-les-Moulineaux. His period of cooperation with the Parisian avant-garde had ended, and with it the final chapter of Fauvism was closed.

(top) Matisse: *Blue Still Life.* 1907. Oil, 35 x 45¾". The Barnes Foundation, Merion, Pennsylvania

(above) Matisse: *Still Life in Venetian Red.* 1908. Oil, 35 x 41⅜". The Hermitage, Leningrad

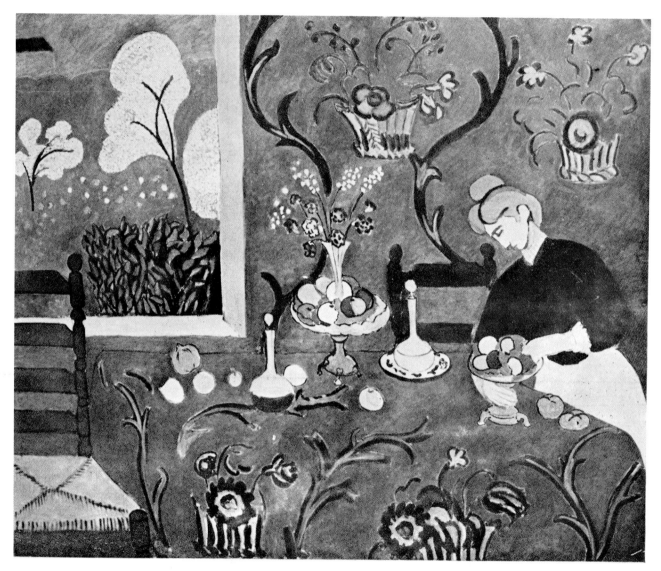

Matisse: *Harmony in Red*. 1909. Oil, 69¾ x 85⅞". The Hermitage, Leningrad

Postscript: Fauvism and Its Inheritance

"You can't remain forever in a state of paroxysm," Braque insisted, explaining his abandonment of the Fauvist style! Matisse's reason was the same. "Later," he said, "each member denied that part of Fauvism we felt to be excessive, each according to his personality, in order to find his own path."[2] The post-Fauvist work by all of the members had in common a rejection of the excessive, for something more rational and classical in form. To all except Matisse, this meant a repudiation of color as well. With the emergence of the Cubist tradition, and its entrenchment as the dominant pictorial style of the first half of the twentieth century, color took second place to form in most subsequent painting; and so it remained, with isolated exceptions, until comparatively recent times. The logic of form created through color—of design in color—that Fauvism made possible seems not to have been fully accessible at once, except to someone as utterly obsessed with pictorial purity as Matisse. He realized immediately that color alone could evoke the complete range of pictorial attributes that other components of painting separately convey: depth as well as flatness, contours as well as planes, the substantive as well as the illusory.

The lesson of Matisse's art, however, is finally more than a pictorial one. Not just the reality of color but the reality available in color is what his art continually demonstrates. In the end, that reality outlasted the one available through form. While the Cubists exacerbated the division between painting and what it represented—making it as object-like as what it represented—and finally excluded the figurative conventions of the past, Matisse continued to preserve and to celebrate the traditional subjects of painting,[3] identifying with what he saw, "entering into things...that arouse his feelings."[4] "Perhaps it is sublimated voluptuousness," he speculated later, "and that may not yet be visible to everyone."[5]

Fauvism itself was both less and more than this. Matisse's ideal voluptuous world only fully emerged when Fauvism had ended, and could only have been created by renouncing that part of it he felt to be excessive. If the liberation of color from natural appearances so that it could more truly describe his sensations was what Matisse took from the Fauve style, this aspect was not what immediately affected the course of twentieth-century art.

We may speak of the impact of Fauvism in two distinct, though overlapping, senses. First, there is the educative impact of the Fauve achievement: how the Fauves' own development from Impressionist-mode painting to a synthesis of Post-Impressionist alternatives helped a large number of painters in the next decade to leave their Impressionist beginnings and come to

terms with Post-Impressionism far more swiftly than the Fauves did themselves. Second, we may note the specific stylistic impact of the work of individual Fauves on those who saw Fauve paintings and immediately developed their own Fauve-based styles, though often they soon abandoned them for more personal manners[6] In certain instances, for example, in the work of Kirchner, these two points come down to one and the same thing; in others, Fauvism was merely a liberating influence for an art that was never stylistically a Fauve one, as with Metzinger, for example, who learned a heightened form of Neo-Impressionism from Fauve examples before becoming a Cubist painter.[7]

As far as the education in Post-Impressionism is concerned, it is clear that ambitious French painters who used pre-Fauve styles after Fauvism could not remain unaffected by the redefinition of those styles the Fauvists had achieved. Each new generation of painters learns its history from the advanced art of its own time, if only to reject it later. Although they were never Fauvists in other than a superficial sense, Delaunay (p. 142), Duchamp, Gleizes, Léger, and others, all broke with Impressionist-mode painting through the mediation of Fauvism[8] Many of these future Cubist painters considered Fauvism an extension of the Impressionist tradition, the last obstacle they had to overcome to create something that was entirely new[9] Insofar as Fauve color is concerned, only Delaunay and Léger may be said to have extended the Fauve vision, though in drastically revised forms. But for all of these artists, the late Cézannist phase of Fauvism —the geometricism and primitivism of 1907—formed an important source for their mature work, as it also did for the principal Cubist artists, Picasso and Braque.

The situation for non-Parisian artists is more complicated, and we should be wary of attributing Fauve influence to all vigorous high-color painting after 1905. The same Post-Impressionist sources the Fauves used were used independently by others as well. We saw, for example, that van Dongen reached his Fauve style independent of the others. Similarly, Mondrian passed through an exaggerated form of Neo-Impressionism derived from Toorop that at moments became so relaxed as to assume a "Fauvist" character, most overtly in his *Windmill in Sunlight* of 1908 (p. 142).[10] The principle of parallel developments should not be overemphasized, though. Donald Gordon has convincingly demonstrated that the familiar conception of the Fauve and Brücke styles as being chronologically parallel must now be discounted.[11] Kirchner's seeing Fauve paintings in Berlin in 1908, and especially Matisse's first one-man show in Germany at Paul Cassirer's Berlin Gallery in January 1909, changed his work

Delaunay: *Self-Portrait*. 1906. Oil, 21¼ x 18⅛". Centre National d'Art et de Culture Georges Pompidou. Musée National d'Art Moderne, Paris

from van Gogh-, Munch-, and Jugendstil-inspired painting to what has been called a "German Fauve" style. As Gordon has pointed out, Kirchner's woodcuts and lithographs of 1909 derived very directly from Marquet, van Dongen, and especially Matisse's prototypes.[12] The painting *Girl under a Japanese Umbrella* (p. 144), of the same year, displays a flat-patterned stylization of features that recalls Matisse's *The Green Line* (p. 55), and the pose itself is indebted to the *Blue Nude* or to the related sculpture, *Reclining Nude, I* (p. 118). Other Brücke artists soon began heightening their palettes and simplifying their forms under the general influence of Fauve art, though often transforming it to far more graphic effect, as in Schmidt-Rottluff's *Flowering Trees* (p. 143). By the time of the Brücke exhibition of June 1909, the Brücke artists were finding a reception similar to that given the Fauves in 1905. Their new styles were being blamed on their working "under the curse of these [French] prototypes, whose individuality is too sharply stamped, too much the expression of particular eccentric temperaments, for other worthy painters to be able lightly to appropriate their manner."[13] Of course, the Brücke development from overtly Post-Impressionist-inspired work to a new two-dimensional flatness

(top) Kandinsky: *Street in Murnau with Women*. 1908. Oil, 28 x 38⅛". The Norton Simon Foundation, Los Angeles

(above) Mondrian: *Windmill in Sunlight*. 1908. Oil, 44⅞ x 34¼". Gemeentemuseum, The Hague

(top) Kandinsky: *White Sound.* 1908. Oil on cardboard, 28¼ x 28¼".
Collection Mr. and Mrs. Ben J. Fortson, Fort Worth

(above) Schmidt-Rottluff: *Flowering Trees.* 1909. Oil, 27¼ x 31¾".
Mr. and Mrs. Leonard Hutton, New York

under Fauvist influence "represents, in broad outline, the same path of evolution followed by the French Fauves some three to four years earlier in Paris."[14] So, too, does the turn to angular Cézannist forms that followed later.

By 1910-11, the Fauvist Expressionism of the Brücke group was the dominant modern German style. For most of those who practiced it, Fauvism reached them in secondhand form. This was not the case, however, with Kandinsky and Jawlensky, who used Fauvism to significant effect in their canvases of 1908. These two had been exposed to Fauve art from 1905, when they had exhibited at the Salon d'Automne in Paris that year. At Murnau in 1908, Kandinsky painted in a mixed-technique style of high color, exaggerated broken brushstrokes, and flat planes. His *Street in Murnau with Women* (p. 142) does not recall any specific Fauve source (except, perhaps, some of Vlaminck's street scenes of 1906)[15] in the way that Kirchner's paintings do, but it is undoubtedly a Fauvist-inspired work. For Jawlensky, who visited Kandinsky at Murnau, Fauvism had a more lasting impact, especially on his series of portraits with high-pitched colors and complementary shadows and on his vivid still lifes. Again, a comparison with Vlaminck is suggested: in the raw, folk-art quality of many of the portraits and in the harsh, bright outlining and frontal quality of the still lifes. Jawlensky's *Still Life with Round Table* of 1910 (p. 146) looks back particularly to such works as Vlaminck's still lifes of 1905 (pp. 146, 147).

The exotic coloring of Jawlensky and of the Murnau Kandinsky sets the German work apart from the French. French coloring resolved itself around the primaries and around the contrast of complementary hues; the German use of color depended upon an orchestration of adjacent hues, set off and enlivened by complementaries, and generally deeper and more resonant in effect. In this sense, German "Fauvist" art extends the form of pictorial resolution of van Gogh, where the primary colors are often modified by the addition of darker pigment to unite the work tonally. The glowing internal light of German paintings contrasts with the light-reflective surfaces of the French. The Fauves, it has been said, used high color in a harmonious way; the Brücke group, for the drama it evoked; Kandinsky and his friends, at the service of an inward vision.[16] There is certainly truth in this; and yet, as we have seen, drama and inwardness were not absent from original Fauvism. Its very diversity as a style opened it to multiple interpretations.

For the development of northern twentieth-century art—indeed, for a large sector of twentieth-century art as a whole—the influence of Fauvism is indisputable. This should be qualified with the reminder that the artists it affected had been looking to Post-Impressionism—as well as to Munch, Ensor, and others—before Fauvism reached them. Hence, Nolde's *The Last Supper* and Rouault's *Head of Christ* (p. 146) should equally be viewed as part of a general Expressionist impulse, which affected early twentieth-century art as a whole. The "wild" aspect of Fauvism

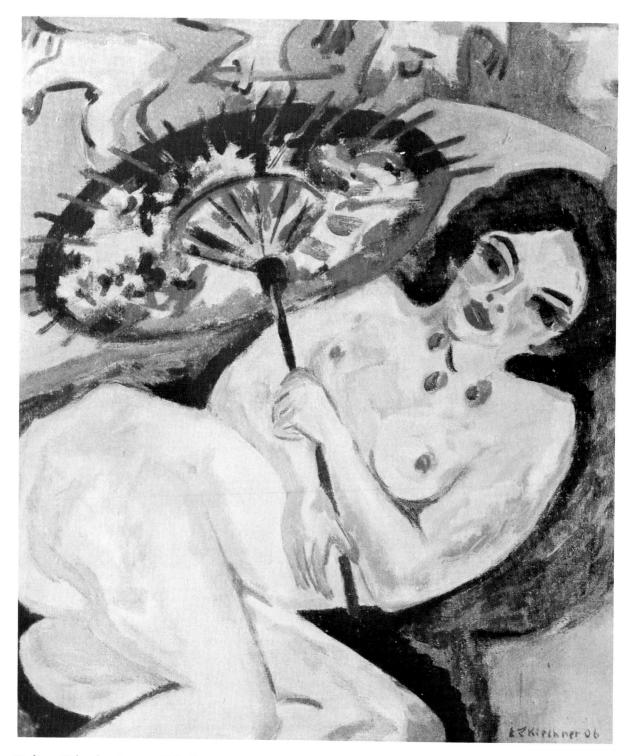

Kirchner: *Girl under a Japanese Umbrella.* 1909. Oil, 36¼ x 31½". Kunstsammlung Nordrhein-Westfalen, Düsseldorf

Pechstein: *Evening in the Dunes.* 1911. Oil, 27½ x 31½". Mr and Mrs. Leonard Hutton, New York

was by no means unique to that movement. It seems certain, however, that for many artists, Fauvism catalyzed and speeded their understanding of earlier art, offering an example of how it could be revitalized while showing that ideas which paralleled their own had already found artistic resolution. Certainly, Matisse and Kandinsky's interests in the musical analogies of pictorial composition should be thought of as parallel developments;[17] so, too, should the idealist notion of art as representing a truer reality behind visible appearances that links Matisse, Kandinsky, Mondrian, and Malevich. Various forms of the Fauvist style spread to Russia, Belgium, Italy, the Netherlands, England, and America, where they were welcomed as the first clear demonstration of a new artistic liberation at the beginning of the twentieth century.[18]

It would be wrong, however, to overstate the radical nature of the Fauvist achievement. That it became so immediately popular and so readily was assimilated by ambitious painters only shows that it was as much a collation and summation of the past as the spearhead of a new sensibility. It was never an autonomous movement in the way most subsequent modern movements were. This lack of autonomy and clearly defined identity presents itself in several striking ways, chief among which is that

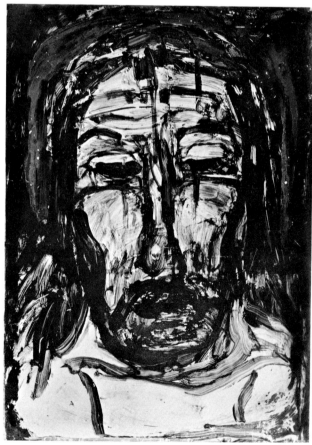

(top left) Nolde: *The Last Supper.* 1909. Oil, 34 x 42". Statens Museum for Kunst, Copenhagen

(top) Jawlensky: *Still Life with Round Table.* 1910. Oil on composition board, 22 x 20". Private collection, New York

(above) Vlaminck: *Still Life.* 1906. Oil, 21⅛ x 25⅝". Private collection, New York

Rouault: *Head of Christ.* 1913. Oil on porcelain, 15⅛ x 11¼". Private collection

Vlaminck: *Still Life.* 1906. Oil, 20⅞ x 28¼". Private collection, Switzerland

even within the most narrowly defined Fauve period, between the Indépendants of 1905 and of 1907—and even at its height, between the Salon d'Automne of 1905 and of 1906—not all the paintings produced by those we call Fauves can truly be described as Fauve paintings. This applies principally to artists such as Manguin, Camoin, Marquet, and Puy, that is to say, to the more conservative members of Matisse's original circle, but even to Matisse himself![9]

Because no single all-embracing definition can possibly encompass the complexities and contradictions of this movement, the differentiations between the group, movement, and styles of Fauvism have been the principal concern of this essay. What finally requires emphasis is that the cooperative group status was absolutely central to Fauvism, though it demonstrates its fugitive character at the same time. What we call modern movements are, of course, all group activities. With Fauvism, this takes on a special significance. So much depended upon the interactions of personalities and on the special role that Matisse played as advisor and example to the others. This explains how Fauvism developed from a movement centered around Matisse and his friends from Gustave Moreau's studio and the Atelier Carrière to one formed around the triangle of Matisse, Derain, and Vlaminck. The Matisse-Derain association became the linchpin of Fauvism, and when it broke after the Indépendants of 1907, Fauvism soon declined. Even at its height, however, Fauvism was not a single coherent group but a grouping of separate allegiances, of pairs of painters following a similar vision: Matisse with Marquet, Matisse with Derain, Derain with Vlaminck, Marquet with Dufy, and so on. For little more than two brief years they pursued broadly similar aims, stimulated by each other's examples and above all by Matisse's, until that "paroxysm" of which Braque spoke—which was nothing less than the convulsion during which twentieth-century art was born—had finally passed.

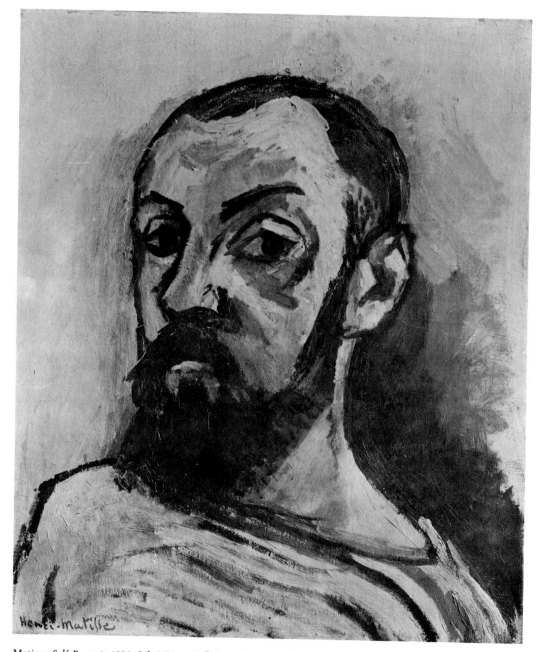

Matisse: *Self-Portrait*. 1906. Oil, 21⅝ x 18⅛". Statens Museum for Kunst, Copenhagen. J. Rump Collection

Notes

Wherever possible, English language sources are given alongside original ones. In the case of translated quotations, there may be differences between the versions presented here and the English sources to which the reader is directed. The author has modified certain translations in the interest of clarity or accuracy but prefers, for the convenience of students, to indicate wherever material is readily available in English.

The author's last name alone is used in reference to the following sources:

Alfred H. Barr, Jr. *Matisse: His Art and His Public* (New York: The Museum of Modern Art, 1951).

Georges Duthuit. *The Fauvist Painters* (New York: Wittenborn, Schultz, 1950).

Jack D. Flam. *Matisse on Art* (London: Phaidon, 1973).

Ellen C. Oppler. "Fauvism Reexamined" (Ph.D. dissertation, Columbia University, 1969).

INTRODUCTION

1. Duthuit, p. 35.

2. "Oh, do tell the American people that I am a normal man," Matisse implored Clara T. MacChesney, who, when she arrived to interview him in 1912, was somewhat surprised not to find "a long-haired, slovenly dressed eccentric." See her "A Talk with Matisse, Leader of post-Impressionism," *New York Times Magazine*, March 9, 1913. (Reprinted in Flam, pp. 49-53.)

3. See below, chap. 1, p. 30 and n. 52.

4. Barr, p. 54.

5. E. Tériade, "Constance du fauvisme," *Minotaure* (Paris), October 15, 1936, p. 3. (Flam, p. 74.)

6. E. Tériade, "Matisse Speaks," *Art News Annual* (New York), 1952, p. 43. (Flam, p. 132.)

7. Although it is possible to speak of the Fauve artists as having had certain "Expressionist" ambitions—as evidenced by Matisse's published concern with "expression" (see below, p. 139)—we must await more precise study of the concept and usage of the term before too readily describing Fauvism as an Expressionist movement. A proper distinction certainly should be made between French and German art in this respect: Fauvism is often treated as a parallel movement to the Brücke group. Donald E. Gordon in "Kirchner in Dresden," *The Art Bulletin* (New York), September-December 1966, pp. 335-61, argues convincingly that this concept should be reconsidered. See postscript for further comments.

8. Gaston Diehl's *The Fauves* (New York: Abrams, 1975) valuably illustrates the idea of Fauvism as a broad European form of color painting derived from French sources.

9. Both popular studies of Fauvism, such as Jean Leymarie's *Fauvism* (Geneva: Skira, 1959) and Joseph-Emile Muller's *Fauvism* (New York: Praeger, 1967), and scholarly accounts such as Ellen C. Oppler's dissertation, "Fauvism Reexamined," exclude Rouault from their discussions.

10. Hence, Valtat was represented in depth in the important exhibition, "Le Fauvisme français et les débuts de l'expressionnisme allemand" (Paris, Musée National d'Art Moderne and Munich, Haus der Kunst, 1966). See below, p. 29, for discussion of Valtat's relationship to Fauvism.

11. The term is Meyer Schapiro's.

CHAPTER ONE: THE FORMATION OF FAUVISM

1. For details of the composition of Moreau's studio, see *Gustave Moreau et ses élèves* (Marseilles: Musée Cantini, 1962). For the period of Matisse's life discussed in this chapter, see Barr, pp. 15-59.

2. See Léonce Bénédite, "La Collection Caillebotte au Musée du Luxembourg," *Gazette des Beaux-Arts* (Paris), March 1897, p. 256.

3. Reported by Barr, p. 15.

4. *Gil Blas* (Paris), March 23, 1905. For the development of critical interest in "the atelier Moreau," and the way in which this interest prepared for the reception given the Fauves in 1905, see William J. Cowart III, "'Ecoliers' to 'Fauves': Matisse, Marquet, and Manguin Drawings: 1890-1906" (Ph.D. dissertation, The Johns Hopkins University, 1972), pp. 194-201.

5. The exception here is Rouault, who was closest to Moreau of all the pupils, both in friendship and in style.

6. It is uncertain precisely when Matisse was asked to leave. Cormon's excuse, that Matisse was too old at thirty, would indicate a date early in 1900. See Barr, p. 38.

7. Raymond Escholier, *Henri Matisse* (Paris: Floury, 1937), pp. 77-78.

8. See Charles Chassé, *Les Fauves et leur temps* (Lausanne-Paris: Bibliothèque des Arts, 1963), pp. 127-28, for clarification of the details and date of this meeting.

9. For precise details of Braque's early career, see Douglas Cooper, *Georges Braque* (Munich: Haus der Kunst, 1963), and Stanislas Fumet, *Georges Braque* (Paris: Maeght, 1965).

10. See Bernard Esdras-Grosse, "De Raoul Dufy à Jean Dubuffet: ou la descendance du 'Père' Lhuillier," *Etudes Normandes* (Rouen), no. 59, p. 33.

11. For van Dongen's early background, see Louis Chaumeil, *Van

Dongen: L'Homme et l'artiste—la vie et l'oeuvre (Geneva: Pierre Cailler, 1967).

12. Duthuit, "Le Fauvisme," *Cahiers d'Art* (Paris), 1929, p. 260.

13. The term "proto-fauve" is used by Barr (p. 49), and "pre-Fauvism" by Leymarie (*Fauvism*, p. 27).

14. Duthuit, p. 23.

15. Part of the reason for this was undoubtedly the delay in official recognition of the Impressionists—the Caillebotte Bequest was only opened to the public in 1897. The advanced artists, however, still generally considered themselves heirs to Impressionism (see Charles Morice's "Enquête" cited below, p. 32). Monet and Renoir were still active and exhibiting; Pissarro continued to advise members of the younger generation, Matisse included.

16. The French word *impression* does not carry the meaning of imprecision that the English term does, but suggests instead a precise record, such as that created by a printer's plate.

17. Gauguin's late subjects, however, are essentially geographical extensions of Impressionist subjects, that is, views of a world of pleasure not merely outside the sophisticated metropolis but outside Europe.

18. *La Revue Blanche* (Paris), May 1, May 15, July 1, 1898. See Paul Signac, *D'Eugène Delacroix au néo-impressionnisme*, ed. Francoise Cachin (Paris: Hermann, 1964).

19. See Oppler, p. 97.

20. See especially Vuillard's *Self-Portrait* of 1891, illustrated in Jacques Salomon, *Vuillard* (Paris: Gallimard, 1968), p. 47.

21. Lawrence Gowing, *Henri Matisse: 64 Paintings* (New York: The Museum of Modern Art, 1966), p. 6.

22. Barr, pp. 38–39. The work, painted ca. 1880, appears in Lionello Venturi, *Cézanne: Son Art—son oeuvre* (Paris: Paul Rosenberg, 1936), no. 381.

23. Matisse's *Interior with Harmonium* of 1900 is often cited as a proto-Fauve work. Its color certainly points toward Fauvism, but in composition it looks more surely to the still lifes after 1910. See Barr, p. 49.

24. Marquet's painting is dated 1898. This, however, is probably a later addition, since Matisse did not return to Paris from Toulouse until early in 1899.

25. See Pierre Cabanne, *Henri Manguin* (Neuchâtel: Ides et Calendes, 1964), pp. 7 *ff.*

26. Duthuit, p. 24.

27. This work has traditionally been dated 1901. In *Henri Matisse. Exposition du centenaire* (Paris: Grand Palais, 1970), Pierre Schneider gives the later date.

28. See Albert E. Elsen, *The Sculpture of Henri Matisse* (New York, Abrams, n.d.), pp. 25-48, for a valuable discussion of Matisse's *The Serf* of 1900-03 and its relation to his painting, as well as for the influence of Cézanne and the relationship of Matisse's painting and sculpture in general.

29. Duthuit, p. 23.

30. Both Matisse and Marquet were making sketches of street scenes around 1900. Matisse destroyed a large number of these when reorganizing his studio in 1936 (Raymond Escholier, *Matisse: A Portrait of the Artist and the Man* [New York: Praeger, 1960], p. 34). Marquet's cannot be securely dated, but early examples appear in *Albert Marquet* (Bordeaux: Galerie des Beaux-Arts, 1975), nos. 97-100.

31. André Derain, *Lettres à Vlaminck* (Paris: Flammarion, 1955), p. 48. Letter of January 9, 1902.

32. According to Derain, this relationship was noticed by contemporary critics (*Lettres*, p. 52).

33. *L'Assiette au Beurre* (Paris), October 26, 1901. The cover and sample illustrations are reproduced in Chaumeil, *Van Dongen*, figs. 26-30.

34. This exhibition is emphasized by John Rewald, in "Quelques notes et documents sur Odilon Redon," *Gazette des Beaux-Arts*, November 1956, and considered in detail by Oppler (pp. 87 *ff.*), to whose account the following discussion is indebted.

35. André Salmon, *La Jeune Peinture française* (Paris: Albert Messein, 1912), pp. 6-7.

36. Matisse, Letter to John Rewald, February 12, 1949. In Rewald, "Quelques notes," p. 122.

37. Barr, p. 40.

38. The upper area of this painting suggests Redon, but it also combines Vlaminck's broken-touch Fauvism of 1906 with the further influence of Cézanne, who began to affect Vlaminck's art toward the end of that year. See below, p. 83.

39. See, for example, Leymarie, *Fauvism*, p. 22, and *Le Fauvisme français* (Paris: Musée National d'Art Moderne, 1966; preface by Bernard Dorival, Michel Hoog, and Leopold Reidemeister), pp. 164-68, where he is considered a precursor of Fauvism.

40. *Gil Blas*, October 5, 1906.

41. See Raymond Cogniat, *Louis Valtat* (Neuchâtel: Ides et Calendes, 1963); *Hommage—Souvenir à Albert André, 1869-1954* (Cagnes-sur-Mer: Musée d'Art Méditerranéen Moderne, 1958); Jean Loize, *De Maillol et codet à Segalen: Les amitiés du peintre Georges-Daniel de Monfreid et ses reliques de Gauguin* (Paris: n.p., The Author, 1951).

42. See *Valtat et ses amis. Albert André, Camoin, Manguin, Puy* (Besançon: Musée des Beaux-Arts, 1964).

43. See *Le Fauvisme français*, nos. 106-09, and Jean-Paul Crespelle, *Les Fauves* (Neuchâtel: Ides et Calendes, 1962), pls. 72-76.

44. For example, *Promenade aux Champs-Elysées*, 1905. (*Le Fauvisme français*, no. 109.)

45. Duthuit, p. 43.

46. Oppler, p. 93.

47. Quoted by Leymarie, *Fauvism*, p. 41.

48. *Ibid.*, p. 46.

49. Florent Fels, *Vlaminck* (Paris: Marcel Seheur, 1928), p. 39.

50. *Dangerous Corner* (London: Elek Books, 1961), p. 147.

51. *Ibid.*, p. 74.

52. Duthuit, pp. 27–28.

53. See Vlaminck, *Portraits avant décès* (Paris: Flammarion, 1943), pp. 18–19.

54. *Lettres*, p. 27.

55. *Ibid.*, p. 116.

56. See Derain's *Trees*, in Georges Hilaire, *Derain* (Geneva: Pierre Cailler, 1959), no. 14, and *The Bedroom*, in *Le Fauvisme français*, no. 18.

57. The principal Fauve exhibitions are summarized in Duthuit, pp. 115–17, and *Le Fauvisme français*, p. 15. More detailed information will be found in Donald E. Gordon, *Modern Art Exhibitions 1900–1916*, 2 vols. (Munich: Prestel-Verlag, 1974), and in the relevant Salon catalogues.

58. For the Weill gallery, see her memoirs, *Pan! dans l'oeil* (Paris: Librarie Lipschutz, 1933), in which are given details of exhibitions and sales.

59. Quoted by Barr, p. 45.

60. The popularity of Neo-Impressionism among younger artists is to be explained not only by the way it transformed Impressionism into a readily learned system (and one that admitted high color) but also, more prosaically, by Signac's presidency of the Salon des Indépendants. To work in this style was to gain his influential support.

61. It is said that Matisse strongly disliked Dufy and refused to let his paintings be hung with those of the other Fauves. It is significant that Duthuit (Matisse's son-in-law) hardly mentions Dufy in *The Fauvist Painters.*

62. Leymarie, *Fauvism*, p. 23.

63. *Gil Blas*, March 23, 1905. Vauxcelles, however, disliked *Ordre, luxe et volupté* [*sic*] and suggested that Matisse abandon his Neo-Impressionist experiments. For additional details of this exhibition, see Marcel Giry, "Le Salon des Indépendants de 1905," *L'Information d'Histoire de l'Art* (Paris), May–June 1970, pp. 110–14.

64. *Mercure de France* (Paris), April 15, 1905.

65. *Mercure de France*, August 1, 1905. See Oppler, pp. 35–37, and Marcel Giry, "L'Oeuvre de Cézanne à la veille du fauvism," *Revue Marseille*, no. 84–85, pp. 11–17, for valuable discussions of the "Enquête."

66. The questionnaire was sent to such a wide range of artists that no definite conclusions could be drawn from the responses.

67. *Mercure de France*, April 15, 1905.

68. Letter of September 7, 1904. Quoted in Barr, p. 53.

69. Quoted by Leymarie, *Fauvism*, p. 61.

70. Manguin's *Nude in the Studio* (p. 33) is dated on the canvas 1903. Cowart ("'Ecoliers' to 'fauves,'" p. 222) suggests that the date is a later addition, and that the work more likely belongs to the autumn of 1904. This is a convincing placement, if only because it suggests one solution to the questionable attribution of "Matisse's" *Marquet Painting a Nude* of 1904–05 (p. 34). The latter work was ascribed to Matisse when it entered the Musée National d'Art Moderne, Paris, and was discussed as such (together with Marquet's *Matisse Painting in Manguin's Studio* (p. 35) and a companion work by Manguin) in Bernard Dorival, "Nouvelles Oeuvres de Matisse et de Marquet au Musée d'Art Moderne," *La Revue des Arts* (Paris), May–June 1957, pp. 115–20. It was published as a Matisse in *Le Fauvisme français*, no. 92, beside Matisse's so-called *Study for "Marquet Painting a Nude,"* no. 91. This monogrammed "study," however, was probably the only work that Matisse made in Manguin's studio on this occasion. *Marquet Painting a Nude* is most likely the work of one of Matisse's companions.

As Cowart points out (p. 222), the common presumption that Manguin did not share in the Divisionist experiments of Matisse and Marquet is already belied by his *Nude in the Studio*. Dating this work to the autumn of 1904 not only is supported by its relationship to a 1904 painting by Puy of the same model in the same pose (Cowart, fig. 245) and to 1904 drawings made by Manguin (Cowart, figs. 229–30), but also supports the thesis that Manguin further developed his Divisionist touch in the winter of 1904–05 and produced *Marquet Painting a Nude* before abandoning this style. The problem of attributing this work to Manguin, however, is that the Divisionist touch of his *Nude in the Studio* is so tentative as to afford no real basis of comparison with *Marquet Painting a Nude*, and that no other of Manguin's paintings so boldly adopts a self-consciously avant-garde idiom. Moreover, this attribution rests on the assumption that the title is an accurate one. It is impossible to tell if Marquet is indeed represented. If this is not the case, then Marquet himself emerges as the probable creator of this work, and Manguin as its subject. For Marquet to make companion paintings of Matisse and then Manguin painting a nude seems entirely in character.

71. The phrase is Robert L. Herbert's (*Neo-Impressionism* [New York: Solomon R. Guggenheim Museum, 1968], p. 113). The study is reproduced in the catalogue *Albert Marquet* (San Francisco: Museum of Art, 1958), pl. 12.

72. *Portrait of André Rouveyre*, of 1904, is reproduced in *Le Fauvisme français*, no. 69. The pose recalls Manet's portrait of Théodore Duret; the placement of the signature, his *Fifer.*

73. Camoin first visited Cézanne in 1901, and then again late in 1904. His reply to Morice's "Enquête" (*Mercure de France*, August 1, 1905) mentions these meetings and quotes from Cézanne's letters to him.

74. It especially bears comparison with a Cézanne portrait that had been exhibited at the 1904 Salon d'Automne and entered the Stein collection (Venturi, *Cézanne*, no. 369), and with one from the Vollard collection (*ibid.*, no. 572).

75. The vivid costume of this work (*Le Fauvisme français*, no. 12) only serves to accentuate the utterly conventional modeling of the face and arms.

76. The Puy is illustrated in *Le Fauvisme français*, no. 103. The Vlaminck is marked verso "1904." See below, p. 68, for discussion of the dating of Vlaminck's oeuvre.

77. Fénéon wrote the introduction to the catalogue of van Dongen's first one-man exhibition at Vollard's in November 1904. It is reprinted in Françoise Cachin, ed., *Fénéon: Au delà de l'impressionisme* (Paris: Hermann, 1966), pp. 150-51.

78. *Mercure de France*, April 15, 1905. The painting is reproduced in *Le Fauvisme français*, no. 111.

79. *Gil Blas*, March 23, 1905.

80. Denys Sutton, *André Derain* (London: Phaidon, 1959), p. 14.

81. For example, by Oppler (p. 108), who nevertheless recognizes the source of this method in Cézanne's work. In Cézanne, the arbitrary color breaks were derived from *chiaroscuro* modeling. In Derain's painting of 1906-07 we see him returning this device to its Cézannist source, and in his subsequent painting, to *chiaroscuro* methods themselves.

82. The comparison is not a fortuitous one. Derain writes that this visit to London, as well as the one he made in 1906 (see n. 84), was arranged by Vollard, who "sent me in the hope of renewing completely at that date the expression which Claude Monet had so strikingly achieved which has made a very strong impression on Paris in the preceding years." Letter to the President of the Royal Academy, London, May 15, 1953. Ronald Alley, *Tate Gallery Catalogues; The Foreign Paintings, Drawings and Sculpture* (London: The Tate Gallery, 1959), pp. 64-65.

83. See Herbert, *Neo-Impressionism*, p. 209, for a discussion of this work.

84. The chronology of Derain's painting is highly problematical, since his style changed rapidly throughout the Fauve period. His two visits to London, in 1905 and 1906, are not precisely documented. The second was certainly in the spring of 1906 (see below, p. 81). Opinions vary widely on the first. Sutton (*Derain*, p. 17) favors the autumn of 1905 for the Neo-Impressionist paintings. Oppler (p. 104) notes the anomaly in placing these works after the summer of 1905, when Derain worked with Matisse at Collioure, and suggests a spring visit to London. Anthea Callen (in the catalogue *The Impressionists in London* [London: The Arts Council of Great Britain, 1973], pp. 71 and 79, n. 5) doubts whether any paintings were made on the 1905 visit. Oppler's reasoning is most easily supported, though nothing is yet proven on this topic.

85. *L'Ermitage* (Paris), May 15, 1905. Denis's early criticism may be conveniently studied in his anthology, *Théories (1890-1910): Du symbolisme et de Gauguin vers un nouvel ordre classique*, 4th ed. (Paris: Rouart et Watelin, 1920); for this review, see pp. 196-97.

86. Francis Lepeseur, "L'Anarchie artistique—Les Indépendants," *La Rénovation Esthétique* (Paris), June 1905, pp. 91-96. Oppler (pp. 193-94) says that Lepeseur was a pseudonym for Bernard himself, but gives no source. Giry ("Le Salon des Indépendants," p. 113, n. 10) notes that Lepeseur has been identified with Louis Lormel, which in turn was apparently a pseudonym for Louis Libaude, co-founder of *La Rénovation Esthétique*.

87. Barr, p. 40.

88. See Vlaminck, *Portraits avant décès*, pp. 17-18.

89. Vlaminck, *Dangerous Corner*, pp. 58-63. Most of the Fauves, like all young Frenchmen except those of privileged background or with special dispensations, were compelled to spend three years in military service. There they not only suffered from rigid class distinctions but were at times forced by officers to break up assemblies of striking workers, with whom they sympathized. Vlaminck's development of left-wing ideas was undoubtedly accelerated by his attendance, while serving in the army, at Dreyfus's retrial, which marked a new polarization of French society between liberals and conservatives. For a detailed discussion of the Fauves' anarchist sympathies, see Oppler, pp. 184-95, to which my account is indebted.

90. *Dangerous Corner*, p. 64.

91. Derain entered the army at the end of 1901 and encountered disillusioning experiences similar to those Vlaminck had suffered earlier. See Derain, *Lettres*, pp. 132-33.

92. Crespelle, *Les Fauves*, p. 153.

93. See Eugenia W. Herbert, *The Artist and Social Reform, France and Belgium, 1885-1898* (New Haven: Yale University Press, 1961), chaps. 5 and 6, for the political affiliations of the Neo-Impressionists.

94. See Paul Yaki, *Le Montmartre de nos vingt ans* (Paris: G. Girard, 1933), pp. 100 *ff.*

95. *L'Ermitage*, December 15, 1906. (*Théories*, p. 221.)

96. *Gil Blas*, October 5, 1906.

97. *La Rénovation Esthétique*, November 1908, p. 52.

98. *La Revue Hebdomadaire* (Paris), October 17, 1908.

99. *La Grande Revue* (Paris), December 25, 1908.

100. By July 1905, Derain spoke of his having had enough of anarchism (*Lettres*, p. 156). Only Vlaminck retained his left-wing sympathies through the rest of his life.

101. See Daniel Robbins, "From Symbolism to Cubism: the Abbaye de Créteil," *Art Journal* (New York), Winter 1963, pp. 111-16.

102. *Gil Blas*, October 5, 1906.

103. See below, p. 43, for a discussion of the reactions to the Salon d'Automne of 1905.

104. "Braque—La Peinture et nous," ed. Dora Vallier. *Cahiers d'Art*, October 1954, p. 14; Vlaminck, *Paysages et personnages* (Paris: Flammarion, 1953), p. 85.

105. See Apollinaire's amusing early account of 1907, in *Apollinaire on Art: Essays and Reviews 1902-1918*, ed. Leroy C. Breunig (New York: Viking, 1972), p. 33.

106. See Derain, *Lettres*, p. 42.

107. See Marcel Raymond, *From Baudelaire to Surrealism* (New York: Wittenborn, Schultz, 1950), pp. 57-61, and Oppler, pp. 198-200.

108. Tériade, "Matisse Speaks." (Flam, p. 132.)

109. *Ibid.*

110. *Gil Blas*, October 17, 1905.

111. Desvallières was vice-president of the Salon d'Automne and

responsible for the hanging of the works. See Chassé, *Les Fauves et leur temps*, p. 9.

112. Marque (not Marquet, with whom he is occasionally confused) exhibited a marble *Portrait of Marthe Lebasque* and a bronze *Torso of a Child* at the Salon d'Automne. The latter was the "Donatello" bust. According to Michel Hoog, it was bought by the state and sent to the Bordeaux Museum, where it was destroyed during World War II. (Conversation with the author, October 1975.) Marque's *Portrait of Jean Baignères* (p. 44), exhibited at the Indépendants of 1905, serves to illustrate his work of this period.

113. *Gil Blas*, October 17, 1905. Vauxcelles may have been punning on "Daniel in the Lions' Den," and have coined the phrase in the context of seeing the Douanier Rousseau's *Le Lion, ayant faim, se jette sur l'antilope*, which was exhibited in the Salon. Crespelle's suggestion (*Les Fauves*, p. 12) that the name may have been provoked by Matisse's hairy overcoat, which made him look like a bear, seems an unlikely one. For details of other versions of the discovery and further discussions of this Salon, see Marcel Giry, "Le Salon d'Automne de 1905," *L'Information d'Histoire de l'Art*, January-February 1968, pp. 16-25.

114. *Gil Blas*, October 26, 1905.

115. *L'Illustration* (Paris), November 4, 1905, pp. 294-95, from which the quotations below derive.

116. See the comments accompanying the work in *L'Illustration*, p. 294.

117. *La Plume* (Paris), June 1, 1905.

118. For discussion of the source of Mauclair's statement, see Oppler, p. 21, n. 3.

119. See Crespelle, *Les Fauves*, p. 7.

120. Michel Puy, *L'Effort des peintres modernes* (Paris: Albert Messein, 1933), pp. 62-63.

121. *Société du Salon d'Automne—Catalogue de la 3ᵉ exposition* (Paris: 1905), p. 19. See also Vauxcelles, *Gil Blas*, October 17, 1905.

122. André Gide, "Promenade au Salon d'Automne," *Gazette des Beaux-Arts*, December 1905, pp. 476-85.

123. Leo Stein, *Appreciation: Painting, Poetry and Prose* (New York: Crown, 1947), pp. 158-59.

124. *Gil Blas*, October 17, 1905.

CHAPTER TWO: THE FAUVIST WORLD

1. Derain, *Lettres*, pp. 154-55.

2. *Ibid.*, p. 161.

3. *Ibid.*, pp. 148, 156-57.

4. It is significant that Derain now reserved the flatter infilling for the upper part of the painting to keep it from receding, and used the Neo-Impressionist-derived touch in the foreground, rather than the other way around (as he had done in *The Bridge at Le Pecq*).

5. Gauguin was represented in the first Salon d'Automne of 1903.

In 1904 and 1905, Vollard held major retrospectives of his work.

6. Raymond Escholier, *Matisse, ce vivant* (Paris: A. Fayard, 1956), p. 69.

7. In Gauguin's notes, then in manuscript form in de Monfreid's possession, he observed that effects of light are better suggested by the contrast of heightened colors than of values. See Jean de Rotonchamp, *Paul Gauguin* (Paris: Edouard Druet, 1906), p. 211. Since Rotonchamp's book was published in 1906, it seems reasonable to suppose that de Monfreid had ready access to the notes in the summer of 1905. He might well have discussed them with Matisse and Derain. Klaus Perls has noted that even the most "abstract" of Derain's Collioure paintings, for example, *Fishermen at Collioure* (p. 50), are nevertheless highly realistic in effect: the brilliant red accents on the water in this painting stand specifically as the representation of the effects of light. (Conversation with the author, November 1975.)

8. Not only would they have seen the exhibitions of 1903-05, but they were well aware of the importance of Gauguin even earlier. Around 1900 Matisse obtained from Vollard a Gauguin portrait, *Jeune Homme à la fleur* (Georges Wildenstein, *Gauguin* [Paris: Les Beaux-Arts, 1964], no. 422). See Barr, pp. 38-39.

9. *Lettres*, p. 150.

10. *Ibid.*, p. 161.

11. *Ibid.*

12. See Herbert, *Neo-Impressionism*, pl. 15 and accompanying text.

13. Guillaume Apollinaire, "Henri Matisse," *La Phalange* (Paris), December 1907, pp. 481-85. (Flam, p. 31.)

14. Gowing, *Henri Matisse*, p. 9. See also Gowing's discussion of Matisse's use of complementary colors. Matisse was deliberate and methodical in his new procedures of 1905. He later made a chart contrasting the Neo-Impressionists' modulation from red to blue via intermediate hues and his own direct juxtaposition of them. See Frank A. Trapp, "The Paintings of Henri Matisse: Origins and Early Development (1890-1917)" (Ph.D. dissertation, Harvard University, 1951), p. 99 and fig. 74.

15. The stylistic self-consciousness that allowed Matisse to work in a mixed-technique form is a particularly modern characteristic, and may be usefully compared in this respect with Picasso's work across a wide range of styles.

16. *La Grande Revue*, December 25, 1908. (Flam, pp. 36-37.)

17. *Gil Blas*, October 17, 1905.

18. Barr, p. 62.

19. E. Tériade, "Visite à Henri Matisse," *L'Intransigeant* (Paris), January 14 and 22, 1929. (Flam, p. 59.)

20. Sarah Stein's Notes, 1908. (Flam, p. 45.)

21. Matisse apparently obtained either one or two van Gogh drawings in 1897 when he met van Gogh's friend J. P. Russell (Barr, pp. 35 and 530). The catalogue of the 1905 Indépendants lists van Gogh drawings in Matisse's possession. He also saw the 1901 van Gogh exhibition at Bernheim-Jeune's, for it was there that Derain introduced him to Vlaminck. Although Matisse reputedly

thought less of van Gogh than of Gauguin, or even of Redon (Barr, p. 109), he seems certainly to have been affected by him in the Fauve period.

22. Muller also compares these two works (*Fauvism*, pp. 148–50) but without suggesting Matisse's familiarity with the van Gogh.

23. *L'Illustration*, November 4, 1905, p. 295.

24. *Ibid.*

25. *Gil Blas*, October 17, 1905.

26. The phrase is William Rubin's, in conversation with the author.

27. *La Grande Revue*, December 25, 1908. (Flam, p. 36.)

28. Duthuit, p. 34.

29. *Gil Blas*, October 17, 1905.

30. Monet's pair of flag paintings were in fact made on the national holiday of June 30, 1878 (John Rewald, *A History of Impressionism* [New York: The Museum of Modern Art, 1961], p. 419; and p. 418, for Manet's Bastille Day painting). The authenticity of the van Gogh has been questioned. See J. B. de la Faille, *The Works of Vincent van Gogh* (New York: Reynal, 1970), no. F 222, p. 118.

31. *Gil Blas*, October 17, 1905. Manguin's colleague at Saint-Tropez had been in personal contact with Cézanne (see above, chap. 1, n. 73), and doubtless communicated his enthusiasm to his friends.

32. *Gil Blas*, October 17, 1905. For illustrations of Marquet's Saint-Tropez paintings, see *Albert Marquet* (Bordeaux: Galerie des Beaux-Arts, 1975), nos. 24–27.

33. For example, *La Creuse (soleil couchant)*, and *La Creuse (matinée)*. Other titles of the same nature appear in Friesz's Salon entries, even through to 1906.

34. In the catalogue introduction to Friesz's one-man show at the Druet Gallery. Reprinted in Jean de Saint-Jorre, *Fernand Fleuret et ses amis* (Coutances: Imprimerie Bellée, n.d.), p. 57.

35. First reported in Marcelle Berr de Turique, *Raoul Dufy* (Paris: Floury, 1930), p. 81.

36. *Mercure de France*, August 15, 1905.

37. See Fénéon's introduction to the catalogue of this exhibition. Reprinted in *Fénéon: Au delà de l'impressionisme*, pp. 150–51.

38. See Pierre Daix and Georges Boudaille, *Picasso: The Blue and Rose Periods* (Greenwich, Conn.: New York Graphic Society, 1967), especially pp. 156–59.

39. *Gil Blas*, October 17, 1905.

40. The work is dated 1902, but is given to 1904 by Fels (*Vlaminck*, p. 15). Vauxcelles was clearly referring to this work rather than to a later version of the same subject in *Gil Blas*, March 23, 1905. Although it is likely that Vlaminck would show recent paintings in the Salons, we cannot presume that he always did so.

41. See Vlaminck, *Dangerous Corner*, p. 70.

42. There are certain common problems in studying the work of Derain and Vlaminck, since both varied their styles considerably throughout the Fauve period. But whereas with Derain we are helped somewhat by locations, notably Collioure, London, and L'Estaque, this is not the case with Vlaminck, who mostly worked around Chatou. Vlaminck, moreover, almost certainly falsified the dates of his early paintings to support his contention that he invented Fauvism in 1900. All of the dating in John Rewald's *Les Fauves* (New York: The Museum of Modern Art, 1952) was provided by the respective artists, which makes the catalogue listings invaluable, while leaving the problem of Vlaminck's own dates. (Conversation with the author, November 1975.) Some of the dates given in *Le Fauvisme français* clearly demand revision. For Vlaminck, the Perls Galleries catalogue, *Vlaminck: His Fauve Period, 1903–1907* (New York: 1968), contains the best stylistically based attribution of dates (though on some occasions they seem to the present author to be slightly early). Oppler presents a convincing case that Vlaminck's Fauve period only fully developed after the Salon d'Automne of 1905, but does not account for the possibility of earlier paintings being exhibited at a later date, or of Vlaminck's reworking earlier paintings after they had been exhibited. I am grateful here to Klaus Perls for suggestions regarding such difficulties. It is to be hoped that the Vlaminck and Derain oeuvre catalogues now in preparation by Paul Petrides and Michel Kellermann, respectively, will cast new light on the development of Fauvism.

43. Paintings of earlier in 1905 and even of 1904—for example, *The Kitchen* (illustrated in *Le Fauvisme français*, no. 126), which must be given to 1904 or early 1905, despite the fact that it was not exhibited until the Indépendants of 1906—show high color, but Vlaminck's characteristic Fauve style did not emerge until later.

44. Reported by Cooper, *Georges Braque*, pp. 30–31.

45. Quoted by Barr, p. 82.

46. Duthuit, p. 61.

47. Barr, p. 81.

48. *Gil Blas*, March 20, 1906.

49. *Gazette des Beaux-Arts*, December 1905, p. 483.

50. *Mercure de France*, April 15, 1906.

51. *L'Ermitage*, November 15, 1905. (*Théories*, p. 208.)

52. Barr, pp. 64 and 81.

53. *L'Ermitage*, November 15, 1905.

54. Stein, *Appreciation*, p. 161.

55. See Derain, *Lettres*, p. 156.

56. The painting was acquired by Vollard, probably when he bought the contents of Vlaminck's studio in spring 1906. As Oppler notes (p. 114, n. 2), the bare trees suggest that it was painted in the autumn or spring.

57. Vlaminck, *Dangerous Corner*, p. 74.

58. Duthuit, p. 27.

59. Fels, *Vlaminck*, p. 39.

60. Leymarie, *Fauvism*, p. 49.

61. Oppler, p. 350.

62. Vlaminck exaggerates his dependence upon primaries. By late 1906, for example, in *The Circus* (p. 57), he was using subtle modulations.

63. The psychological, not physical, primary colors are the four hues blue, green, yellow, and red, each of which has no resemblance to the others.

64. Matisse, "Rôle et modalités de la couleur," in Gaston Diehl, *Problèmes de la peinture* (Lyons: Confluences, 1945), pp. 237–40. (Flam, p. 99.)

65. A similar zoned effect may be observed in the *Tugboat at Chatou* (William S. Lieberman, ed., *Modern Masters: Manet to Matisse* [New York: The Museum of Modern Art, 1975], p. 117), where the blue water is surrounded by complementary oranges and punctuated by the startling red bands of the two boats.

66. In some cases the inconsistencies appear to be the result of Vlaminck's having reworked earlier paintings, as with *Les Coteaux à Rueil* (Musée National d'Art Moderne, Paris), completed in 1906.

67. *Gil Blas*, October 5, 1906.

68. Vlaminck, *Paysages et personnages*, p. 33. His *Reclining Nude* (p. 67) was probably painted in this period, which shows that his style could change dramatically from painting to painting.

69. See François Daulte, "Marquet et Dufy devant les mêmes sujets," *Connaissance des Arts* (Paris), November 1957, pp. 87–93.

70. Maurice Laffaille's oeuvre catalogue dates *Fête nautique* to 1905 (*Raoul Dufy* [Geneva: Motte, 1972–73], no. 113). The painting is clearly dated 1906, however, and belongs stylistically with the works of early that year.

71. See Laffaille, *Dufy*, nos. 142–45.

72. Paul Jamot, *Gazette des Beaux-Arts*, December 1906, p. 480.

73. See Maximilien Gauthier, *Othon Friesz* (Geneva: Pierre Cailler, 1957), pls. 10 and 11.

74. Only in the summer of 1906 did Matisse paint nudes in landscape from life, the studies for the *Bonheur de vivre* including figures having been made in the studio in Paris. (Information from Pierre Schneider, November 1975.)

75. Barr, p. 77.

76. See above, chap. 1, n. 82.

77. Sutton, *Derain*, p. 18.

78. Derain dates this painting to "about the month of April 1906" in London, with retouching taking place after his return to Paris. Letter to the President of the Royal Academy, London, May 15, 1953. *Tate Gallery Catalogues; The Foreign Paintings*, pp. 64–65.

79. Leymarie (*Fauvism*, pp. 112–13) shows a striking comparison between Derain's *Three Trees* and a *Decorative Landscape* of 1889 (Nationalmuseum, Stockholm) now usually attributed to Serusier. Van Gogh's *Park of the Hospital Saint-Paul*, 1889 (de la Faille, *van Gogh*, no. F 640, p. 255), is also compositionally similar to Derain's painting, although there is no evidence that Derain saw either of these paintings.

80. This work has traditionally been dated to 1905 (*Vlaminck: His Fauve Period*, no. 13) or to 1905-06 (Oppler, pl. 79). The Fauve-Cézannist combination, however, suggests a date of 1906-07.

81. See *Georges Braque: An American Tribute* (New York: Saidenberg Gallery, 1964), no. 3, and Cooper, *Georges Braque*, no. 6.

82. Braque sold all of the six paintings he exhibited, five to Wilhelm Uhde and one to Kahnweiler.

83. *Lettres*, p. 152.

84. *La Grande Revue*, December 25, 1908. (Flam, p. 38.)

85. *Ibid.* (Flam, p. 39.)

86. Duthuit, p. 46.

CHAPTER THREE: THE PASTORAL, THE PRIMITIVE, AND THE IDEAL

1. See Werner Hofmann, *The Earthly Paradise* (New York: Braziller, 1961), p. 387; and chap. 11 for interesting background to the themes discussed here.

2. The title *Joie de vivre* was given to the work by Albert C. Barnes when it entered his collection, and is commonly, though erroneously, used as an alternative to Matisse's title.

3. See Isabelle Compin, *H. E. Cross* (Paris: Quatre Chemins-Editart, 1964), especially nos. 96, 97, 144, 147, and Herbert, *Neo-Impressionism*, pl. 15 and accompanying text. Although bathers or nymphs are rarer in Signac's work than in Cross's, Signac importantly contributed to the iconography of the Golden Age theme. His painting of workers in an idyllic setting, *Au temps d'harmonie* of 1893-95 (p. 99), not only liberated modern figure compositions from the bourgeois frame of reference of contemporaneous works by Manet, Seurat, and Renoir (see text discussion below) but from a contemporary setting as well. At the Indépendants of 1895, the Signac was exhibited under the following title (taken, apparently, from the writings of the anarchist Malato): "Au temps d'harmonie. L'âge d'or n'est pas dans le passé, il est dans l'avenir." (See Herbert, *The Artist and Social Reform*, p. 191, and the catalogue *Signac* [Paris: Musée du Louvre, 1963-64], no. 51.) Although the proletarian reference of Signac's painting separates it from comparable Fauve works, its idealized (though future) setting prepares for the timeless ones of Matisse and Derain.

4. A particularly striking comparison is Cézanne's *Les Grandes Baigneuses* of 1898-1905, in the Philadelphia Museum of Art.

5. See Barr, pp. 17 and 60, for comparison with Puvis's *Pleasant Land*, and Richard J. Wattenmaker, *Puvis de Chavannes and the Modern Tradition* (Toronto: Art Gallery of Ontario, 1975), pp. 12-13 and 154, for a discussion of Matisse's indebtedness to Puvis.

6. See Frank A. Trapp, "Art Nouveau Aspects of Early Matisse," *Art Journal*, Fall 1966, p. 5.

7. See Barr, p. 88. Mantegna's *Parnassus* in the Louvre is a likely precedent for the ring of dancers, though John Hallmark Neff has recently shown a striking similarity between the dancers and Goya's *Blindman's Buff* of 1789 (p. 101), citing Matisse's

interest in Goya's art. "Matisse and Decoration: The Shchukin Panels," *Art in America* (New York), July-August 1975, p. 40.

8. Oppler (p. 176) draws attention to Maurice Denis's *Danse d'Alceste* of 1904 (p. 101; reproduced and discussed in Adrien Mithouard, "Maurice Denis," *Art de Décoration*, July 1907, pp. 6-8) as a source for dancers, flutist, and reclining figures.

9. See Barr, pp. 88-89; also below, pp. 102-05 for Derain's companion work.

10. Robert Rosenblum, *Ingres* (New York: Abrams, 1967), p. 168 and pl. 47, and for Matisse's development of Ingres's theme, pp. 168-69. Some preparatory studies for Ingres's *L'Age d'or* were exhibited at the Salon d'Automne of 1905. We should be wary, however, of hoping to specify the sources too exactly. The standing figure to the left is reminiscent of Ingres's *Venus Anadyomene*, but also of Cézanne's *La Toilette* of 1878-80, itself a variation on Delacroix's *Le Lever* of 1850. Matisse was working in an established tradition with a repertory of familiar studio poses and long-developed images and themes.

11. According to Jean Puy, "Souvenirs," *Le Point* (Colmar), July 1939, p. 36. Quoted after Barr, p. 91.

12. *La Grande Revue*, December 25, 1908. (Flam, p. 37.)

13. See Charles Chasse, *The Nabis and Their Period* (New York: Praeger, 1969), pls. 9 and 11.

14. *Vers et Prose* (a continuation of the Symbolist magazine, *La Plume*) was founded by Paul Fort in spring 1905. Matisse was a subscriber. *La Phalange* published the first detailed study of Fauvism in November 1907, and in the following month Apollinaire's interview with Matisse. See Oppler, chap. 7, on the Symbolist revival, to which the following discussion is indebted.

15. Quoted by Escholier, *Matisse*, p. 37.

16. Replying to an "Enquête" in *Gil Blas*. See Georges le Cardonnel and Charles Vellay, *La Littérature contemporaine* (1905), 3rd ed. (Paris: Société du Mercure de France, 1921), p. 87. (Oppler, p. 239.)

17. Michel Décaudin, ed., *Oeuvres complètes de Guillaume Apollinaire* (Paris: André Balland et Jacques Lecat, 1966), vol. 3, p. 780. (Oppler, p. 241.)

18. *La Phalange*, February 15, 1908. (Oppler, p. 244.)

19. *Art et Critique* (Paris), August 1890.

20. See especially his "Les Arts à Rome ou la méthode classique," *Le Spectateur Catholique* (Brussels), 1898, nos. 22 and 24. (*Théories*, pp. 45-56.) For the new classicism, see Theodore Reff, "Cézanne and Poussin," *Journal of the Warburg and Courtauld Institutes* (London), January 1960, pp. 150-74, and Oppler, pp. 260-68. The popular *L'Age d'or* theme of this period was itself easily associated with the revived classicism, and in many respects was an aspect of it, since the Golden Age most vividly represented in earlier French art was the classical one of Versailles.

21. *L'Ermitage*, May 15, 1905. (*Théories*, pp. 196–97.)

22. See above, chap. 2, p. 70 and n. 54.

23. Maurice Malingue, ed., *Lettres de Gauguin à sa femme et à ses amis* (Paris: Grasset, 1946), no. CLXXIV.

24. See above, n. 5.

25. Information from Pierre Schneider, November 1975. It is known that *Luxe, calme et volupté*, too, was created in this way. See *Henri Matisse. Dessins et sculpture* (Paris: Musée National d'Art Moderne, 1975), pp. 19-20 and no. 30.

26. See below, n. 137.

27. *La Grande Revue*, December 25, 1908. (Flam. p. 38.)

28. Sarah Stein's Notes, 1908, and for the following quotations. (Flam, p. 45.)

29. *La Grand Revue*, December 25, 1908. (Flam, p. 36.)

30. Quoted by John Rewald, *Gauguin* (Paris: Hyperion, 1938), p. 30.

31. See above, chap. 2, n. 7.

32. The painting was first exhibited under this title at the Venice Biennale of 1950.

33. *Lettres*, p. 162.

34. Hilaire, *Derain*, pl. 4. Marcel Giry suggests that Derain developed the idea for *L'Age d'or* in 1903, evidencing the sketchbook studies (see following note) and Derain's contact with the Neo-Impressionist circle that year. He believes that it was painted toward the end of 1904, after Derain saw Matisse's *Luxe, calme et volupté* (that is, before the Matisse was publicly exhibited in the spring of 1905), and cannot be considered a 1905 painting because it is formally less assured and more overtly tied to Neo-Impressionism than typical 1905 Derains. (Letter to the author, December 1975.) Although there is no firm external evidence for the dating of *L'Age d'or* or its preparatory sketchbook studies, the *terminus ante quem* is probably the period of Matisse's work on *Luxe, calme et volupté*—between the end of 1904 and February-March 1905—and the *terminus post quem* exactly a year later—between October 1905 and February-March 1906, when Matisse painted the *Bonheur de vivre*, which shows the influence of *L'Age d'or*. Although *L'Age d'or* does indeed seem formally less resolved than Derain's 1905 landscapes, this in itself does not necessarily place the work in 1904, for Derain seems to have conceived his landscape and subject paintings in very different terms (see below, p. 107): the subject paintings are by nature more conservative.

35. In the sketchbook the studies for *L'Age d'or* precede a study for Derain's *Ball of Suresnes* of 1903. There is no reason, however, to assume that the sketchbook is chronological in arrangement —although at the same time one cannot entirely discount the possibility that Derain first began to investigate the theme of this painting in 1903, given his documented interest in Delacroix that year (see following note). I am grateful here to Pierre Georgel of the Musée National d'Art Moderne, Paris, for showing the sketchbook to me, and for his discussion of its contents. See also B. Dorival, "Un Album de Derain au Musée National d'Art Moderne," *La Revue du Louvre* (Paris), nos. 4-5, 1969, pp.

257-68. While noting the comparison with Delacroix's work, Dorival (p. 265) also draws attention to Derain's sketchbook study after Tintoretto's *Paradise* in the Louvre, suggesting that this work influenced the composition of contrasting groups in *L'Age d'or*. The contrasting groups in the Delacroix and in the Rubens, however, are far closer to those in Derain's work.

36. *Lettres*, p. 116.

37. See above, n. 34.

38. Pédron sale (Paris, Hôtel Drouot, June 2, 1926), no. 12.

39. Vauxcelles, *Gil Blas*, March 23, 1905.

40. A selection of Gauguin's woodcarvings was included in his 1906 retrospective at the Salon d'Automne. See Christopher Gray, *Sculpture and Ceramics of Paul Gauguin* (Baltimore: Johns Hopkins Press, 1963).

41. Date confirmed by D.-H. Kahnweiler, 1965. A number of comparable watercolors of dancing or bathing figures exist from 1906 (for example, Hilaire, *Derain*, pls. 43, 67, 110). The *Dance* itself has been dated as late as 1909 (Hilaire, *Derain*, pl. 73), but clearly belongs to three years earlier. Mme Alice Derain has confirmed that the painting was certainly in existence by 1907. (Letter to the author from Marcel Giry, December 1975.)

42. See Oppler, pp. 143-44.

43. See Wattenmaker, *The Fauves* (Toronto: Art Gallery of Ontario, 1975), p. 6 and n. 12. Marcel Giry has also emphasized the medieval-cum-exotic sources of this work, suggesting that it depicts not a dance but the familiar medieval theme of the opposition of vice and virtue, the former represented by the scantily clad figure accompanied by the serpent at the right, and the latter by the more heavily clothed figure at the left, who carries a bird and might be viewed as being tempted by the naked demon in the center. (Letter to the author, December 1975.) Michel Kellermann speculates that the painting is a representation of Adam and Eve being expelled from Paradise, with the figure at the left an angel. (Letter to the author, December 1975.)

44. I am indebted here to Judith Cousins Di Meo for suggesting this comparison.

45. *Lettres*, p. 188.

46. *Ibid.*, p. 95.

47. *Ibid.*, p. 146.

48. An obvious comparison is with Gauguin's *Wood Cylinder with Figure or Hina*, 1892-93, from the de Monfreid collection, which was exhibited at the 1906 Salon d'Automne (Gray, *Sculpture and Ceramics*, no. 95).

49. See Gray, *Sculpture and Ceramics*, nos. 41, 43, 44, 46, and 51.

50. See Barr, p. 100, and for documentation on Fauve ceramics, see *Französische Keramik zwischen 1850 und 1910: Sammlung Maria und Hans-Jörgen Heuser, Hamburg* (Munich: Prestel-Verlag, 1974).

51. *Gil Blas*, March 20, 1907.

52. *Dangerous Corner*, p. 71.

53. See Douglas Fraser, "The Discovery of Primitive Art," *Arts Yearbook* (New York, 1957), pp. 119-33; Edward F. Fry, "Note on the Discovery of African Sculpture," in his *Cubism* (New York: Praeger, 1966), pp. 47-48; Robert Goldwater, *Primitivism in Modern Art*, rev. ed. (New York: Vintage Books, 1967), chaps. 3 and 4; and Jean Laude, *La Peinture française (1905-1914) et "L'Art nègre"* (Paris: Editions Klincksieck, 1968).

54. In *Dangerous Corner* (p. 71), he claims there were two; in *Portraits avant décès* (p. 105), he says three, and gives the date of the incident as 1905. In *Poliment* (Paris: Librarie Stock, 1931, p. 180), he indicates it happened in 1903.

55. *Portraits avant décès*, pp. 105-06. This, however, seems unlikely. Both Gertrude Stein and Max Jacob insist that it was Matisse who introduced Picasso to African sculpture when the two met in the autumn of 1906. (Stein, *The Autobiography of Alice B. Toklas* [New York: Harcourt, Brace, 1933], p. 78; Jacob, "Souvenirs sur Picasso," *Cahiers d'Art*, 1927, p. 202.) A likely order of events is that Derain saw the objects Vlaminck had obtained, appreciated their significance, and introduced Matisse to African art; and that either Derain or Matisse was responsible for passing on the interest to Picasso.

56. *Portraits avant décès*, pp. 105-06.

57. *Ibid.*, for Vlaminck's characterizations of African art.

58. See Goldwater, *Primitivism*, part 3, for the notion of "Romantic Primitivism," and Oppler's reservations about this description (pp. 153-67), to which this discussion is indebted.

59. Francoise Gilot and Carlton Lake, *Life with Picasso* (New York: McGraw-Hill, 1964), p. 266.

60. *Lettres*, pp. 196-97, a letter which Oppler (p. 159) convincingly dates to the spring of 1906.

61. In 1909, Apollinaire noted Guinea, Senegal, and Gabon sculptures in Matisse's apartment. (*Apollinaire on Art*, p. 56.)

62. "The Wild Men of Paris," *The Architectural Record* (New York), May 1910, p. 410. See the important discussion of this article by Edward F. Fry, "Cubism, 1907-1908: An Early Eyewitness Account," *Art Bulletin*, March 1966, pp. 70-73.

63. See above, n. 60.

64. "The Wild Men of Paris," p. 406.

65. *Ibid.*, p. 414.

66. Venturi, *Cézanne*, no. 542, in the Kunstmuseum, Basel.

67. Vauxcelles, *Gil Blas*, October 6, 1906; Guillemot, *L'Art et Les Artistes* (Paris), November 1906, p. 296.

68. *Gil Blas*, March 20, 1907.

69. See Michel Puy, *L'Effort des peintres modernes*, p. 65.

70. *La Phalange,* November 15, 1907, pp. 450-59; *ibid.,* December 15, 1907, pp. 481-85. (Translation in Barr, pp. 101-02.)

71. Barr, p. 102.

72. *La Grande Revue,* October 25, 1907.

73. *Gil Blas,* March 20, 1907, and for the following quotations.

74. John Golding was the first to correctly identify and to recognize the importance of this work, in *Cubism: A History and an Analysis, 1907-1914* (New York: Harper and Row, 1968), p. 139. See also below, n. 109.

75. Oppler (p. 289) cites Hans Purrmann's report to Alfred Barr that Matisse's *Blue Nude* "was the result of a friendly competition with Derain as to who could paint the best figure in blue. When Derain saw Matisse's *Blue Nude* he conceded his defeat and destroyed his canvas." (Barr, p. 533.) Oppler's suggestion that Derain did not destroy the canvas rests on the prominence of blue in his *Bathers.* None of the figures, however, is blue. Derain did destroy a number of his figure paintings of this period (see below, p. 120 and n. 97); the anecdote probably refers to one of these.

76. *Le Temps* (Paris), October 14, 1912. *(Apollinaire on Art,* p. 260.)

77. *Gil Blas,* March 23, 1905.

78. *La Phalange,* November 15, 1907, pp. 453-54.

79. Denis, *Mercure de France,* August 1, 1905. For other interpretations of Cézanne, see Oppler, pp. 314 *ff.*

80. *Mercure de France,* August 1, 1905. See the important article by Theodore Reff, "Cézanne and Poussin," *Journal of the Warburg and Courtauld Institutes,* January 1960, pp. 150-74.

81. *Gil Blas,* October 5, 1906.

82. *Ibid.,* March 30, 1907.

83. The *Blue Nude* is derived from the right-hand central figure of the *Bonheur* and looks back to the reclining figure in *Luxe, calme et volupté.* The central figure in Derain's *Bathers* recalls the left-hand standing figure in the *Dance,* and the left-hand bather recalls the figure to the extreme left of *L'Age d'or.*

84. See Golding, *Cubism,* pp. 49-50.

85. Barr, p. 87.

86. Oppler, p. 289.

87. According to Kahnweiler, Derain said that Picasso would one day hang himself behind the picture. Kahnweiler, *Mes Galeries et mes peintres: Entretiens avec Francis Crémieux* (Paris: Gallimard, 1961), pp. 45-46.

88. For a discussion of Derain's probable knowledge of these sculptures, see Golding, *Cubism,* p. 140.

89. See Ronald Johnson, "Primitivism in the Early Sculpture of Picasso," *Arts Magazine* (New York), June 1975, pp. 64-68.

90. See Fry, "Cubism, 1907-1908," p. 73, and Laude, *La Peinture française,* p. 180.

91. Barr, p. 539, n. 10 to p. 142.

92. *L'Occident,* November 1905. *(Théories,* pp. 210 and 235.)

93. "The Wild Men of Paris," p. 410, and for the quotations below.

94. Laude, *La Peinture française,* p. 215.

95. Sarah Stein's Notes, 1908. (Flam, p. 44.)

96. *La Toilette,* from the 1908 Indépendants, is reproduced in Hilaire, *Derain,* no. 69.

97. Daniel-Henry [Kahnweiler], *André Derain* (Leipzig: Klinckhardt and Biermann, 1920), pp. 4-5.

98. The 1908 Salon d'Automne *Bathers* is reproduced in Hilaire, *Derain,* no. 68. It bears comparison with Cézanne's *Five Bathers,* of which Derain had a reproduction hanging in his studio (p. 110). Another *Bathers* (p. 121) of 1908 or 1909 was exhibited in Prague in 1910. See *Paris-Prague: 1906-1930* (Paris: Musée Nationale d'Art Moderne, 1966), no. 158.

99. Golding, *Cubism,* p. 139.

100. See Marcel Giry, "Le Paysage à figures chez Othon Friesz (1907-1912)," *Gazette des Beaux-Arts,* January 1967, pp. 45-57.

101. Saint-Jorre, *Fleuret,* p. 57.

102. Burgess, "The Wild Men of Paris," p. 410.

103. Florent Fels, *Propos d'artistes* (Paris: La Renaissance du Livre, 1925), p. 69.

104. *Gil Blas,* March 20, 1908.

105. *La Grande Revue,* April 10, 1908.

106. *L'Occident,* May 1909. *(Théories,* p. 267.)

107. Although the painting is dated on the canvas 1906, this may well be a later addition, since Braque only rarely dated his early work. If indeed it is from 1906, the strongly Cézannist elements render it unique for that year. It more likely belongs to 1907.

108. See Golding, *Cubism,* pp. 63-64, to which the following description is indebted, and n. 109.

109. I am indebted to William Rubin for having drawn to my attention the as yet unappreciated implications of Braque's *View from the Hôtel Mistral* for the history of early Cubism. In his essay "Cézanne, *Cézannisme,* and Early Twentieth-Century Painting," now in preparation and scheduled to appear as a chapter in the catalogue of the Museum's forthcoming exhibition (1977-78) of the late work of Cézanne, Mr. Rubin argues that the impact of Cézannism on avant-garde painting in 1906-08 has not been sufficiently assessed, and that under its influence, Braque was well on his way to Cubism (as instanced by the *View from the Hôtel Mistral)* before his exposure to Picasso's *Demoiselles d'Avignon;* that the experience of the latter picture less opened the road to Cubism for Braque than it deflected him from it; that what are widely accepted as the first thoroughly Cubist pictures —Braque's 1908 work at L'Estaque—represent a continuation of

the distinctly Cézannist path Braque had laid out for himself prior to meeting Picasso and required a *rejection* of the influence of the *Demoiselles* that had permeated his female nudes of the winter of 1907-08.

In his reevaluation of the avant-garde situation in 1907, Mr. Rubin also stresses the crucial role of Derain's large *Bathers* (see p. 116), a picture which up to now has been so sequestered as to be all but unknown to art historians—although it was illustrated in Kahnweiler's early monograph on Derain, *Derain*, fig. 3. Discussed only by Golding in *Cubism* (see no. 74 above), it is unknown to or overlooked by almost all authors writing on either Cubism or Fauvism. I want to take this opportunity to thank Mr. Rubin for arranging the loan for this work to the Museum's exhibition and prevailing on the owner to permit it to be reproduced in color. This is, as far as I know, the first public exhibition of Derain's *Bathers* since the Indépendants of the spring of 1907.

110. See *Le Fauvisme français*, no. 10, and *Braque: An American Tribute* (New York: Saidenberg Gallery, 1964), no. 2 (dated 1906).

111. See Golding, *Cubism*, p. 62.

112. See D.-H. Kahnweiler, "Du temps que les cubistes étaient jeunes," *L'Oeil* (Paris), January 15, 1955, p. 28.

113. Burgess, "The Wild Men of Paris," p. 407.

114. *La Grande Revue*, December 25, 1908. (Flam, p. 37.)

115. Laude (*La Peinture française*, pp. 167-68) relates the faces to the mask Vlaminck had sold to Derain.

116. Christian Zervos, *Pablo Picasso: Oeuvres*, vol. 2 (Paris: Editions Cahiers d'Art, 1942), nos. 46 and 47.

117. *Dangerous Corner*, p. 76, and p. 77 for the quotation that follows.

118. *Méditations esthétiques—Les Peintres cubistes*, ed. L. C. Breunig and J.-C. Chevalier (Paris: Hermann, 1965), pp. 58 and 96. Marquet and Manguin were also excluded.

119. Dufy's *Flowers in a Vase* (Laffaille, *Dufy*, no. 203) also bears interesting comparison with Picasso's *Still Life with Skull* (Zervos, *Picasso*, vol. 2, no. 50), also of 1907.

120. See above, p. 110 and n. 68.

121. See Herbert, *Neo-Impressionism*, p. 209.

122. Jean-Paul Crespelle, *Montmartre Vivant* (Paris: Librarie Hachette, 1964), p. 194. Somewhat surprisingly, given the direction of his own art, Dufy's reply to Morice's "Enquête" stated that Seurat was one of the two modern painters who impressed him most. The other was Manet. (*Mercure de France*, August 15, 1905.)

123. See Fernand Fleuret, *La Boîte à perruque* (Paris: Les Ecrivains associés, 1935), pp. 40-50.

124. See Laffaille, *Dufy*, no. 240.

125. As noted by Golding, *Cubism*, p. 66. Braque specifically stated that it was the Cézanne paintings he had seen at Vollard's that affected his work at L'Estaque in 1908 (*Cahiers d'Art*, October 1954, p. 14).

126. Apollinaire, *L'Intermédiaire des chercheurs et des curieux*, October 10, 1912. (*Apollinaire on Art*, p. 257.) See also Barr, p. 87.

127. *Gil Blas*, November 14, 1908.

128. *Ibid.*, March 25, 1909.

129. *Autobiography*, p. 79.

130. *Gil Blas*, March 25, 1909.

131. *L'Occident*, May 1909. (*Théories*, p. 267.) Denis quoted from Apollinaire's preface to Braque's Kahnweiler Gallery exhibition catalogue, November 1908. (*Apollinaire on Art*, p. 51.)

132. *Ibid.*

133. *La Phalange*, December 15, 1907. (Barr, p. 101.)

134. *Ibid.*

135. Barr, p. 96.

136. *La Grande Revue*, October 25, 1907.

137. On the basis of Matisse's recollections, Barr (p. 95) dates *Le Luxe, I* to Collioure early in 1907 and *Le Luxe, II* to Paris, autumn 1907 or possibly early 1908. Now that the large-scale charcoal sketch, *Le Luxe* (p. 136), is known (*Henry Matisse. Dessins et sculpture* [Paris: Musée Nationale d'Art Moderne, 1975], no. 30), the later date for *Le Luxe, II* seems preferable. Stylistically, this sketch is closer to the second painting, for which it presumably served as a study. Matisse probably exhibited the first painting as an *esquisse* in the Salon d'Automne of 1907 because he had then begun to rework the subject, completing the second in 1908 before he began working on the *Game of Bowls* (Barr, p. 356), which uses the same three general poses of *Le Luxe*. Because *Le Luxe, II* was not exhibited until May 1912 (at the Cologne Sunderbund), its date cannot easily be fixed. Trapp has suggested that it was not painted until 1911, citing the recollections of Mme Duthuit (1950), and supporting this with the observation that its medium, tempera, is only shared in Matisse's early oeuvre by *The Aubergines* of 1911 ("The Paintings of Henri Matisse," p. 178, n. 1). Such a lengthy gap between two paintings of an identical subject, however, is totally out of character for Matisse. The unusual medium of *Le Luxe, II* is to be explained by the example of Puvis de Chavannes, as is its creation from a cartoon. In subject, too, it recalls Puvis's *Girls by the Seashore* of 1879 in the Louvre (p. 136). See Wattenmaker, *Puvis de Chavannes*, pp. 122-23. For sharing their opinions on this problematic work, I am indebted to John Golding and Pierre Schneider.

138. See previous note.

139. *La Grande Revue*, December 25, 1908. (Flam, p. 36.)

140. *Ibid.* (Flam, p. 37.)

141. *Ibid.*

142. Tériade, "Constance du fauvisme." (Flam, p. 74.)

143. *Ibid.*

144. See Barr, pp. 124-26.

145. On the implications of still-life subjects, see Meyer Schapiro, "The Apples of Cézanne: An Essay on the Meaning of Still Life," *Art News Annual*, 1968, pp. 34–53.

146. Matisse was represented by thirty paintings, drawings, and bronzes in a section of his own, which serves to show the esteem in which he was then held.

147. M. J. Péladan, "Le Salon d'Automne et ses retrospectives— Greco et Monticelli," *La Revue Hebdomadaire*, October 17, 1908, p. 361.

148. *Ibid.,* p. 370.

149. See Devaillières's preface to Matisse's "Notes," *La Grande Revue*, December 25, 1908, pp. 731–32.

150. *Ibid.,* pp. 732–45, from which the following quotations derive. (Flam, pp. 35–40.) For additional background to the "Notes," see Flam, pp. 32–35, and Oppler, pp. 275–82.

151. Barr, p. 118.

POSTSCRIPT: FAUVISM AND ITS INHERITANCE

1. Recorded by Duthuit, p. 26.

2. Tériade, "Matisse Speaks," p. 43. (Flam, p. 132.)

3. See Gowing, *Henri Matisse*, pp. 11–12.

4. Matisse, "Letter from Matisse to Henry Clifford," in *Henri Matisse: Retrospective* (Philadelphia: Philadelphia Museum of Art, 1948), pp. 15–16. (Flam, p. 121.)

5. "Notes d'un peintre sur son dessin," *Le Point*, July 1939, p. 109. (Flam, p. 82.)

6. Of course, a third category might be added: the general indebtedness to Fauvist principles of much subsequent color painting, after the period discussed here.

7. See Herbert, *Neo-Impressionism*, pp. 219–21.

8. See, for example, Delaunay's *Self-Portrait*, 1906 (Musée National d'Art Moderne, Paris); Duchamp's *Portrait of Dr. Tribout*, 1910 (Musée des Beaux-Arts, Rouen); Gleizes's *Paris from the Seine*, 1908 (Private collection, Paris; reproduced in *Albert Gleizes* [New York: Solomon R. Guggenheim Museum, 1964], p. 33); and Léger's *Ile rousse*, 1907 (Private collection, Paris).

9. See the statements to this effect by Braque and Léger to Dora Vallier in *Cahiers d'Art*, 1954, pp. 14 and 140, respectively.

10. For discussion of this and similar works, see Robert P. Welsh, *Piet Mondrian* (Toronto: The Art Gallery of Ontario, 1966), pp. 104 *ff.* and 110.

11. Donald E. Gordon, "Kirchner in Dresden," *Art Bulletin*, September-December 1966, pp. 335–65.

12. *Ibid.,* pp. 347–48.

13. R[ichard] S[tiller], "Die Ausstellung der Künsttergruppe 'Die Brücke,'" *Dresdener Anzeiger*, June 25, 1909, p. 3. Quoted by Gordon, "Kirchner in Dresden," p. 351.

14. Gordon, "Kirchner in Dresden," p. 351.

15. With the exception of Bastille Day paintings, Fauve street scenes are rare. The French artists' preference for landscapes and river scenes contrasts with the more frequently urban subjects of German practitioners of Fauvist methods. Vlaminck's views of Marly-le-Roi (for example, *Le Fauvisme français*, no. 130) are among the few truly Fauve street scenes.

16. Will Grohmann, *Wassily Kandinsky* (New York: Abrams, n.d.), p. 56.

17. There were, of course, certain common sources. Kandinsky's *Über das Geistige in der Kunst* (Munich: Piper, 1912), which propounded his version of the musical analogy, makes reference to van Gogh, Gauguin, and Signac in drawing up a classification of the emotive effects of color.

18. See Diehl, *Fauvism*, pp. 32 *ff.* for illustration and discussion of the spread of Fauvist methods.

19. To speak in these terms, of course, is to posit a definition of Fauvism as a style, which is to some degree independent of a definition of the Fauvist group or Fauvist movement. It is not, however, to present a set of a priori Fauve attributes, which each artist exhibits to a greater or lesser degree; the evidence of Fauvist art itself, taken as a whole, forces one to acknowledge that certain works made by the Fauves are stylistically anomalous. Although the division of group, movement, and style adopted here might usefully recommend itself to the study of other modern movements, Fauvism itself seems to demand such an approach.

Bibliography

Although there are very few scholarly, detailed studies of Fauvism or of individual Fauve artists, the literature on this period is considerable. This bibliography is highly selective, listing only the more useful references. For fuller listings of works on Fauvism up to 1950, the reader is referred to the bibliography in Georges Duthuit, *The Fauvist Painters* (bibl. 25), and for works up to 1969, to that in Ellen C. Oppler, "Fauvism Reexamined" (bibl. 60). The citations given here comprise books, articles, and exhibition catalogues arranged chronologically, and are divided into general references on Fauvism and references on individual Fauve artists, including writings by the artists.

GENERAL REFERENCES

1. Paris. Société des Artistes Indépendants. Catalogues. 1901-10.

2. Paris. Société du Salon d'Automne. Catalogues. 1903-10.

3. Gide, André. "Promenade au Salon d'Automne." *Gazette des Beaux-Arts* (Paris), December, 1905, pp. 475-85.

4. Vauxcelles, Louis. "Le Salon d'Automne. 1905." *Gil Blas* (Paris), October 17, 1905.

5. "Le Salon d'Automne." *L'Illustration* (Paris), November 4, 1905, pp. 294-95.

6. Vauxcelles, Louis. "Le Salon des Indépendants." *Gil Blas* (Paris), March 20, 1906.

7. Burgess, Gelett. "The Wild Men of Paris." *The Architectural Record* (New York), May 1910, pp. 400-14.

8. Salmon, André. *La Jeune Peinture française.* Paris: Albert Messein, 1912, pp. 9-40.

9. Fels, Florent. *Propos d'artistes.* Paris: La Renaissance du Livre, 1925.

10. Rouault, Georges. *Souvenirs intimes.* Preface by André Suarès. Paris: E. Frapier, 1927, pp. 17-51.

11. Salmon, André. "Les Fauves et le fauvisme." *L'Art Vivant* (Paris), May 1, 1927, pp. 321-24.

12. Paris. Galerie Bing. *Les Fauves, 1904 à 1908.* April 15-30, 1927. Preface by Waldemar George.

13. Rouault, Georges. "Evocations." *Les Chroniques du Jour* (Paris), April 1931, pp. 8-9.

14. Puy, Michel. *L'Effort des peintres modernes.* Paris: Albert Messein, 1933, pp. 61-78.

15. Weill, Berthe. *Pan! dans l'oeil!...ou Trente ans dans les coulisses de la peinture contemporaine, 1900-1930.* Paris: Lipschutz, 1933.

16. Yaki, Paul. *Le Montmartre de nos vingts ans.* Paris: G. Girard, 1933.

17. Vauxcelles, Louis. "Les Fauves, à propos de l'exposition de la Gazette des Beaux-Arts." *Gazette des Beaux-Arts* (Paris), December 1934, pp. 272-82.

18. Paris. Galerie Gazette des Beaux-Arts. *Les Fauves: L'Atelier Gustave Moreau.* 1934. Text by Raymond Cogniat.

19. Huyghe, René, ed. *Histoire de l'art contemporain: La Peinture.* Paris: Félix Alcan, 1935. Reprint ed.: New York: Arno Press, 1968, chaps. 4-6.

20. Goldwater, Robert J. *Primitivism in Modern Painting.* New York and London: Harper and Brothers, 1938, pp. 74-86. Revised ed.: *Primitivism in Modern Art.* New York: Vintage Books, 1967.

21. Paris. Galerie de France. *Les Fauves. Peintures de 1903 à 1908.* June 13-July 11, 1942.

22. Dorival, Bernard. *Les Etapes de la peinture française contemporaine.* Vol. 2: *Le Fauvisme et le cubisme 1905-1911.* 13th ed. Paris: Gallimard, 1944.

23. Paris. Galerie Bing. *Chatou.* March 1947. Text and illustrations by Derain and Vlaminck.

24. Lassaigne, Jacques. "Les Origines du fauvisme." *Panorama des arts 1947.* Paris: Somogy, 1948, pp. 60-65.

25. Duthuit, Georges. *Les Fauves.* Geneva: Trois Collines, 1949. English translation: *The Fauvist Painters.* New York: Wittenborn, Schultz, 1950.

26. Sutton, Denys. "The Fauves." *The Burlington Magazine* (London), September 1950, pp. 263-65.

27. Bern. Kunsthalle. *Les Fauves...und die Zeitgenossen.* April 29-May 29, 1950. Text by Arnold Rüdlinger.

28. New York. Sidney Janis Gallery. *Les Fauves.* November 13-December 23, 1950. Texts by Georges Duthuit and Robert Lebel.

29. Venice. 25th Biennale. *I "Fauves."* 1950, pp. 42-48. Preface by Roberto Longhi.

30. Vauxcelles, Louis. "Le Fauvisme à Chatou." *Art-Documents* (Geneva), July-August 1951, pp. 4-6.

31. Paris. Musée National d'Art Moderne. *Le Fauvisme.* June-September 1951. Introduction by Jean Cassou.

32. Dorival, Bernard. "Fauves: The Wild Beasts Tamed." *Art News Annual* (New York), 1952-53, pp. 98-129, 174-76.

33. New York. The Museum of Modern Art. *Les Fauves.* October 8, 1952-January 4, 1953. Introduction by John Rewald.

34. Salmon, André. *Le Fauvisme.* Paris: Somogy, 1956.

35. Vauxcelles, Louis. *Le Fauvisme.* Geneva: Pierre Cailler, 1958.

36. Golding, John. *Cubism, A History and an Analysis 1907-1914.* London: Faber and Faber Limited, 1959.

37. Leymarie, Jean. *Fauvism.* Geneva: Skira, 1959.

38. Dallas. Museum for Contemporary Arts. *Les Fauves.* January 29-March 16, 1959. Introduction by Hannah C. Boorstin.

39. Schaffhausen. Museum zu Allerheiligen. *Triumph der Farbe. Die Europäischen Fauves.* July 5-September 13, 1959. Introduction by Leopold Reidemeister.

40. Apollinaire, Guillaume. *Chroniques d'art (1902-1918).* Edited by L. C. Breunig. Paris: Gallimard, 1960.

41. Reff, Theodore. "Cézanne and Poussin." *Journal of the Warburg and Courtauld Institutes* (London), January 1960, pp. 150-74.

42. Dorival, Bernard. "L'Art de la Brücke et le fauvisme." *Art de France* (Paris), 1961, pp. 381-85.

43. Kahnweiler, Daniel-Henry. *Mes Galeries et mes peintres. Entretiens avec Francis Crémieux.* Paris: Gallimard, 1961. English translation, London: Thames and Hudson; New York: Viking, 1971.

44. Chassé, Charles. "L'Histoire du fauvisme revue et corrigée." *Connaissance des Arts* (Paris), October 1962, pp. 54-59.

45. Crespelle, Jean-Paul. *The Fauves.* London: Oldbourne Press; Greenwich, Connecticut: New York Graphic Society, 1962.

46. Marseilles. Musée Cantini. *Gustave Moreau et ses élèves.* June 26-September 1, 1962. Preface by Jean Cassou.

47. Paris. Galerie Charpentier. *Les Fauves.* March 7-May 31, 1962. Preface by Raymond Nacenta.

48. Cartier, Jean-Albert. "Gustave Moreau, professeur à l'Ecole des Beaux-Arts." *Gazette des Beaux-Arts* (Paris), May 1963, pp. 347-58. (English summary.)

49. Chassé, Charles. *Les Fauves et leur temps.* Lausanne-Paris: Bibliothèque des Arts, 1963.

50. Hoog, Michel. "La Direction des Beaux-Arts et les fauves, 1903-1905. Notes et documents." *Art de France* (Paris), 1963, pp. 363-66.

51. Besançon. Musée des Beaux-Arts. *Valtat et ses amis: Albert André, Charles Camoin, Henri Manguin, Jean Puy.* August-September 1964. Preface by George Besson.

52. Paris. Galerie de Paris. *La Cage aux fauves du Salon d'Automne 1905.* October 12-November 6, 1965. Text by Pierre Cabanne. Preface by Jean Cassou.

53. Gordon, Donald E. "Kirchner in Dresden." *The Art Bulletin* (New York), September-December 1966, pp. 335-61.

54. Hamburg. Kunstverein. *Matisse und seine Freunde—Les Fauves.* May 25-July 10, 1966. Introduction by Hans Platte.

55. Paris. Musée National d'Art Moderne. *Le Fauvisme français et les débuts de l'expressionisme allemand.* January 15-March 6, 1966. Texts by Bernard Dorival, Michel Hoog, and Leopold Reidemeister.

56. Muller, Joseph-Emile. *Fauvism.* London: Thames and Hudson; New York: Praeger, 1967.

57. Giry, Marcel. "Le Salon d'Automne 1905." *L'Information d'Histoire de l'Art* (Paris), January-February 1968, pp. 16-25. (Summaries in English and German.)

58. Laude, Jean. *La Peinture française (1905-1914) et "l'art nègre." Contribution à l'étude des sources du fauvisme et du cubisme.* Paris: Klincksieck, 1968.

59. Hoog, Michel. "La Peinture et la gravure: Fauvisme et expressionisme." In *Histoire de l'Art 4, Du Réalisme à nos jours.* Paris: Encyclopédie de la Pléiade, 1969, pp. 526-612.

60. Oppler, Ellen Charlotte. "Fauvism Reexamined." Ph.D. dissertation, Columbia University, New York, 1969.

61. Mechelen. Cultureel Centrum. *Fauvisme in de europese kunst.* September 14-November 16, 1969. Texts by Emile Langui and Jean Leymarie.

62. Giry, Marcel. "Matisse et la naissance du fauvisme." *Gazette des Beaux-Arts* (Paris), May 1970, pp. 331-44.

63. Giry, Marcel. "Le Salon des Indépendants de 1905." *L'Information d'Histoire de l'Art* (Paris), May-June 1970, pp. 110-14.

64. Diehl, Gaston. *Les Fauves.* Paris: Nouvelles Editions françaises, 1971. English translation: *The Fauves.* New York: Abrams, 1975.

65. Cowart, William John, III. "'Ecoliers' to 'Fauves', Matisse, Marquet, and Manguin Drawings: 1890-1906." Ph.D. dissertation, The Johns Hopkins University, Baltimore, 1972.

66. Osaka. Galeries Seibu Takatsuki. *Exposition les fauves.* November 15-December 8, 1974. Introduction and catalogue by François Daulte.

67. Toronto. Art Gallery of Ontario. *The Fauves.* April 11-May 11, 1975. Text by Richard J. Wattenmaker.

REFERENCES ON INDIVIDUAL ARTISTS

GEORGES BRAQUE

68. Paris. Galerie Daniel-Henry Kahnweiler. *Georges Braque.* November 9-28, 1908. Preface by Guillaume Apollinaire.

69. Braque, Georges. "Pensées et réflexions sur la peinture." *Nord-Sud* (Paris), December 1917, pp. 3-5.

70. Isarlov, Georges. *Georges Braque.* Paris: Corti, 1932.

71. Bonjean, Jacques. "L'Epoque fauve de Braque." *Les Beaux-Arts* (Paris), February 18, 1938, p. 4.

72. New York. The Museum of Modern Art. *Georges Braque.* March 29-June 12, 1949. Preface by Jean Cassou. Text and catalogue by Henry R. Hope.

73. "Braque—La peinture et nous. Propos de l'artiste recueillis par Dora Vallier." *Cahiers d'Art* (Paris), October 1954, pp. 13-24.

74. Edinburgh. Royal Scottish Academy. *Georges Braque.* August 18-September 15, 1956; and London, The Tate Gallery, September 28-November 11, 1956. Text by Douglas Cooper.

75. Richardson, John. *Braque.* London: Oldbourne; Greenwich, Connecticut: New York Graphic Society, 1961.

76. Munich. Haus der Kunst. *Georges Braque.* October 18-December 15, 1963. Text by Douglas Cooper.

77. Fumet, Stanislas. *Georges Braque.* Paris: Maeght, 1965.

78. Paris. Orangerie des Tuileries. *Georges Braque.* October 16, 1973-January 14, 1974. Text by Jean Leymarie.

CHARLES CAMOIN

79. Camoin, Charles. "Souvenirs sur Paul Cézanne." *L'Amour de l'Art* (Paris), January 1921, pp. 25-26.

80. Crespelle, Jean-Paul. "Camoin, fauve de l'avenue Junot." In *Montmartre vivant.* Paris: Hachette, 1964, pp. 91-113.

81. Marseilles. Musée des Beaux-Arts. *Ch. Camoin.* October-November 1966. Preface by Marielle Latour.

82. Cologne. Gemälde-Galerie Abels. *Charles Camoin.* May 4-June 29, 1968.

83. Giraudy, Danièle. *Camoin: Sa Vie, son oeuvre.* Marseilles: "La Savoisienne," 1972. Preface by Bernard Dorival.

ANDRE DERAIN

84. [Kahnweiler] Daniel-Henry. *André Derain.* Leipzig: Klinkhardt and Biermann, 1920.

85. Jolinon, Joseph. "La Rencontre de Vlaminck avec Derain." *L'Art Vivant* (Paris), March 1932, p. 121.

86. Derain, André. *Lettres à Vlaminck.* Paris: Flammarion, 1955. Introduction by Vlaminck.

87. Paris. Musée National d'Art Moderne. *Derain.* December 11, 1954-January 30, 1955. Preface by Jean Cassou. Catalogue by Gabrielle Vienne.

88. "Propos d'André Derain." *Prisme des Arts* (Paris), November 1956, pp. 2-6.

89. Hilaire, Georges. *Derain.* Geneva: Pierre Cailler, 1959.

90. Sutton, Denys. *André Derain.* London: Phaidon, 1959.

91. Diehl, Gaston. *Derain.* Paris: Flammarion; New York: Crown, 1964.

92. Dorival, Bernard. "Un Chef-d'oeuvre fauve de Derain." *Revue du Louvre et des Musées de France* (Paris), 1967, pp. 283-88.

93. Edinburgh. Royal Scottish Academy. *Derain.* August 18-September 17, 1967; and London, Royal Academy, September 30-November 5, 1967. Foreword by Jean Leymarie. Texts by Guillaume Apollinaire (1916), André Breton (1924), Alberto Giacometti (1957).

94. Dorival, Bernard. "Un Album de Derain au Musée National d'Art Moderne." *Revue du Louvre et des Musées de France* (Paris), 1969, pp. 257-68.

95. Hoog, Michel. "Les Deux Péniches de Derain." *Revue du Louvre et des Musées de France* (Paris), 1972, pp. 212-16.

96. Cologne. Baukunst. *André Derain. Handzeichnungen, Gouachen, Olbilder, Terrakotten, Plastiken.* November 22, 1973-February 2, 1974. Essay by de Chirico (1955).

KEES VAN DONGEN

97. Paris. Galerie Vollard. *Exposition Van Dongen.* November 15-25, 1904. Preface by Félix Fénéon.

98. Paris. Galerie E. Druet. *Kees van Dongen.* October 23-November 11, 1905.

99. Paris. Galerie Bernheim-Jeune. *Exposition Van Dongen.* November 25-December 8, 1908. Preface by Marius-Ary Leblond.

100. Amsterdam. Stedelijk Museum. *Van Dongen. Eeretentoonstelling.* December 1937-January 1938.

101. Bordeaux. Musée de Bordeaux. *Exposition Van Dongen.* Decem-

ber 11, 1943-January 3, 1944. Texts by Sacha Guitry and Elie Faure.

102. Nice. Galerie des Ponchettes. *Van Dongen.* 1959. Text by Louis Chaumeil. Preface by Jean Cocteau.

103. Chaumeil, Louis. *Van Dongen: L'Homme et l'artiste—la vie et l'oeuvre.* Geneva: Pierre Cailler, 1967.

104. Paris. Musée National d'Art Moderne. *Van Dongen.* October 13-November 26, 1967. Preface by Bernard Dorival.

105. Diehl, Gaston. *Van Dongen.* Paris: Flammarion, 1968; New York: Crown, 1969.

106. Hoog, Michel. "Repères pour Van Dongen." *Revue de l'Art* (Paris), 1971, pp. 93-97.

107. Melas Kiriazi, Jean. *Van Dongen et le fauvisme.* Paris: La Bibliothèque des Arts, 1971.

108. Tucson. University of Arizona. Museum of Art. *Cornelius Theodore Marie van Dongen.* February 14-March 14, 1971. Texts by William E. Steadman and Denys Sutton.

RAOUL DUFY

109. "Raoul Dufy et son oeuvre." *Le Nouveau Spectateur* (Paris), [1919], pp. 103-43.

110. Berr de Turique, Marcelle. *Raoul Dufy.* Paris: Floury, 1930.

111. Paris. Musée National d'Art Moderne. *Raoul Dufy.* 1953. Catalogue by Bernard Dorival. Preface by Jean Cassou.

112. Lassaigne, Jacques. *Dufy. Biographical and Critical Studies.* [Geneva] Skira, 1954.

113. San Francisco. Museum of Art. *Raoul Dufy.* May 12-July 4, 1954. Texts by Grace L. McCann Morley, Jean Cassou, and Marvin C. Ross.

114. Daulte, François. "Marquet et Dufy devant les mêmes sujets." *Connaissance des Arts* (Paris), November 1957, pp. 86-93.

115. Dorival, Bernard. "Les Affiches à Trouville." *Revue des Arts* (Paris), September-October 1957, pp. 225-28.

116. Werner, Alfred. *Raoul Dufy.* New York: Abrams, [1970].

117. Bordeaux. Galerie des Beaux-Arts. *Raoul Dufy.* May 2-September 1, 1970. Texts by Jacques Lassaigne, Raymond Cogniat, and Gilberte Martin-Méry.

118. Laffaille, Maurice. *Raoul Dufy.* Vols. 1-2. Geneva: Motte, 1972-73.

119. Munich. Haus der Kunst. *Raoul Dufy.* June 30-September 30, 1973. Foreword by Bernard Dorival.

EMILE-OTHON FRIESZ

120. Paris. Galerie Druet. *Othon Friesz.* November 4-16, 1907. Preface by Fernand Fleuret.

121. Salmon, André. *Emile-Othon Friesz et son oeuvre.* Paris: Nouvelle Revue française, 1920.

122. Fleuret, Fernand, and others. *Friesz: Oeuvres (1901-1927).* Paris: Chroniques du jour, 1928.

123. Paris. Galerie Charpentier. *Rétrospective Othon Friesz.* 1950. Texts by Charles Vildrac and Maximilien Gauthier.

124. Gauthier, Maximilien. *Othon Friesz.* Geneva: Pierre Cailler, 1957.

125. Paris. Musée Galliera. *Othon Friesz.* October-November 1959. Preface by René Héron de Villefosse.

126. Giry, Marcel. "Le Paysage à figures chez Othon Friesz (1907-1912)." *Gazette des Beaux-Arts* (Paris), January 1967, pp. 45-57.

HENRI MANGUIN

127. Cabanne, Pierre. *Henri Manguin.* Neuchâtel: Ides et Calendes, 1964.

128. Albi. Musée Toulouse-Lautrec. *Exposition Henri Manguin (1874-1949): Peintures, aquarelles, dessins.* April 10-May 25, 1957. Text by Charles Terrasse.

129. Paris. Galerie de Paris. *Manguin. Tableaux fauves.* May 3-June 2, 1962. Text by J.-P. Crespelle.

130. Neuchâtel. Musée des Beaux-Arts. *Henri Manguin.* June 4-September 6, 1964. Introduction by Daniel Vouga.

131. Terrasse, Charles, "Manguin, il 'Fauve.'" *Arti* (Milan), May 1969, pp. 2-15. Articles by Terrasse, Cogniat, Dunoyer de Segonzac, and Mme Albert Marquet.

132. Düsseldorf. Städtische Kunsthalle. *Henri Manguin.* October 24-December 7, 1969. Texts by Karl Ruhrberg and Jean Goldman.

133. Tucson. University of Arizona. Museum of Art. *Manguin in America. Henri Manguin 1874-1949.* December 21, 1974-February 2, 1975. Text by Denys Sutton.

ALBERT MARQUET

134. Besson, George. *Marquet.* Paris: Georges Crès, 1929.

135. "Marquet; dessins...." *Le Point* (Lanzac), 1943. Texts by André Rouveyre and George Besson.

136. Paris. Musée d'Art Moderne. *Albert Marquet, 1875-1947.* October-December, 1948. Preface by Jean Cassou. Texts by George Besson and Claude Roger-Marx.

137. Marquet, Marcelle. *Marquet*. Paris: R. Laffont, 1951.

138. ———, and Daulte, François. *Marquet*. Lausanne: Spes, 1953.

139. Dorival, Bernard. "Nouvelles Oeuvres de Matisse et Marquet au Musée National d'Art Moderne." *Revue des Arts* (Paris), May-June 1957, pp. 114-20.

140. San Francisco. Museum of Art. *Albert Marquet*. 1958. Introduction by Marcelle Marquet. Text by Grace L. McCann Morley.

141. Hamburg. Kunstverein. *Albert Marquet. Gemälde, Pastelle, Aquarelle, Zeichnungen*. November 14, 1964-January 10, 1965. Introduction by Hans Platte.

142. Bordeaux. Musée des Beaux-Arts. *Albert Marquet, 1875-1947*. May 9-September 7, 1975. Preface by Jean Cassou. Text by Marcel Sembat.

HENRI MATISSE

143. Paris. Galerie Vollard. *Exposition des oeuvres du peintre Henri Matisse*. June 1-18, 1904. Preface by Roger Marx.

144. Sembat, Marcel. *Matisse et son oeuvre*. Paris: Gallimard, 1920.

145. "L'Oeuvre de Henri Matisse." *Cahiers d'Art* (Paris), 1931, pp. 229-316. Texts by Christian Zervos, Paul Fierens, Pierre Guéguen [and others].

146. Fierens, Paul. "Matisse e il 'fauvisme.'" *Emporium* (Bergamo) October 1938, pp. 195-208.

147. "Matisse." *Le Point* (Colmar), 1939. Texts by Jules Romains, Réne Huyghe, Jean Puy, George Besson, Raymond Cogniat.

148. Philadelphia. Museum of Art. *Henri Matisse: Retrospective Exhibition of Paintings, Drawings and Sculpture Organized in Collaboration with the Artist*. April 3-May 9, 1948. Text by Louis Aragon.

149. Barr, Alfred H., Jr. *Matisse: His Art and His Public*. New York: The Museum of Modern Art, 1951.

150. Trapp, Frank Anderson. "The Paintings of Henri Matisse: Origins and Early Development (1890-1917)." Ph.D. dissertation, Harvard University, Cambridge, Massachusetts, 1951.

151. Escholier, Raymond. *Matisse, ce vivant*. Paris: A. Fayard, 1956.

152. Lassaigne, Jacques. *Matisse*. Geneva: Skira, 1959.

153. Los Angeles. University of California Art Galleries. *Henri Matisse Retrospective*. January 5-February 27, 1966. Texts by Jean Leymarie, Herbert Read, and William S. Lieberman.

154. Gowing, Lawrence. *Henri Matisse: 64 Paintings*. New York: The Museum of Modern Art, 1966.

155. Negri, Renata. *Matisse e i fauves*. Milan: Fratelli Fabbri, 1969.

156. Russell, John. *The World of Matisse, 1869-1954*. New York: Time-Life Books, 1969.

157. *Homage to Henri Matisse*. Edited by G. diSan Lazzaro. New York: Tudor, 1970. Essays by Georges Rouault, Jean Cassou, Roger Fry, Jean Leymarie, Herbert Read, and others.

158. Paris. Grand Palais. *Henri Matisse. Exposition du centenaire*. April-September 1970. 2nd ed., revised.

159. Elsen, Albert E. *The Sculpture of Henri Matisse*. New York: Abrams, [1972].

160. Matisse, Henri. *Ecrits et propos sur l'art*. Edited by Dominique Fourcade. Paris: Hermann, 1972.

161. Jacobus, John. *Henri Matisse*. New York: Abrams, 1972.

162. Flam, Jack D. *Matisse on Art*. London and New York: Phaidon, 1973.

163. Paris. Musée National d'Art Moderne. *Henri Matisse. Dessins et sculpture*. May 29-September 7, 1975. Introduction by Dominique Boza. Text by Dominique Fourcade.

JEAN PUY

164. Puy, Michel. *Jean Puy*. Paris: Gallimard, 1920.

165. Puy, Jean. "Souvenirs." *Le Point* (Colmar), July 1939, pp. 112-33.

166. Bettex-Cailler, Nane. "Jean Puy." *Cahiers d'Art-Documents* (Geneva), no. 104, 1959, pp. 1-16.

167. Lyon. Musée de Lyon. *Jean Puy*. 1963. Preface by George Besson.

168. Staub, François-Xavier. "Le Peintre Jean Puy." *L'Information d'Histoire de l'Art* (Paris), 1968, pp. 31-36.

MAURICE DE VLAMINCK

169. [Kahnweiler, Daniel-Henry]. *Maurice de Vlaminck*. Leipzig: Klinkhardt and Biermann, 1920.

170. Fels, Florent. *Vlaminck*. Paris: Marcel Seheur, 1928.

171. Vlaminck, Maurice de. *Tournant dangereux*. Paris: Librairie Stock, 1929. English translation: *Dangerous Corner*. London: Elek Books, 1961.

172. ———. *Poliment*. Paris: Librairie Stock, 1931.

173. ———. *Le Ventre ouvert*. Paris: Corrèa, 1937.

174. Perls, Klaus G. *Vlaminck*. New York: Hyperion Press, Harper and Brothers, 1941.

175. Vlaminck, Maurice de. *Portraits avant décès*. Paris: Flammarion, 1943.

176. ———. *Paysages et personnages*. Paris: Flammarion, 1953.

177. ———. "Avec Derain nous avons créé le fauvisme." *Jardin des Arts* (Paris), 1955, pp. 473-79.

178. Roger-Marx, Claude. "Vlaminck ou le fauve intégral." *Jardin des Arts* (Paris), April 1956, pp. 350-54.

179. Sauvage, Marcel. *Vlaminck, sa vie et son message.* Geneva: Pierre Cailler, 1956.

180. Paris. Galerie Charpentier. *L'Oeuvre de Vlaminck. Du fauvisme à nos jours.* 1956. Text by Claude Roger-Marx.

181. Crespelle, Jean-Paul. *Vlaminck, fauve de la peinture.* 9th ed. Paris: Gallimard, 1958.

182. Bern. Kunstmuseum. *Vlaminck.* February 4-April 3, 1961. Preface by Hugo Wagner.

183. Werner, Alfred. "Vlaminck: Wildest of the 'Beasts!'" *Arts Magazine* (New York), March 1968, pp. 30-33.

184. New York. Perls Galleries. *Vlaminck: His Fauve Period (1903-1907).* April 9-May 11, 1968. Text by John Rewald.

Compiled by Inga Forslund
Librarian, The Museum of Modern Art

Photograph Credits

Photographs of the works of art reproduced have been supplied, in the majority of cases, by the owners or custodians of the works, as cited in the captions. The following list applies to photographs for which a separate acknowledgment is due.

Architectural Record (New York), May 1910, p. 414: 110 top; Art Gallery of Ontario, Toronto: 66 right, 115, 147; Raymond Asseo, Geneva: 75 bottom left; Adam Avila, Los Angeles: 37, 58; Oliver Baker-Geoffrey Clements, New York: 98; Copyright Barnes Foundation, Merion, Pa.: 100 top, 139 top; Bérard, Nice: 16; J. E. Bulloz, Paris: 120, 121 top left; Klaus Burkard, Winterthur: 78 right; Cleveland Museum of Art: 20; Alain Danvers, Bordeaux: 21, 24 right; Foto Kleinhompel, Hamburg, Copyright Stiftung Seebüll A.u.E. Nolde: 146 top left; Claude Frossard, Le Cannet: 108 right; Galerie Beyeler, Basel: 72 bottom left; Galerie de Paris: 63; Galerie Valtat, Paris: 29 left; Giraudon, Paris: 39 top left, 79; André Godin, Troyes: 39 top right, 50 top left, 81 bottom; The Solomon R. Guggenheim Museum, New York: 112 right; IFT, Grenoble: 138; Jan Jachniewicz, New York: 146 top right; Peter A. Juley and Son, New York: 17; Kate Keller, The Museum of Modern Art, New York: 57, 94, 126; James Mathews, The Museum of Modern Art, New York: 42 bottom; Allen Mewbourn, Houston: 39 bottom left, 75 right, 114; Musées Nationaux, Paris: 30, 33 right, 34, 35 left, 70, 75 top left, 76 top left, 77, 82, 87, 89 right and bottom left, 104, 108 bottom left, 130 right, 133 bottom left, 185 left; O. E. Nelson, New York: 89 top left; Perls Galleries, New York: 73; Rolf Peterson, The Museum of Modern Art, New York: 23 left; Petit Palais, Musée, Geneva: 29 right, 66 left, 121 top right; Photopress, Grenoble: 80 top right; Photothèque Connaissance: 41, 72 top left; Photos-Bianquis, Saint-Tropez: 64; Renger Foto, Essen: 50 right, 83 left; San Francisco Museum of Modern Art: 53; John D. Schiff, New York: 76 right, 83 right: Galerie Schmit, Paris: 122 top right; Sunami, The Museum of Modern Art, New York: 52, 80 bottom left, 85, 100 bottom left, 103, 106, 117, 118, 121 bottom left, 124, 134, 137 top, 146 bottom left; Charles Uht, New York: 27, 90; Malcolm Varon, New York: back cover, right; 25, 26, 28, 46, 48, 60, 93, 113, 116, 125, 128; Wildenstein and Company, New York: 65 right, 133 right; A. J. Wyatt, Philadelphia Museum of Art: 68 left.